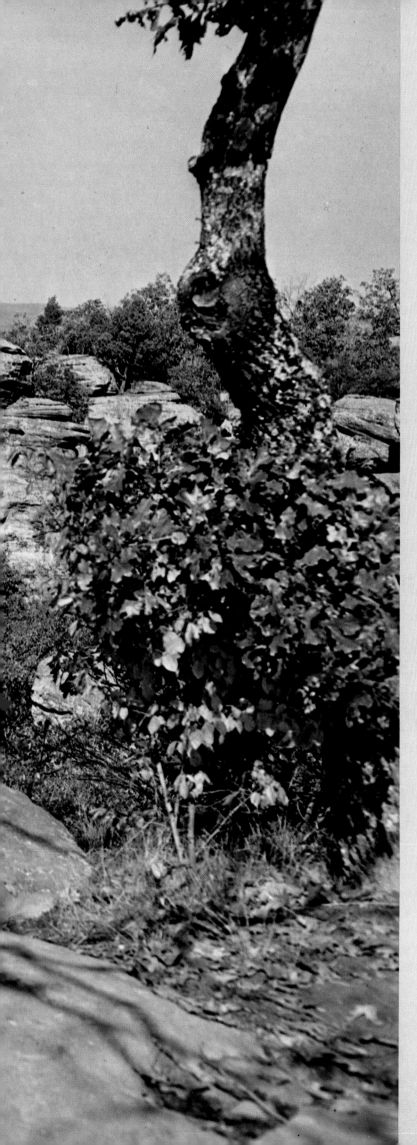

LAND

BETWEEN

THE RIVERS

The Southern Illinois

Country

By C. William Horrell,
Henry Dan Piper,
and John W. Voigt

Southern Illinois University Press

CARBONDALE AND EDWARDSVILLE

COPYRIGHT © 1973 by Southern Illinois University Press

International Standard Book Number 0–8093–0566–6
Library of Congress Catalog Card Number 71–156777
Printed in the United States of America
Designed by Andor Braun
Endpaper maps by Dan Irwin

SOUTHERN ILLINOIS UNIVERSITY CENTENNIAL PUBLICATIONS

Publications Committee

BASIL C. HEDRICK

HAROLD M. KAPLAN

CARROLL L. RILEY

The Country is very fine; the great rivers which water it, the vast and dense forests, the delightful prairies, the hills covered with very thick woods,—all these features make a charming variety. Although this Country is farther South than Provence, the winter here is longer; the cold weather, however, is somewhat mitigated. During summer the heat is less scorching: the air is cooled by the forests and by the number of rivers, lakes, and ponds with which the Country is intersected. . . .

The swamps are filled with roots, some of which are excellent, as are the potatoes and others, of which it is useless to note here the barbarous names. The trees are very tall and very fine: there is one to which has been given the name of cedar of Lebanon; it is a lofty, very straight tree, which shoots out its branches only at the top, where they form a sort of crown. The Copal is another tree, from which issues a gum that diffuses an odor as agreeable as that of incense.

Fruit-trees are not very numerous here; we find apple-trees and wild plum-trees that would perhaps produce good fruit, if they were grafted; there are many mulberry-trees, of which the fruit is not so large as those in France and there are different kinds of nut-trees. The pecans (it is thus that the fruit of one of the Nut-trees is called) have a better flavor than our nuts in France. Peach-trees from the Mississippi have been brought to us; they come in very good condition. . . . We also have grapes, but they are only indifferently good; they must be gathered from the tops of the trees. Sometimes we have been compelled to make wine of them, for lack of having any other in saying our Mass. Our Savages are not accustomed to gather fruit from the trees; they think it better to cut down the trees themselves; for this reason, there are scarcely any fruit-trees in the vicinity of the Villages.

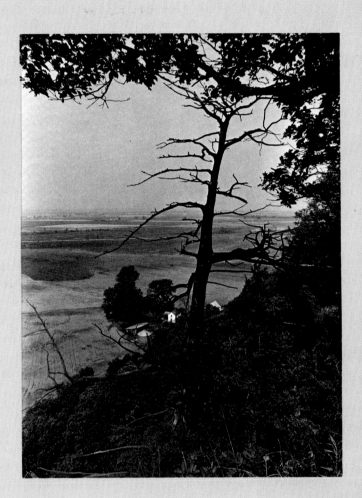

—An early view of Southern Illinois (1712). Letter from Father Gabriel Marest, Missionary of the Society of Jesus, from Kaskaskia. *The Jesuit Relations and Allied Documents,* Vol. 66, reprinted in *Illinois Prose Writers: A Selection,* edited by Howard Webb, Jr., Southern Illinois University Press (1968)

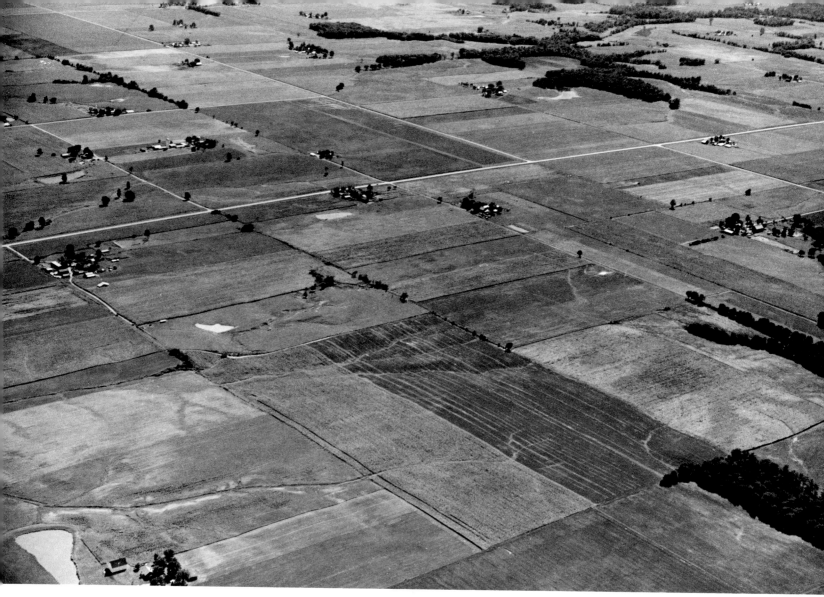

Typical prairie farms along Southern Illinois's northern border

Illinois, like Caesar's Gaul, is divided into three parts: Northern, Central, and Southern Illinois. Of these, Southern Illinois (or "Egypt" as it has been called now for over one hundred and fifty years) is the oldest and the most sparsely populated. It has no major cities, and few of its towns contain more than ten thousand inhabitants. It is not only the least-known region of Illinois but—in the opinion of Southern Illinoisans as well as an ever-growing number of newcomers and tourists—it is the most scenic, and perhaps the most beautiful.

Most of Illinois deserves its nickname of "the Prairie State." But the great ice sheets that smoothed out the upper Midwest, and helped make the prairies, stopped in Southern Illinois. Southwards they left a broken, heavily-forested terrain that contrasts dramatically today with the rich flatland farms and the bustling cities to the north. This land of steep hill farms, rocky ravines, and long blue vistas is a wilder-

ness paradise, a land between the rivers, "the Southern Illinois country."

On the east, south, and west, Southern Illinois is bordered by three well-known rivers: the romantic Wabash, the beautiful Ohio, and the mighty Mississippi. The northern border is harder to define so precisely. It is generally agreed that Southern Illinois begins where the smooth prairie farmland gradually changes to rolling hills and wooded ravines that grow steeper and more forested as you travel south. Putting it another way, Southern Illinois consists primarily of the land south of U.S. Route 50 (the east-west highway from Vincennes, Indiana, to St. Louis, Missouri) and also includes the tier of counties bordering Route 50 on the north. These thirty-four counties make up one-fourth of the area of the state, and contain about one-tenth of the population—something over one million inhabitants. Southern Illinois covers approximately ten thousand square

9

Crested Coralroot Orchid

miles—an area as big as Belgium, or the states of Maryland or Massachusetts. If Southern Illinois were a state it would be larger than ten other states, including New Jersey, Vermont, and New Hampshire. It is twice the size of Connecticut.

Driving or flying south across Southern Illinois, you leave what geographers call the "Grand Prairie" (or "Springfield Plain") of central Illinois and enter the region known as the "Mount Vernon Hill Country." It is hard to distinguish sharply between these two topographical regions, except to say that as you go farther south, the farms grow smaller and are surrounded by thicker woodlands. Before the white man came, this hill country consisted of small prairie meadows interspersed with long fingers of timberland that marked the beds of streams. Today, except for a few carefully preserved sites, most of these prairie fields and the adjacent stands of virgin forest have long since disappeared. The Mount Vernon Hill country is now primarily rolling farmland, except for a great crescent stretching southeast from Randolph and Perry counties to Gallatin county, where coal beds come so close to the surface that they have made this the most heavily mined region in the state. To the east along the Wabash, and alongside these

Indian Pink

10

Common Dandelion

coal reserves, lies a rich basin of crude oil that, since its discovery in 1937, has made Illinois the eighth ranking state in the production of petroleum.

South of the Mount Vernon Hill country you come next to the Shawnee Hills, the so-called "Illinois Ozarks," that mark the southernmost limit of the prehistoric ice sheets. Here the land rises sharply into hill farms that are more suited to orchards and grazing than the corn and soybean land to the north. The Shawnee Hills culminate in Shawneetown Ridge, a heavily timbered wilderness of bluffs and knobs reaching up to an elevation of over a thousand feet, with rocky cliffs towering hundreds of feet above the valley floor. The Shawnee Hills are the heart of Southern Illinois, an all-year-round vacation-land that comprises several state parks, campsites, hiking and bridle trails, wildlife preserves, and the 204,000-acre Shawnee National Forest.

Beyond the Shawneetown Ridge the land drops away in steep valleys and gentle foothills to the low-lying cypress swamps and lakes along the Cache River—the ancient bed of the Ohio River. Beyond Cache valley you come to the flood plain of the Ohio River itself. Two similar flood plains border Southern Illinois on the east and west, forming the banks of the Wabash and Mississippi rivers.

Situated as it is at about the same latitude as Southern Virginia and California's Death Valley, Southern Illinois enjoys an unusually varied climate. Winters are mild with snowfalls of short duration, and an occasional ten days to two weeks of good ice skating. The growing season for plants and crops is a month longer than in northern Illinois. Southern Illinois also enjoys an annual rainfall averaging ten inches more than in the north. This is distributed fairly evenly over the year, with the heaviest precipitation occurring in the Shawnee Hills. During recent years this runoff has been conserved by a massive program of dam building in the lower valleys that has provided the region with hundreds of square miles of lakes for recreational and industrial purposes of various kinds. For example, Crab Orchard Lake, comprising 9,000 acres, has a 125-mile shore line, while the 26,000-acre Carlyle and 19,000-acre Rend lakes have shore lines of 90 and 165 miles, respectively. And there are several new lakes in various stages of planning and construction.

Summers are hot in the valleys of Southern Illinois, but noticeably cooler in the hills and the shaded forest glades. On a July day in Giant City Park it is not unusual to find a twenty-five degree difference in temperature between an exposed, sun-baked rocky ledge and the cool, moist underside below. Such wide temperature variations match the extremes in topog-

One of the few surviving patches of virgin prairie. This is near Kinmundy, Marion County.

ABOVE: *Bellflower*

11

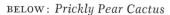

BELOW: *Prickly Pear Cactus*

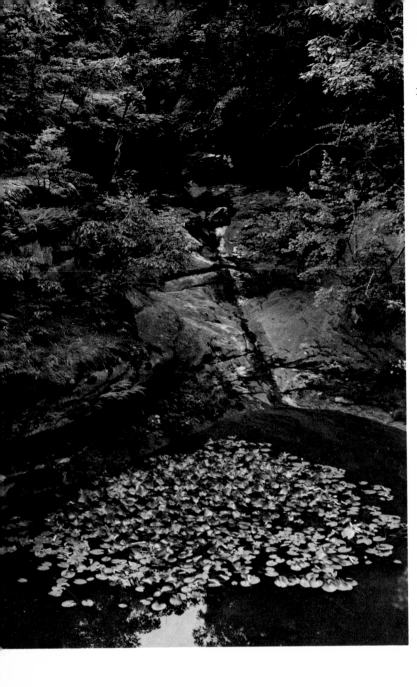

raphy, ranging from the hot river-bottom cypress swamps to hill prairies, upland meadows, and high rocky knobs. With these variations, it is not surprising that the plant and animal life of Southern Illinois is the most profuse and diversified in the state.

Over two thousand species of blooming plant life have been observed by naturalists during the ten-month growing season extending from February through November. Because of its ideal location at the meeting point of so many rivers and ecological regions, Southern Illinois is the natural terminal boundary for hundreds of plant species reaching out to all points of the compass. It is the northern boundary for the southern yellow or short-leaf pine. And it is the eastern boundary for the Missouri primrose, Harvey's buttercup, wild heliotrope, and ozark coneflower. It is the southern boundary for many northern flowers that were pushed this far south thousands of years ago by the massive glaciers, including the northern harebell, bishop's cap, ground pine, partridge berry, cow parsnip, staghorn sumac, and verticillate holly. And it marks the western boundary of such eastern plants as the filmy fern, stone crop, Virginia willow, swamp iris, silver bell, and Clingman's hedge nettle—few of which have so far managed to cross the Mississippi River. Several hundred,

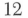

12

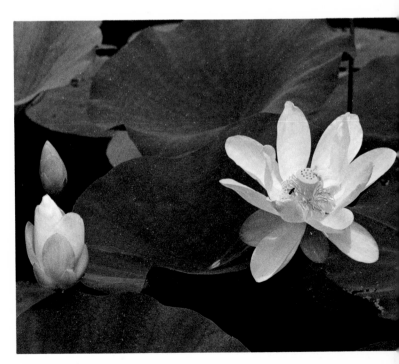

or about 20 percent, of all the plants of Southern Illinois are terminal.

In the dry uplands the hot summer sun produces adaptive features similar to those of the arid southwest. Here one sees such succulents as the American aloe or agave, the prickly pear cactus and woolly-lip fern. Associated with these are scorpions, lizards, the scarlet and black velvet ant, the box turtle, and reptilians that one usually associates with a more desert-like climate. On the other hand, in the moist, stagnant bogs of the Cache River valley one finds the southern swamp cypress, tree frogs, water moccasins and other flora and fauna usually associated with the lower or Southern Mississippi valley. (A century and a half ago the Southern Illinois woods were also alive with flocks of brightly-colored green, red and yellow striped parakeets. Audubon reports having seen them by the thousands. But alas, they now have completely disappeared.)

There are more kinds of trees in Southern Illinois than in all of Europe. The profusion of different species of wild flowers in the spring and early summer, especially in rocky glades with their many picturesque waterfalls, is a treat for the color photographer. Twenty-one different kinds of wild orchid have been identified, including the "showy" and the rattlesnake orchid, lady's-slippers, and lady's-tresses. For the fern fancier, the list includes the filmy and walking ferns, Bradley's spleenwort, and the osmunda. Winds from every direction bring seeds that may take root and so introduce a hitherto unknown species. In a recent ten-year period, professional and amateur naturalists, many of them college students, have discovered over a hundred new plants that had not been previously reported. Among the flowers that can be seen primarily in this region—and very few other places in the world—are Forbes' saxifrage, French's shooting star, and Shay's yellow trillium.

The story is much the same for Southern Illinois animal life. The early settlers, according to their letters and journals, were surprised and delighted by the variety and abundance of the fauna. The bison or buffalo which once covered the upper prairies, the panther and the black bear, of course, have long since departed. And with them, for a time, went the white-tailed deer. But the deer have been restored

(*continued on page 16*)

BELOW: *Pomona Natural Bridge, Jackson County*

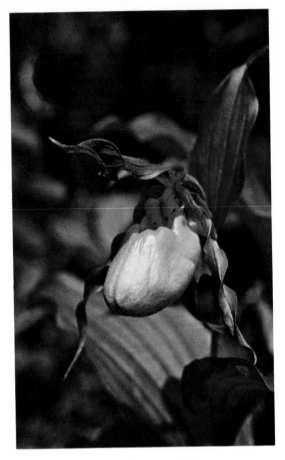

Yellow Lady's-slipper Orchid

The Ozarks of Illinois extend,
Peaceful and primitive, like an etching study,
From the Mississippi and the Big Muddy
To the Saline and Ohio, where they end.
These hills are rugged, strewn with barren rocks,
But spaced with uplands of pastures green
Where sheep browse in a scene that mocks
White clouds above in a blue serene.

Ridges of woodland toward the horizon space
The pastoral silence, where the West commences,
Dotted by log-cabins, lined with rail fences,
Which change and passing years do not displace.
The past still lingers here, that Illinois
Peopled by Kentucky and by Tennessee,
When life was war-less, happy and free
From the insatiate cities which drain, destroy.

—From "Illinois Ozarks," in *Illinois Poems* (1941) by
Edgar Lee Masters

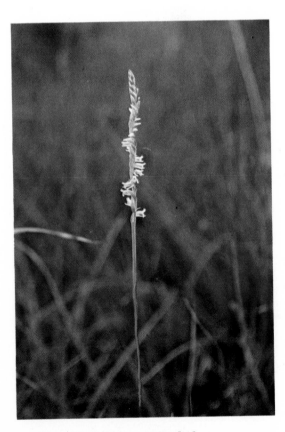

Spring Lady's-tresses Orchid

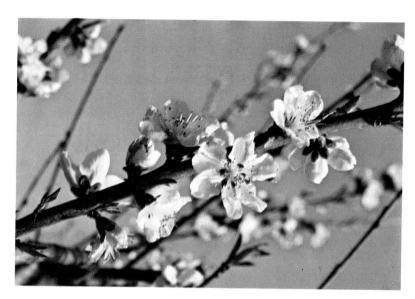

ABOVE: *Peach Blossoms*

LEFT: *Swamp Iris*

BELOW: *Carolina Moonseed*

and have multiplied in abundance, and are now annually hunted in the autumn. Other restored animals include the beaver, wild turkey, and the ruffled grouse. Only an occasional bear, coyote, or wildcat is sighted today. But 85 percent of all the extant vertebrates in Illinois can be found in Southern Illinois; 72 percent of all the fishes; 99 percent of the birds; 91 percent of the amphibians; 85 percent of the mammals; and 60 percent of the reptiles.

Approximately 40 percent of all the fauna in Southern Illinois are indigenous to this region and will not be found elsewhere in Illinois. Indeed, some fauna—like some Southern Illinois flora—are relict types with very limited distribution. Such is the "spring cave" fish that inhabits pools in limestone caves in the Pine Hills bordering the Mississippi River. Found also along the Pine Hills are the pygmy sunfish and mosquito fish. Other unusual Southern Illinois fauna rarely encountered elsewhere in the state include the hell-bender, wood rat, prairie chicken, golden mouse, rice rat, the green and the bird-voiced treefrogs, and several unusual varieties of salamander.

Among the many species of birds that can be seen only in this part of Illinois are the colorful pileated woodpecker, the chuck will's widow, the Carolina chickadee, and the Louisiana water thrush. Located as they are on the main flyway from Canada to the Gulf of Mexico, Southern Illinois lakes play host each winter to literally tens of thousands of ducks and other water fowl, including the Canada goose and the rarer snow goose. Although the primary purpose of the 43,000-acre Crab Orchard National Wildlife Refuge is to provide a wintering area for Canada geese, over 238 other species of birds have also been identified there. Controlled hunting seasons for both ducks and geese occur each year. Other Southern Illinois game include groundhogs, deer, and such fur bearers as the muskrat, mink, beaver, and striped skunk.

Ohio River shore near Elizabethtown, Hardin County

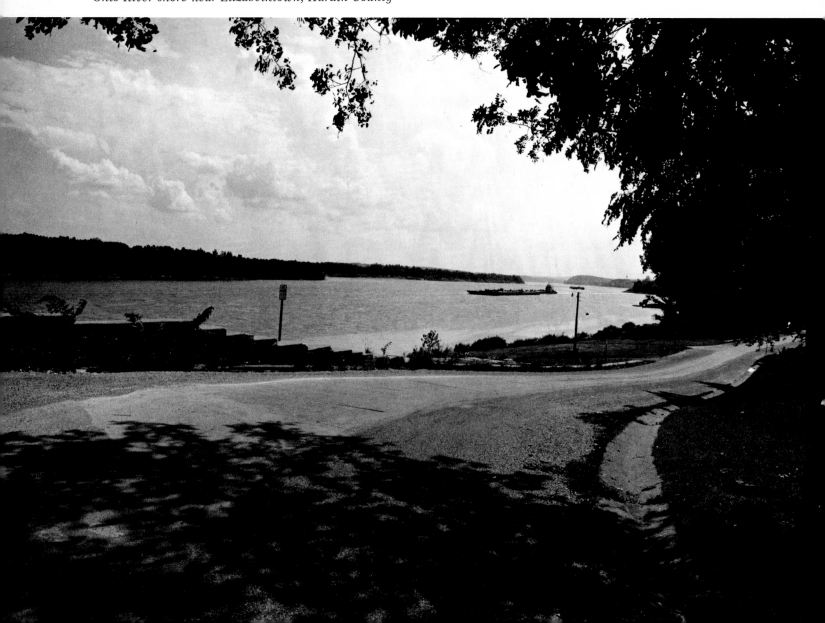

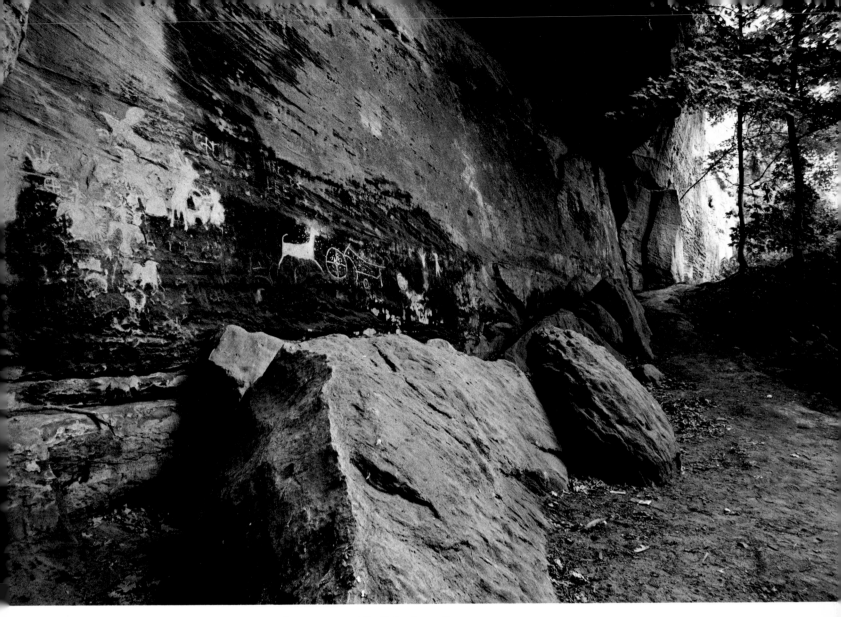

Indian pictographs and petroglyphs, Fountain Bluff, Jackson County

Exploring the byways of Southern Illinois, the traveler is rarely far from reminders of the region's earliest inhabitants, the Indians. Rock carvings (petroglyphs) and wall paintings (pictographs) can still be seen in several remote caves and rock-bluff shelters. In Giant City Park, at the bottom of certain cliffs along the Shawneetown Ridge, and near Lusk Creek, remnants survive of prehistoric stone walls or "stoneforts" whose purpose is still unknown, but that may have been used to trap or perhaps corral the larger wild animals.

Motoring along the Mississippi or Ohio river shores, the traveler occasionally comes upon one or more dirt mounds rising abruptly from the flat bottom land. Monks Mound at Cahokia Mounds State Park in St. Clair County towers over a hundred feet in height. Its four terraces spread out over an area of sixteen acres, larger in volume than that covered by the great pyramid of Cheops in the other "Egypt" along the Nile.

According to archeologists, it seems likely that primitive man, originating in Asia and traveling eastward, reached Southern Illinois about the time that the last of the glaciers receded from Illinois, some ten thousand or more years ago. In 1951 Irvin M. Peithmann, then curator of archeology at the Southern Illinois University Museum, found evidence of prehistoric occupation in a rock shelter near Modoc in Randolph County. Later excavation by the Illinois State Museum, and subsequent dating by Carbon 14 techniques, revealed the site to have been occupied some ten thousand years ago, making it one of the oldest known Indian sites east of the Mississippi River. It has been designated a National Historic Landmark by the U.S. Department of the Interior.

A mild and salubrious climate, game-filled forests and prairies, and rivers that made transportation with dugout canoes relatively easy—all combined to make Southern Illinois a popular place to live for many generations of Indians. Within its borders

17

archeologists have now located numerous sites for all the major North American prehistoric cultural periods, making Southern Illinois a fascinating region for the study of early Indian civilization. These cultural periods are: the Archaic, extending from around 10,000 to 800 B.C.; the Early Woodland, 800 to 300 B.C.; the Middle Woodland or Hopewellian (or so-called "Burial Mound Builders"), 300 B.C. to 400 A.D.; Late Woodland, 400 to 900 A.D.; and the Mississippian or "Temple Mound Builders," 900 to 1600 A.D. Among the most significant sites located to date are Hopewellian burial mounds in Randolph, White, Jackson, and Hardin counties, and the Mississippian ceremonial towns of Cahokia in St. Clair County and Kincaid in the Black Bottom along the Ohio River in Pope and Massac counties.

Of these prehistoric Indian cultures, one of the most advanced as well as the most puzzling and mysterious was the Mississippian. These were the people who built the great Southern Illinois earth mounds and then suddenly disappeared sometime between the coming of the first Spanish conquistadors in 1541 and the arrival of French traders and trappers a century and a half later. In many respects the Mississippian is reminiscent of the Toltec, Mayan, other prehistoric Mesoamerican civilizations that flourished about the same time in Yucatan and Central Mexico. But where these early Mexicans left elaborately carved monuments hewn out of stone, the Mississippians built with the more perishable wood and mud. Yet there is evidence that the Mississippians of Southern Illinois traded with other tribes living as far away as Louisiana and Oklahoma. It seems possible that, although the Mississippians and Mesoamericans did not know each other, both cultures sprang from a common source.

DeSoto, the Spaniard who discovered the Mississippi River in 1541, reported the presence of large villages of Indians along the borders of what are now the states of Mississippi and Arkansas. They were inhabited by sun worshippers who, he said, had developed an unusually high level of political and

Details of Indian art, Fountain Bluff

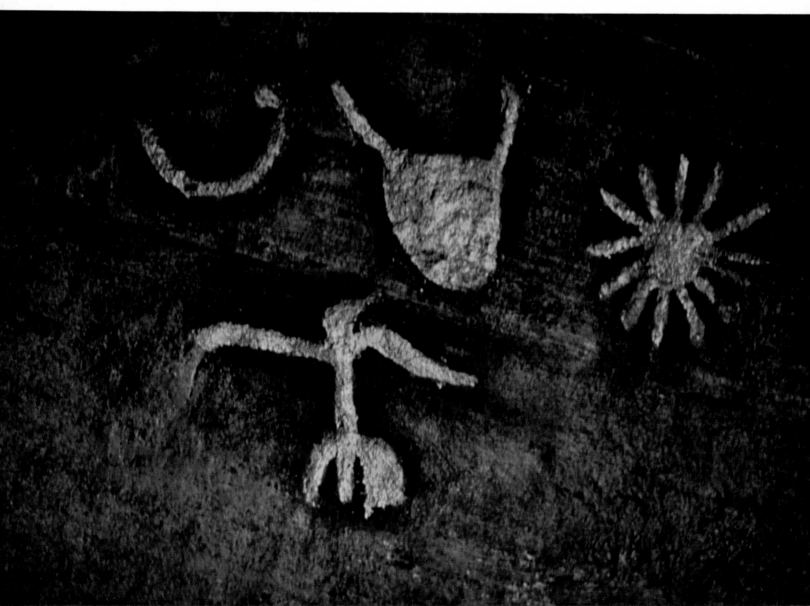

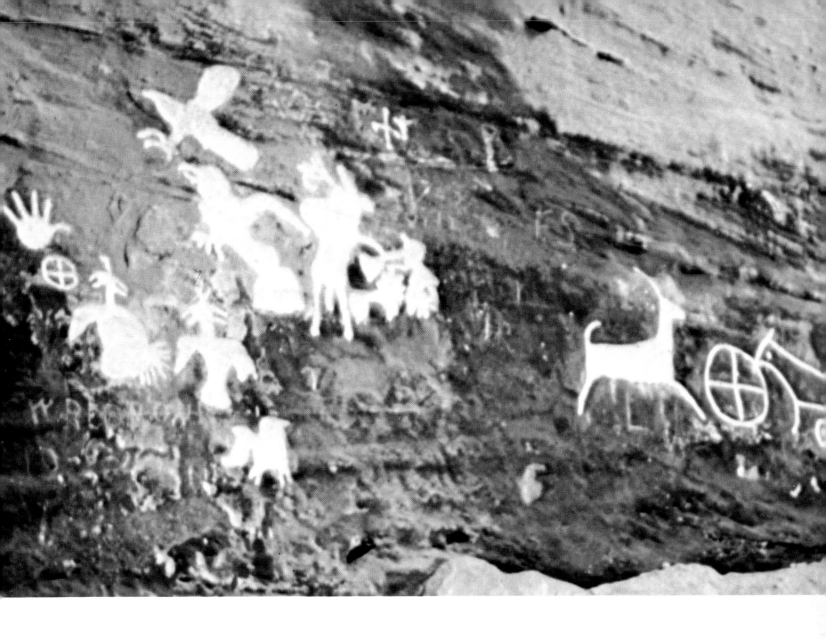

social organization. Despite the presence in Southern Illinois of legends to the contrary, it seems unlikely that DeSoto and his crew ever ascended as far north as the Ohio River. But it does seem probable that the Indians he described as living farther south were part of the so-called Mississippian culture which had one of its largest communities, if not the largest, in the vicinity of Monks Mound, and the many smaller mounds, that now form Cahokia Mounds State Park located several miles back from the east shore of the Mississippi near East St. Louis. Besides Monks Mound, some eighty smaller mounds now survive from what was once a community of more than two hundred mounds. On their tops the Indians erected wooden temples and other buildings associated with their religious worship. These mounds were built by thousands of laborers tediously carrying baskets of dirt up the slopes over many years.

At the height of the Mississippian culture, the villages surrounding Monks Mound are believed to have formed a large "dispersed" city consisting of as many as 150,000 inhabitants. A similar but smaller city flourished 130 miles to the southeast along the Ohio River, on the border between Massac and Pope counties. All that remains today of that settlement is a collection of some twenty mounds, called the Kincaid mounds after the family that owned them for more than a century. Still in private hands, most of them are obscured and overgrown by trees and bushes. Corn and soy beans now grow where once a magnificent plaza extended. But they can be visited, and some systematic excavations have been made. Hopefully, some appropriate public agency will acquire and preserve them for the future, as has been partially done at Cahokia Mounds State Park. With a little imagination, the visitor to the Kincaid site can visualize the impressive spectacle that occurred at sunrise when the great square was crowded with worshipping Indians. One wonders what kinds of ceremonies took place before the altars of the temples that once surmounted these ghostly pyramids.

Unlike most eastern Indians, the Mississippians

19

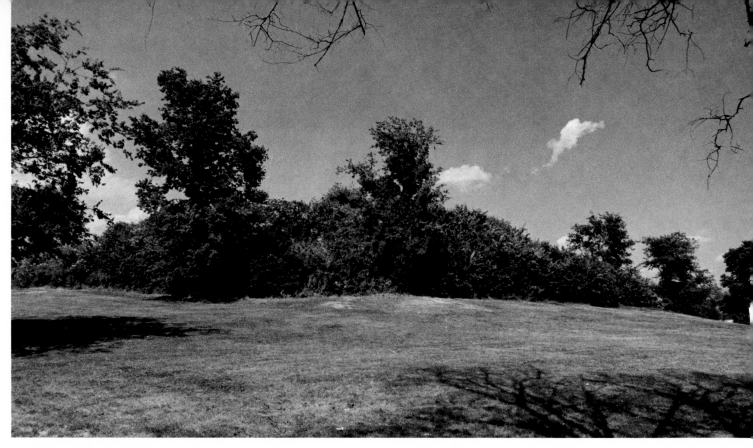

Pre-Columbian Indian mound at Cahokia Mounds State Park, Madison and St. Clair counties

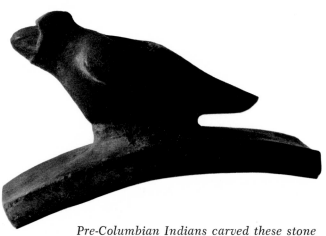

Pre-Columbian Indians carved these stone pipe bowls, Southern Illinois University Museum at Carbondale

were farmers rather than hunters. They had learned to cultivate the rich river valleys and to raise Indian corn, squash, sunflowers, tobacco, and beans. Instead of the "atlatl," a primitive stone weapon used by most Indians for hunting (and often found in Southern Illinois at the sites of earlier Indian cultures), the Mississippians used the bow and arrow. They also knew how to evaporate brine from the various large salt springs still to be found in Jackson and Gallatin counties, and to tan beaver, deer, and other hides for clothing. Their pottery was esthetically the most advanced of any to be found north of Mexico. They also carved stone skillfully into pipes, beads, earrings, and other objects and adornments. They knew how to beat crude copper into thin sheets and to incise intricate designs reminiscent of those found in Mesoamerican excavations.

But, in spite of all this information, we still have much to learn about Southern Illinois's prehistoric inhabitants. There are many unsolved mysteries. The most perplexing is the question: What ever happened to the Mississippians? Although at one time there were tens of thousands of them, Southern Illinois was virtually an empty wilderness when Father Marquette and Louis Jolliet arrived in 1673. The French settlers who followed found only a few thousand Indians in all of Illinois. These consisted of several small tribes loosely associated in a con-

federacy known as the Illiniwek (or "Illinois," as the French pronounced it). They were primarily hunters, presumably the descendants of more primitive tribes who had drifted in from the north. They knew nothing about the Mississippian culture that had so recently preceded them. Today scholars believe that the Mississippian civilization that once stretched from the mouths of the Illinois and Missouri rivers and along the Mississippi to the Gulf of Mexico (and along the Ohio) was probably destroyed by an unrecorded plague of smallpox, measles, or some other contagious disease introduced by early European explorers during the late sixteenth century or early seventeenth century.

The Indian confederacy that the first French visitors found living in Illinois at the end of the seventeenth century consisted primarily of the Kaskaskia, Cahokia, Michigamea, Moingwena, Peoria, and Tamaroa. Later on, Southern Illinois would occasionally be invaded by other tribes from the north, south, and east—Delawares, Iroquois, Shawnees, Kickapoos, Miamis, and Cherokees. The gradual, inevitable, and often ruthless advance of white settlers aroused and disturbed the red man. Whether he capitulated peacefully to the occupation of his lands or defended them with his life made little difference in the long

Monks Mound, largest surviving mound in Illinois of the extinct Mississippian Indian Culture, Cahokia Mounds State Park

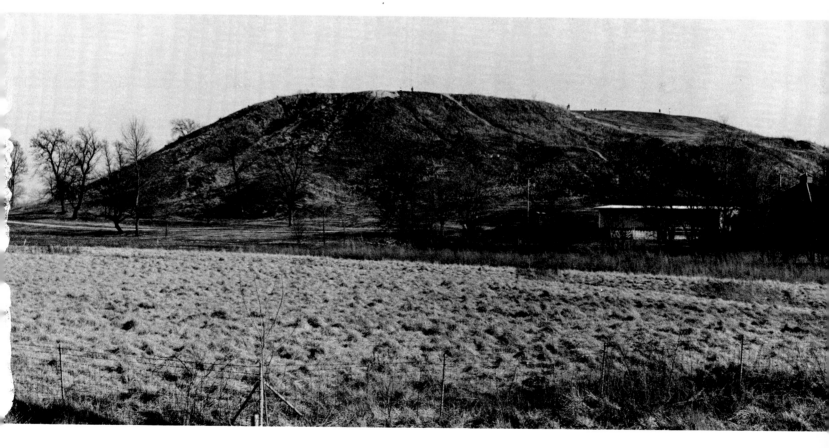

Rattlesnake Plantain Orchid

run. Those Indians who survived were slowly pushed westward across the Mississippi.

The local Southern Illinois tribes seem to have been relatively peaceful, if not apathetic. They were easily debased by hunters and traders who often paid for their furs with an explosive mixture of whisky and gunpowder. Converted to the single industry of trapping, many Indians soon forgot their ancient skills and crafts, and became dependent on white traders for cooking utensils, trinkets, clothing, and other cheap manufactured articles. They crowded into dirty villages around the trading posts for protection from more warlike tribes. As Southern Illinois became trapped out, and the great plains opened up along the Missouri, more and more Indians crossed to the other side of the Mississippi. By 1803, much of Southern Illinois had been ceded by its original inhabitants to the United States government. The only remaining Indian community was on a government reservation at Sand Ridge in Jackson County (from which the residents were removed to Oklahoma in 1833).

There were still Indians living in the northern part of the state, many of whom resented the loss of their southern woodlands. They continued to roam over these traditional hunting grounds, but with each passing year they encountered more stubborn resistance from the land-hungry white settlers. Many of these pioneers had been fighting Indians for several generations, in the rugged Virginia and Pennsylvania hills, and then in eastern Tennessee and Kentucky. Inevitably, bloodshed and violence occurred on both sides. So far as most white settlers were concerned, the only good Indian was a dead Indian.

Over the years Indian leaders occasionally arose and tried to stem the tide. But it was a hopeless cause. In 1763 Pontiac, the heroic chief of the Ottawas, attempted to organize the Appalachian tribes against the encroachments of the British. But after his "conspiracy" failed, he came west to join his old French allies. He was murdered in 1769 at Cahokia by a Peoria, reportedly in the hire of a British fur trader.

During 1811 the Shawnee chief Tecumseh, with his brother The Prophet, crisscrossed Southern Illinois in an attempt to unite tribes along both shores of the Ohio in opposition against the rising flood of settlers. But his cause was doomed from the start. Tecumseh finally joined the British during the War of 1812 and was killed fighting his old enemies the Americans. The last Indian resistance in Illinois was the Black Hawk War in the north. Although it did not directly affect Southern Illinois, many local settlers eagerly volunteered. The Treaty of Chicago in 1833 brought the war to an end, pensioned off the last remaining Indians in the state, and moved them all to a reservation in the Oklahoma territory.

The last and in many ways the most tragic encounter of Southern Illinois with the red men occurred during the bitter winter of 1837–38, when the federal government rounded up thousands of Cherokees living in the Smoky Mountains and forced them to move to a new home in the Oklahoma territory. The Cherokees's line of march (the so-called "Trail of Tears") crossed Southern Illinois from the old Ohio River ferry at Golconda, Pope County, through Jonesboro in Union County to the nearby Mississippi shore. Finding the river too choked with ice to cross by ferry, one group of eight thousand Cherokees was forced to camp for several weeks along Clear Creek, without adequate food, shelter, or protection, in freezing January weather. Many died and were buried in the vicinity of Jonesboro. Of the thirteen thousand Cherokees who were driven from their homes, only eleven thousand survived to reach Oklahoma.

22

As o'er the verdant waste I guide my steed,
Among the high rank grass that sweeps his sides
The hollow beating of his footstep seems
A sacrilegious sound. I think of those
Upon whose rest he tramples. Are they here—
The dead of other days?—and did the dust
Of these fair solitudes once stir with life
And burn with passion? Let the mighty mounds
That overlook the rivers, or that rise
In the dim forest crowded with old oaks,
Answer. A race, that long has passed away,
Built them;—a disciplined and populous race
Heaped, with long toil, the earth, while yet the Greek
Was hewing the Pentelicus to forms
Of symmetry, and rearing on its rock
The glittering Parthenon.

—William Cullen Bryant describes a visit to the Southern Illinois Indian Mounds during the summer of 1832 in his poem "The Prairies"

Archeological dig, Cahokia Mounds State Park
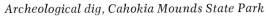

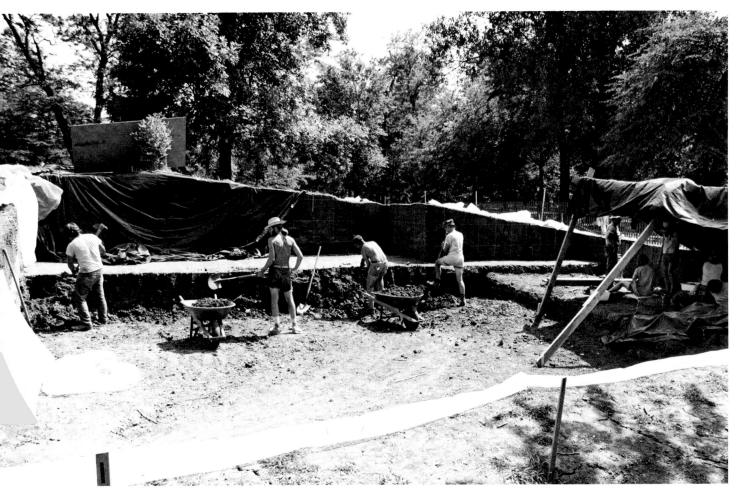

23

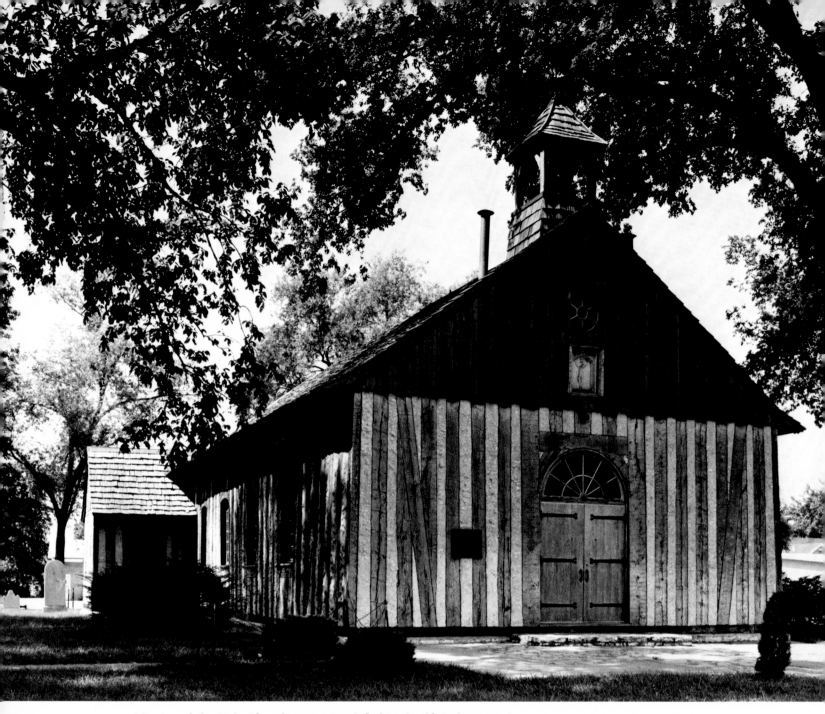

Mission of the Holy Church, ca. 1787, Cahokia, St. Clair County

The French were the first Europeans to settle permanently in Southern Illinois. Although they established themselves in Canada as early as 1608, it was not until many years later that they reached the Mississippi River. In 1673 Father Marquette and his companion Louis Jolliet drifted along the Southern Illinois shore during an exploring trip to the lower reaches of the Mississippi. Then in 1681 Robert Cavalier, Sieur de la Salle, claimed the entire river valley as far as the Gulf of Mexico, for France, naming it "Louisiana" in honor of Louis XIV. In 1699 some Roman Catholic priests from the diocese of Quebec established the first permanent settlement in Southern Illinois on the banks of the Mississippi opposite present-day St. Louis, naming it Cahokia for a tribe of Indians living nearby.

Little of the old town of Cahokia survives today except for the restored residence known as the Saucier House or Old Courthouse that is believed to date from as early as 1736, making it probably the oldest house in the Midwest. In 1793 it was bought by the American territorial government and converted into a combined courthouse and jail. Nearby stands the Church of the Mission of the Holy Family, erected around 1787. It replaced an even earlier structure, and incorporates doors and windows from an older residence. Both buildings are excellent examples of the typical colonial wood-palisade construction used

so much by the French in the Mississippi Valley during the eighteenth century.

Fifty miles south of Cahokia, Jesuit missionaries established a mission in 1702, near the junction of the Kaskaskia and Mississippi rivers, which they named "Kaskaskia" for another Indian tribe living nearby. In time Kaskaskia became the largest and most important of all the French settlements north of New Orleans. In 1809 it was made the capital of the Illinois Territory, and from 1818 until 1820 it served as the capital of the newly-created state of Illinois. But physically Kaskaskia's location was unfortunate. The Mississippi periodically flooded it, and eventually the river's main channel shifted so that by 1910 the river was flowing regularly over what had once been Kaskaskia's main street. By then, of course, its former residents had abandoned it.

Where the river channel had been, a large sandy island formed on the Missouri side of the river. For many years the political status of this island was disputed, but recently it has been awarded to the state of Illinois. In the middle of Kaskaskia Island, safely protected by levees, the state has created a memorial shrine to the old capital, housing the bell that once hung in the steeple of Kaskaskia church. Cast in Paris in 1741, it was given to the parish by Louis XV. Locally it is called "The Liberty Bell of the West" because of the legend that it was rung on July 4, 1778, by Colonel George Rogers Clark when he captured Kaskaskia from its British rulers during the American Revolution and extended to its French inhabitants the protection of the new American government.

Processional emblem, handmade by an early parishioner, Holy Family Church

Interior, Holy Family Church

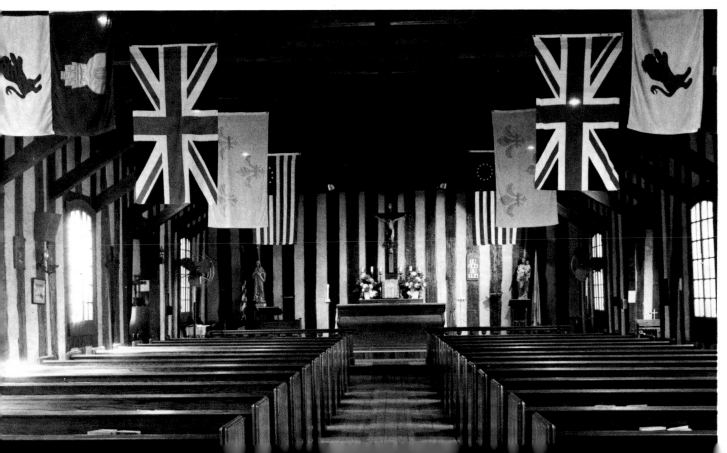

On the bluffs overlooking the drowned site of the old town, the state has established Fort Kaskaskia State Park. Here you can look across the Mississippi and see Kaskaskia Island and behind it the thin thread of water that was once the Mississippi's main channel before it leaped so treacherously across to the foot of the Illinois cliffs and obliterated Illinois's first capital.

Halfway between Cahokia and Kaskaskia the French erected a log stockade in 1709, naming it Fort de Chartres. It was rebuilt with stronger logs in 1719, undermined by floods some years later, partially repaired in 1732, and finally rebuilt solidly of stone in 1756. At this latter date Fort de Chartres was the strongest as well as the most distant of the great chain of forts erected by the French to guard the western approaches to their North American empire. A massive wall eighteen feet high and two feet thick enclosed a parade ground, barracks, a gunpowder magazine, and various outbuildings. In 1763, after the French were defeated in the French and Indian War, the fortress was surrendered to the British. But river floods continued to wash away the foundations, and in 1772 the British abandoned it. In 1915 the state of Illinois established Fort Chartres State Park and reconstructed much of the fort, which by then was almost totally in ruins.

After the defeat of 1763, many French residents in Illinois, disliking British rule and the anarchy that followed, moved across the river and founded the village of St. Louis. Those who remained on the Illinois side in Cahokia, Kaskaskia, Prairie du Rocher, Prairie du Pont, and the other scattered French settlements clung as best they could to their old language and traditions. Of those customs that have survived, probably the most colorful and picturesque is the New Year's Eve ceremony of "La Gui Année" (or "La Guillannée"), originating in medieval France. Its name is a contraction of "la gui de la nouvelle année," the "Mistletoe of New Year's," and it has been regularly celebrated in the little town of Prairie du Rocher for more than two centuries. On New Year's Eve, men of the community disguise themselves in fancy clothes and visit the residences of the town. When they are invited in, they dance, sing the lively old song of the "Gui Année," and make themselves especially agreeable to the ladies. It is then up to the mistress of the household to provide refreshments and a donation for the poor. In the old days, of course, the ceremony was much more elaborate and complicated.

Most of the French settlements in Southern Illinois were on the Mississippi river. There were fewer settlements along the Illinois side of the Wabash and the Ohio rivers. Trappers and fur traders occasionally

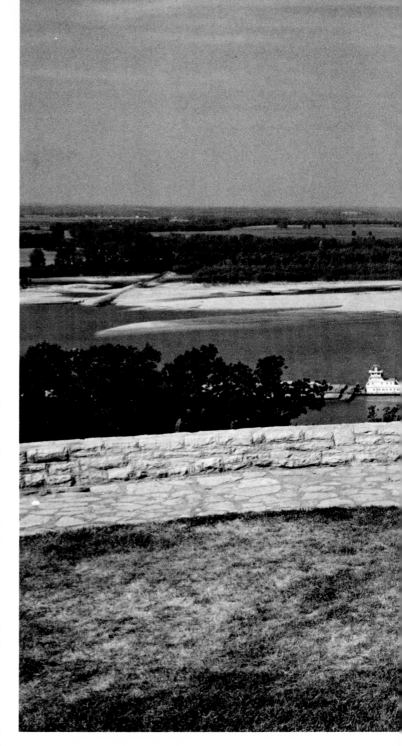

camped on the west shore of the Wabash, opposite the French fort of Vincennes, and some of their descendants still live in that part of Southern Illinois today. The first French settlement along the Ohio occurred in 1702 when a Frenchman named Charles Juchereau de St. Denys established a tanyard and hunters' camp at what is now Post Creek Cutoff in Pulaski County. Juchereau is said to have killed, tanned, and shipped off thousands of skins before the resentful Indians massacred most of his crew in 1704 and he was forced to give up his venture.

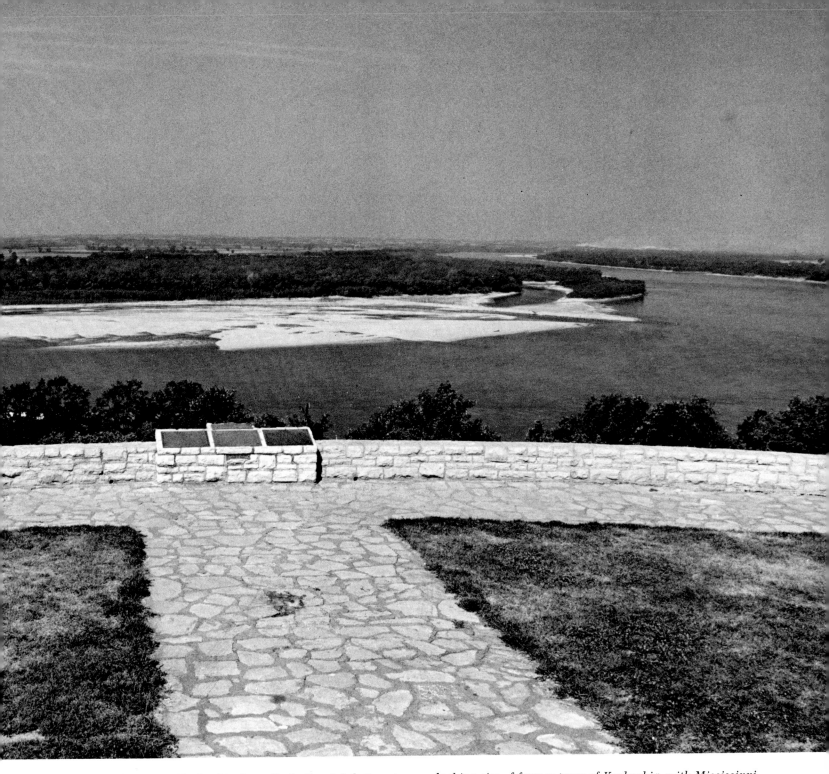

View from Fort Kaskaskia State Park, Randolph County, overlooking site of former town of Kaskaskia, with Mississippi River and Kaskaskia Island in distance

Also in 1702, perhaps coinciding with Juchereau's arrival, a priest named Father Jean Mermet came down from Kaskaskia and established the Mission of the Assumption nearby. But this project too was soon abandoned.

In 1757 the French erected a military fort on a bluff some miles further up the Ohio near the present town of Metropolis in Massac county and named it Fort Ascension because it was dedicated on May 10, Ascension Day. Later it was renamed Fort Massiac in honor of the French Minister of Marine. And this in time was anglicized to "Massac." At the end of the French and Indian War it was turned over to the British, who allowed it to fall to ruins. Later it was often referred to romantically as "Fort Massacre" because of legends associated with Indian fights that occurred in the vicinity.

It would have been better for the British if they had continued to occupy Fort Massac. For this is where the American George Rogers Clark and his troops landed in 1778 and hid their boats before marching overland across the heart of Southern

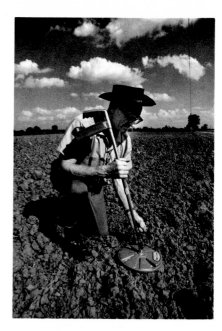

Archeologist using metal detector at Fort de Chartres

"Liberty Bell of the West," Kaskaskia State Memorial

Gate to old stone fort built in 1756, Fort Chartres State Park, Randolph County

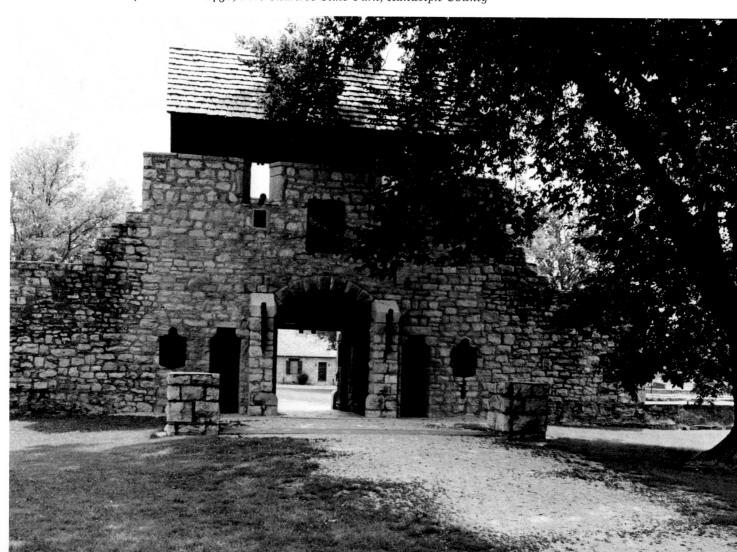

Illinois and surprising and capturing Kaskaskia and the other French settlements along the Mississippi in the name of the state of Virginia and the new United States of America. Then, assisted by French volunteers, Clark and his little band of backwoodsmen plunged eastward into the wilderness, crossing Southern Illinois in the middle of winter to surprise the British fort at Vincennes, which they also captured without the loss of a life.

It was an epic march. The Wabash was in full flood and much of the river was covered with ice. At times Clark and his men were forced to wade up to their necks in freezing water. But Clark's seizure of these British fortifications later provided the American peace commissioners in 1783 with persuasive arguments in favor of the British ceding to the new United States of America not only the original thirteen colonies but also the adjacent western wilderness beyond the Appalachians as far as the Mississippi River.

Earlier the French—in surrendering their claims to the country east of the Mississippi to the British in 1763—had at the same time transferred their holdings west of the Mississippi to Spain. The tyrannical Spanish monarchy was not happy about having a restless new democratic nation next door. It did all it could to persuade American settlers along the Ohio and Mississippi rivers to break away from the United States and set up a smaller, independent "buffer" nation of their own.

To guard against this Spanish threat, President Washington ordered the army to reactivate Fort Massac in 1794. Here Aaron Burr plotted in 1805 with the mysterious Blennerhasset and with General James Wilkinson, the highest ranking general in the American Army (and also a spy in the pay of Spain), in their ill-fated conspiracy to establish a new, independent, frontier nation. Later, during the War of 1812, Fort Massac served as an important American military outpost, with seven hundred troops in residence. At the end of that war it was permanently abandoned. In 1903 the site was acquired by the state of Illinois and became the first in Illinois's now far-flung system of state parks.

At that time a modest restoration was made, and the outlines of the old American fort and its surrounding moat were identified. Now extensive plans are underway for a full-scale excavation and restoration by the state of Illinois that will serve not only as a memorial to George Rogers Clark and his doughty band but also stand as an example of a typical American frontier fort of the 1790s, just as Fort de Chartres illustrates French military construction of the 1750s.

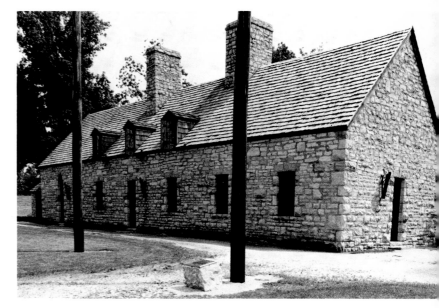

Restored Headquarters, Fort de Chartres

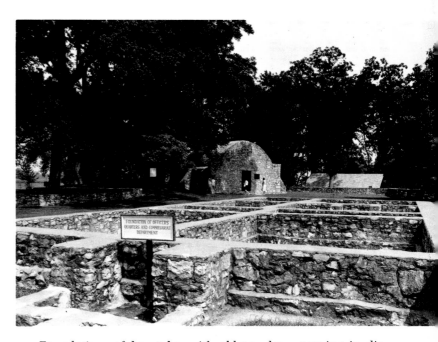

Foundations of barracks, with old powder magazine in distance

La Guillannée

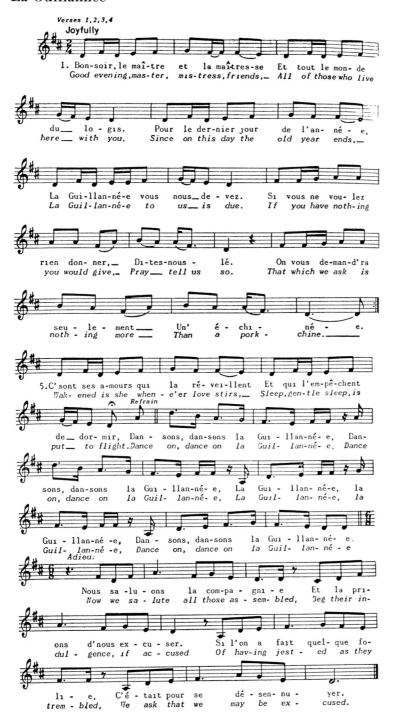

30

2. Un' echinée n'est pas grand'chose;
Ce n'est que dix pieds de long.
Et nous en f'rons une fricassée
De quatre-vingt-dix pieds de long.
Si vous ne voulez rien donner,
Dites-nous-lé.
On vous demand'ra seulement
La fille aînée.

'Tis but a trifle we implore.
Ten feet of pork-chine's all we pray;
Of it we'll have no less, no more
Than ninety feet of fricassée.
If you have nothing you would give,
Pray, tell us so.
That which we ask is nothing more
Than your daughter fine.

3. On y fera faire bonne chère,
On y fera chauffer les pieds.

On y fera faire bonne chère,
On y fera chauffer les pieds.

Quand on fut au milieu du bois,
On fut à l'ombre;
J'ai entendu chanter l'coucou
Et la colombe.

Let us amuse her, we implore,
We'll warm her feet, pray don't de-
cline.
Let us amuse her, we implore,
We'll warm her feet, pray don't de-
cline.
While in the cool and fragrant grove,
There in the shade,
I heard the cuckoo and the dove,
Cooing in the glade.

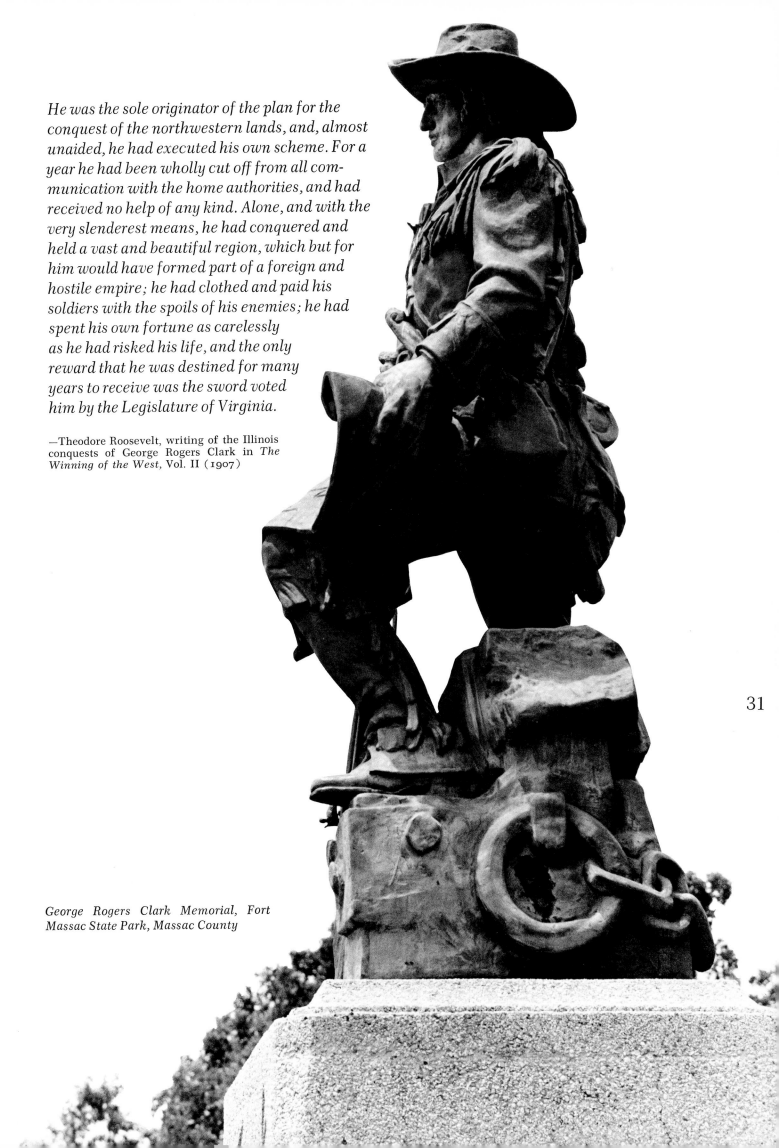

He was the sole originator of the plan for the conquest of the northwestern lands, and, almost unaided, he had executed his own scheme. For a year he had been wholly cut off from all communication with the home authorities, and had received no help of any kind. Alone, and with the very slenderest means, he had conquered and held a vast and beautiful region, which but for him would have formed part of a foreign and hostile empire; he had clothed and paid his soldiers with the spoils of his enemies; he had spent his own fortune as carelessly as he had risked his life, and the only reward that he was destined for many years to receive was the sword voted him by the Legislature of Virginia.

—Theodore Roosevelt, writing of the Illinois conquests of George Rogers Clark in *The Winning of the West*, Vol. II (1907)

George Rogers Clark Memorial, Fort Massac State Park, Massac County

31

Tomb of General Thomas Posey, American Revolutionary War veteran, Old Shawneetown, Gallatin County

Elijah Parish Lovejoy Memorial to the abolitionist martyr, Alton, Madison County

One way of identifying the values and point of view of a given region or community is to examine its public figures and popular heroes. The qualities that the earliest settlers of Southern Illinois admired, in common with most other pioneers, were those that helped in subduing the wilderness—physical prowess, stamina, courage, and self-reliance. If Andrew Jackson embodied these for Southern Illinoisans more than, say Abe Lincoln, it was only in a manner of speaking. There were other more truly indigenous local heroes whose stories tell us a great deal more about Southern Illinois.

One of the earliest was John Moredock of Grand Tower, in Jackson County—the celebrated "Indian hater." In the struggle to conquer the frontier, it is hard to say who was the more brutal—the land-hungry settler or the primitive Indian struggling to protect his land. At any rate, many pioneers responded to the Indian's savage barbarism with a passionate fear and hatred that extended to all members of the Indian race. Some, indeed, became professional Indian killers. One can understand how Herman Melville, the author of *Moby-Dick*, became so fascinated by the legend of John Moredock that he included it in *The Confidence Man*, his strange, surrealistic novel of Mississippi River life. The pathos of Moredock's sad history suggests, however, that he was probably the exception rather than the rule. Daniel Boone and Davy Crockett, even though they belonged primarily to Kentucky, were more typical backwoods supermen. Boone did not spend much time in Southern Illinois, but his brother Joseph lived for many years at Pond Creek, near present-day New Haven at the mouth of the Little Wabash, where he

John Moredock was the son of a woman married thrice, and thrice widowed by a tomahawk. The three successive husbands of this woman had been pioneers, and with them she had wandered from wilderness to wilderness, always on the frontier. . . . All went well till they made the rock of the Grand Tower on the Mississippi, where they had to land and drag their boats round a point swept by a strong current. Here a party of Indians, lying in wait, rushed out and murdered nearly all of them. The widow was among the victims with her children, John excepted, who, some fifty miles distant, was following with a second party.

He was just entering upon manhood, when thus left in nature sole survivor of his race. . . . It is said that when the tidings were brought him, he was ashore sitting beneath a hemlock eating his dinner of venison. . . . From that meal he rose an Indian-hater. . . .

At one time he was a member of the territorial council of Illinois, and at the formation of the state government, was pressed to become a candidate for governor, but begged to be excused. . . . In his official capacity he might be called upon to enter into friendly treaties with Indian tribes, a thing not to be thought of. And even did no such contingency arise, yet he felt there would be an impropriety in the Governor of Illinois stealing out now and then, during a recess of the legislative bodies, for a few days' shooting at human beings, within the limits of his paternal chief-magistracy.

—From Herman Melville's *The Confidence Man: His Masquerade* (1855)

"Madonna of the Trail" statue commemorating the pioneer mothers, Old State House Square, Vandalia, Fayette County

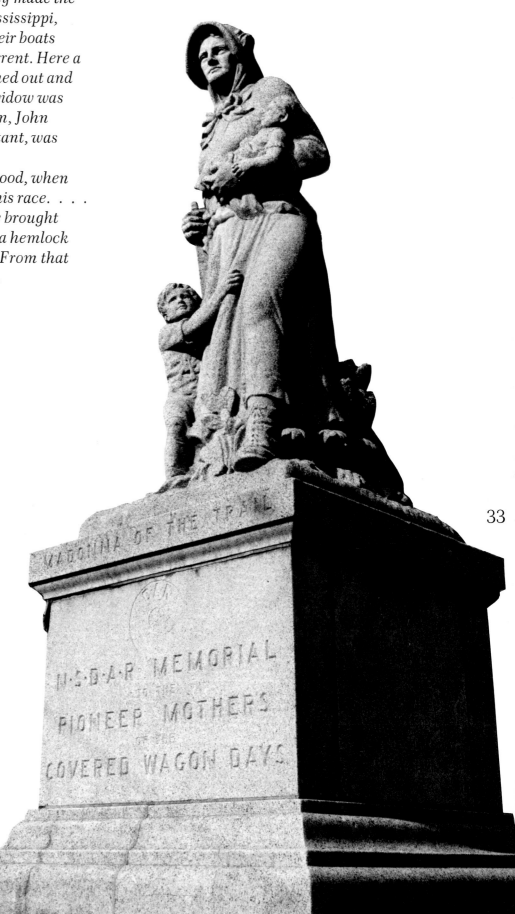

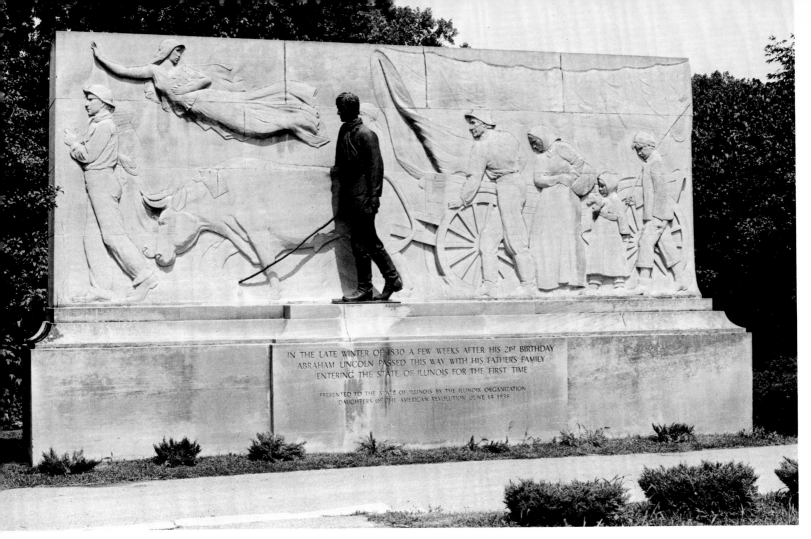

Monument commemorating Lincoln's entry into Illinois as a young man, Lawrence County

After conversing awhile, said I to him. "Lincoln there is a rumor circulating in our region about you and I want you to tell me all about it." "Well," he said, "what is it?" "About thirty years ago, rumor says, Abraham Lincoln was seen walking barefoot, driving an ox-team with an ox-wagon, moving a family through our town of Lawrenceville—is this true?" "In part," says Lincoln,—"about 30 years ago, I did drive my father's ox-wagon and team, moving my father's family through your town of Lawrenceville and I was afoot but not barefoot. . . . I crossed the Wabash at Vincennes and the river being high the road on the low prairie was covered with water a half mile at a stretch and the water covered with ice—the only means by which I could keep the road was by observing the stakes on each side, placed as guides when the water is over the road. . . . After breaking the ice and wading about ¼ mile, my little dog jumped out of the wagon and the ice being thin, he broke through and was struggling for life. I could not bear to lose my dog and I jumped out of the wagon and waded waist deep in the ice and water, got hold of him and helped him out and saved him."

—From a letter in which Peter Smith of Lawrenceville reports a conversation with Lincoln, in which the latter describes his entry from Indiana into Southern Illinois with his family in 1830, in *The History of Edwards, Lawrence and Wabash Counties* (1883)

kept a mill and a ferry. His cousin William "Boon" lived on the other side of Southern Illinois near Fountain Bluff. The latter's son, Benningsen Boone, is said to have been the first white child born in Jackson County.

Another famous early visitor was John James Audubon. His *Journals* record many pleasant hours spent in Southern Illinois, in 1810 and 1811 and again in 1823, when he hunted with the local Indians and observed and sketched the great diversity of wildlife.

On the rivers, especially along the Ohio, one of the most popular folklore heroes was Mike Fink, "King of the Keelboatmen." The first steamboat to navigate the Ohio and the Mississippi rivers arrived in Southern Illinois in 1811, marking the gradual but inevitable doom of the old hand-operated rivercraft. As steamboats multiplied and flatboats and keelboats became less common, Mike's legendary reputation grew. The many stories told about him expressed a way of life that was fast disappearing—along with the boats which he had commandeered. Mike embodied the virtues of the old frontier. Strong as Hercules, wild and uncultivated, he loved nature and resented the encroachment of a machine-age civilization that was already despoiling the wilderness in the name of progress. Mike's well-known war cry expressed the pride, the rugged individualism, and the high spirits of a grass-roots democracy where a man was judged by what he did rather than by who he was or where he came from:

> I'm a Salt River Roarer! I'm a ring-tailed squealer! I'm a reg'lar screamer from the ol' Massassip'! Whoops! I'm half wild horse and half cock-eyed wild alligator and the rest of me is crooked snags and red-hot snappin' turkle. . . . I can out-run, out-shout, out-brag, out-drink, and out-fight, rough and tumble, no holts barred, ary man on both sides o' the river from Pittsburgh to New Orleens and back again' to St. Louiee. Come on, you flatters, you barger, you milk-white mechanics, an' see how tough I am to chaw. I ain't had a fight for two days an' I'm spile'in' for exercise. Cock-a-doodle-doo!

With the passing of the frontier, the next generation of Southern Illinois heroes was associated primarily with the increasingly controversial question of slavery. First to attract national attention was Elijah P. Lovejoy, the single-minded New England abolitionist preacher and newspaper publisher whose determination to use the power of the printed word to alert an unsympathetic community to the evils of

Site of Lincoln-Douglas debate in 1858, Jonesboro, Union County

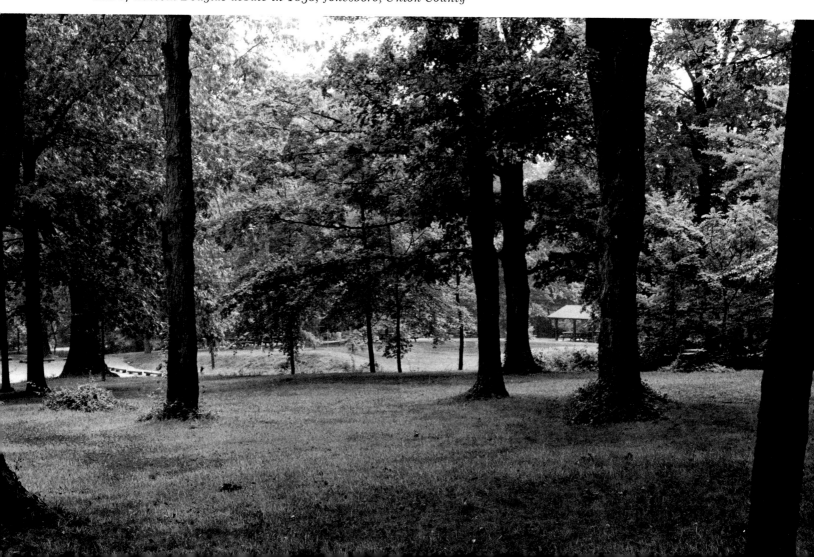

On one occasion, when Mr. Logan was defending a young man being tried for murder, a lamb that had strayed from the fold was chased by dogs into the park that encircled the court-house. In its fright and endeavors to elude its pursuers, it ran into the court-room, down the middle aisle of the crowded room, and lay down at the judge's feet. Quick as a flash Mr. Logan paused in his pleading and seized upon the incident to the profit of his bitterly persecuted client, insisting that the innocent lamb had come to offer itself as a sacrifice to save the life of the unfortunate prisoner. His touching appeal so impressed the jury that the young man was acquitted, while the judge announced the verdict in open court, betraying much emotion, the whole audience and the prisoner weeping like children.

—"Black Jack" Logan defends a local bully with frontier eloquence. From *Reminiscences of a Soldier's Wife* by Mrs. John A. Logan (1913)

Memorial to General "Black Jack" Logan, Murphysboro, Jackson County

slavery led to his murder and the destruction of his printing press, at Alton in 1837. Lovejoy was not a native of Southern Illinois, and his presence at Alton was in many ways fortuitous, but his death awakened countless men of good will to a realization of the lengths to which slavery sympathizers were ready to go, in the legally "free state" of Illinois, to oppose abolitionism. His martyrdom is commemorated by a handsome monument in Alton, as well as by the award given each year by Southern Illinois University to an outstanding defender of the freedom of the press.

The most important national figure to emerge from the ensuing Civil War was, of course, Abraham Lincoln. Although Lincoln was born in Kentucky and lived in Southern Indiana until he was twenty-one, his origins did not differ greatly from those of most Southern Illinoisans. His entrance into Illinois by way of Lawrence County in 1830 is commemorated by an impressive monument near Lawrenceville. Although Lincoln settled in central Illinois, he returned to Egypt on many occasions to practice

law and to campaign for political office. His most celebrated visit came in September, 1858, when one of the famous series of Lincoln-Douglas debates took place on the old fairgrounds at Jonesboro, in Union County. Joshing "Judge" Douglas for having been born in New England, Lincoln asked his Southern Illinois audience, "Did the Judge talk of trotting me down to Egypt just to scare me to death? Why I know these people better than he does. I was raised just a little East of here. I am part of this people."

But the truth was that Senator Douglas, despite his Vermont origins, had inherited the mantle of Jacksonian democracy and was the darling of Egypt, while Lincoln, despite his rustic birth, had gone north and become identified with those Northern Whig vices—abolitionism, progress, industrialism, change—which the Mike Finks of Southern Illinois continued to view with distrust and alarm. As war president, Lincoln had trouble winning support in Southern Illinois.

A more representative political hero was John A. Logan of Murphysboro. A brilliant stump lawyer,

daredevil horseman, and Democratic congressman, Logan was a favorite of the astute Senator Douglas. He not only supported Douglas in the latter's early opposition to Lincoln, but when the war broke out and the Union was threatened, Logan again followed Douglas in pledging loyalty to Lincoln over the opposition of many Democratic party supporters. Resigning from Congress, he volunteered for service with the Northern army. Logan had great difficulty justifying this apparent about-face to his local constituency. He was reviled and disowned by many former Southern Illinois admirers. But he fought effectively under Grant, did yeoman political service for Lincoln in the campaign of 1864, and helped keep Illinois Republican. Despite their traditional Southern sympathies, hundreds of Southern Illinoisans eventually followed Logan into the Union ranks. By 1863, the ten southernmost counties had volunteered 50 percent more than their quotas of army enlistees. Union county alone, with a male voting population of only two thousand, supplied fourteen volunteer companies! After the Civil War, "Black Jack" Logan served Illinois for many years as senator, running unsuccessfully as Republican candidate for the vice-presidency of the United States in 1884.

It is hard to guess what would have happened to the western front if the Confederates had occupied Southern Illinois at the start of the Civil War, as many Egyptians expected. The woods along the Ohio and Mississippi were full of "Copperheads." Fortu-nately for the North, the strategic importance of Southern Illinois, lying like an arrow pointing deep into the Confederacy, was recognized from the beginning. Governor Yates lost no time in raising troops to defend the strategic Ohio River waterfront. Brigadier General U. S. Grant, the former Galena storekeeper, was ordered to secure Cairo, the terminus of the recently completed Illinois Central railway, thereby forestalling Confederate plans to invade the region. During the rest of the war, Cairo played a vital role as Grant's military headquarters and supply center, and served as the site of an important military hospital. From Cairo, Grant moved out to occupy northern Kentucky and Tennessee, to secure the western shores of the Mississippi in Missouri and Arkansas, and then to launch the Vicksburg campaign that brought the entire Mississippi River under Union control.

One of Grant's most valuable military assets was the Illinois Central Railroad, running through the heart of the state from Chicago to Cairo. Completed in 1855, it brought him essential troops and war materiel. It was not uncommon for the "I.C." to be asked to move as many as 10,000 troops on a few hours' notice. Confederate spies, helped by local Southern Illinois sympathizers, plotted to blow up the Illinois Central trestle over the Big Muddy River just north of Carbondale, but their plans were discovered in time by loyal unionists and forestalled. According to local legend, Copperheads joined the

Memorial to General Michael Kelly Lawler, Southern Illinois Civil War hero, Equality, Gallatin County

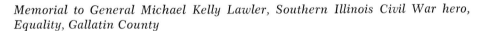

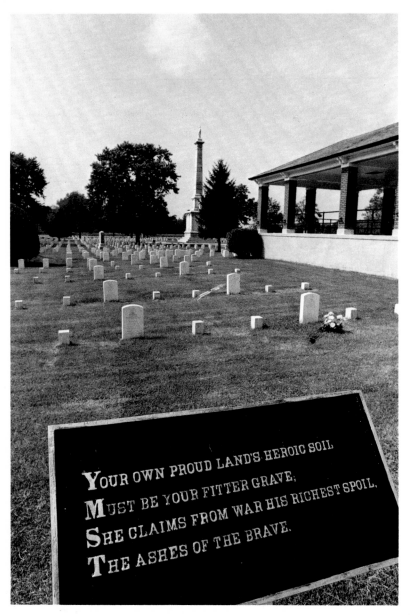

Southern Order of the Knights of the Golden Circle and plotted secretly in the caves of Giant City Park near Makanda, but for the most part their plots were ineffective. Romantic accounts of these and other aspects of Southern Illinois life during the Civil War can be found in two novels by local authors: Mabel Thompson Rauch's *Vinnie and the Flag Tree* and Mary Tracy Earle's *The Flag on the Hilltop*.

Not far from Cairo stood the naval shipyards at Mound City on the shore of the Ohio River. Here the ingenious engineer, James B. Eads, built ironclad gunboats that played an important role in the defense of the Mississippi River and capture of Vicksburg. Near Mound City is a national cemetery for the Union dead. Farther up the Mississippi at Alton, where hundreds of captured Confederates were imprisoned during the war, is another national cemetery where many Southern soldiers lie buried.

The war divided many Southern Illinois families and left behind a legacy of bitterness. But as time passed, former enemies encountered one another at the graves of loved ones and forgot their hatreds. It is said that such a reconciliation inspired the first organized community-wide observance of a Memorial Day, which veterans directed and in which they participated, at Woodlawn Cemetery in Carbondale in 1866. The following year General Logan, then the National Commander of the G.A.R., issued the proclamation officially setting aside May 30 as a day of mourning and commemoration.

After the Civil War, Southern Illinois was associated with three important peacetime personalities of national reputation. The first was Colonel Robert Green Ingersoll (1833–99), philosopher, politician, and popular orator, whose iconoclastic lectures and writings influenced the thinking of several gener-

Mound City National Cemetery, Pulaski County, burial ground for 6500 American war veterans

38

Woodlawn Cemetery, Carbondale, reputed site of the first Memorial Day ceremony honoring Civil War dead from both North and South

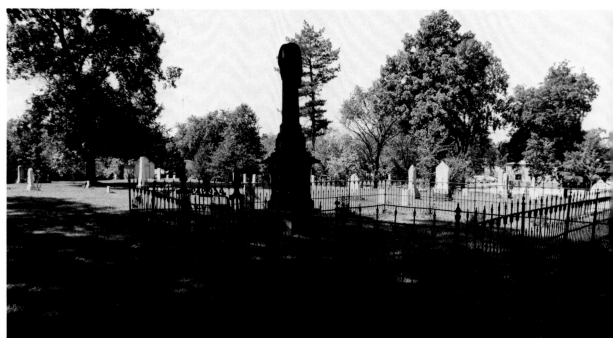

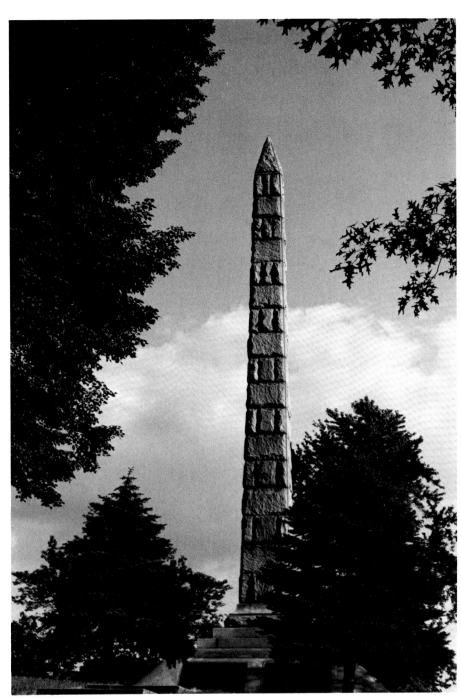

Confederate Soldiers Cemetery, Alton, Madison County

ations of Midwesterners, including Mark Twain, Clarence Darrow, and Sinclair Lewis. Coming to Southern Illinois as a young man, Ingersoll taught school successively in Greenville, Mount Vernon, Marion, and Metropolis, and clerked in the land office at Shawneetown, before moving to the northern part of the state. ("Lord, what an organ is human speech when it is played by a master," Mark Twain wrote to his friend William Dean Howells after hearing one of Ingersoll's speeches. "Bob Ingersoll's music will sing through my memory always, as the divinest thing that ever embraced my ears.")

Ingersoll's natural eloquence and love of public life are reflected in the careers of two younger Southern Illinoisans—Senators William Jennings Bryan (1860–1925) and William E. Borah (1865–1940). Bryan was born in Salem, Marion County, later moving as a young man to Nebraska, where he became a prominent political leader and national figure. Borah grew up on a farm in Jasper Township, in Wayne County, and attended Tom's Prairie School and Enfield Academy before heading west, where he served for many years as U.S. Senator from Idaho. Comparing the careers of all three men, one cannot help but note their powers of eloquence, their political astuteness, and their faith in the necessity of reconciling controversies and differences of opinion through public discussion and debate, rather than

by force and violence. These have been important elements in the thought and democratic aspirations of the midwestern frontier, and represent traditions that are still a part of the Southern Illinois way of life.

Another cultural legacy has been the rich wilderness resources—the forests and hills that have inspired an important group of native Southern Illinois scientists. Of these perhaps the most remarkable was Robert Ridgway (1850–1929) of Mount Carmel, in Wabash County. As a boy he studied the local wildlife, especially birds, and taught himself to draw and paint them. His work attracted the attention of scientists at the Smithsonian Institution at Washington, with the result that at the age of seventeen young Ridgway was hired to serve as an ornithologist with one of the Institution's scientific surveys of the Pacific Northwest under the direction of Clarence King, the distinguished geologist, mountaineer, and author. This was the beginning of what turned out to be Ridgway's permanent association with the Smithsonian as Curator of Birds, leading to his authorship of over five hundred scientific books and papers and his winning of many distinguished scientific honors and awards. Among these works are his eight-volume *Birds of North and Middle America*, his *Manual of North American Birds*, and his guides to the birds of Illinois and of Southern Illinois. Eventually Ridgway retired to Olney, in Richland County, where he established a notable private arboretum on his estate, together with a bird sanctuary and an outdoor laboratory for scientific observations. At his death this was bequeathed to the University of Chicago.

Other outstanding Southern Illinois scientists include Lucien McShane Turner, another member of the staff of the Smithsonian Institution and a distinguished entymologist, and Cyrus Thomas (1825–1910) of Carbondale. Starting out as a school teacher, Thomas successively taught himself theology, entymology, and the law, served as County Clerk of Jackson County, and was one of the founders of the Illinois Natural History Survey. Later appointed State Entymologist of Illinois, and one of the leaders in the movement for state support of scientific research into agricultural blights and diseases, Thomas was also the first professor of Natural History at Southern Illinois University. Afterwards he too joined the staff of the Smithsonian Institution, served for many years as its chief entymologist, and then turned to ethnography, a field in which he published many influential studies of American Indian and Mayan history and languages.

During the present century Southern Illinois has been the birthplace of a number of other talented personalities, including Frankie Trumbauer of Carbondale, the celebrated jazz saxophonist of the 1920s, who is credited with having been one of the first white musicians to carry Chicago jazz to Harlem; Agnes Ayres from Cobden, a popular star of the silent films; Burl Ives, the folk-singer, from Newton; Frank Willard of Anna, creator of the comic strip "Moon Mullins"; and another well-known comic strip artist, Elzie Crisler Segar of Chester, the creator of "Popeye"; and Buddy Ebsen, film and TV star from Belleville. Among its better-known scholars and authors have been Edwin O. Reischauer from Jonesboro, a distinguished orientalist and former Ambassador to Japan; Robert Lewis Taylor from Carbondale, novelist and *New Yorker* magazine editor; Robert Coover of Herrin, the novelist; and H. Allen Smith, formerly of McLeansboro, journalist, humorist, and spinner of tall tales in the old frontier manner.

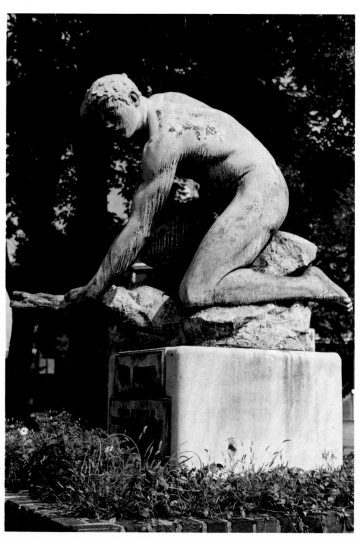

"The Hewer," bronze by George Grey Barnard, erected in 1906, Cairo, Alexander County

The Southern Illinois legacy of rugged individualism has produced at least two authentic twentieth-century folk heroes—one illustrating the region's tradition of hospitable friendliness, and the second its history of frontier violence. The first is Billy Bryan, the beloved railroadman who became the subject of dozens of local stories and legends. Like Casey Jones of the popular ballad, Billy Bryan also worked for the Illinois Central Railroad. But where Casey Jones's famous ride and heroic death became part of the folklore of Tennessee, Billy Bryan was a native of Southern Illinois. During the 1890s and early years of the present century he worked as a conductor on the "Mudline Branch" of the I.C., running diagonally across Southern Ilinois from Johnston City to the Mississippi River bridge at Cape Girardeau.

Billy was admired for his independence and his unwillingness to be hog-tied by company rules and regulations, at a time when people were beginning to feel threatened by the then seemingly unfettered power of the railroads. He was also loved for his unfailing courtesy toward his passengers.

According to Bob Allen, the engineer with whom he rode for many years, Billy liked to start off the day with fifteen shots of homemade Egyptian corn whiskey. Chris Neely, another railroadman, said that Bryan never turned down a passenger who couldn't pay for his ticket. If you wanted to get off the train to go fishing at Bridges's Crossing or Goodman's Ditch, or any other likely place, Billy would stop the train for you. "When you wanted to go home, you flagged down Billy's train. When you had money, Billy collected."

According to the late Dr. T. H. Shastid, formerly of Marion, Billy was so obstreperous that finally the I.C. fired him, whereupon Billy telegraphed the president, "you can't fire me." And they didn't. John Allen, the popular historian and folklorist of Southern Illinois, has said that Billy kept right on "conductoring" until he was finally retired with honor on 1909, on the eve of his seventieth birthday. The many tales about Billy Bryan all have one unifying theme—he wasn't going to let any impersonal organization, no matter how big and powerful, interfere with his doing his job the best way he knew how.

Charlie Burger, the bootlegger whose execution was celebrated in a popular ballad, typifies the tradition of violence that runs like a crimson thread through so much of Southern Illinois history. Beginning with the Indian haters and keelboat bullies, the horsethieves and highwaymen, the feuding families and Negro kidnappers, it extends through the Vigilantes, Flatheads, Regulators, and Ku-Klux Klansmen, the mining camp brawlers, the scabs and

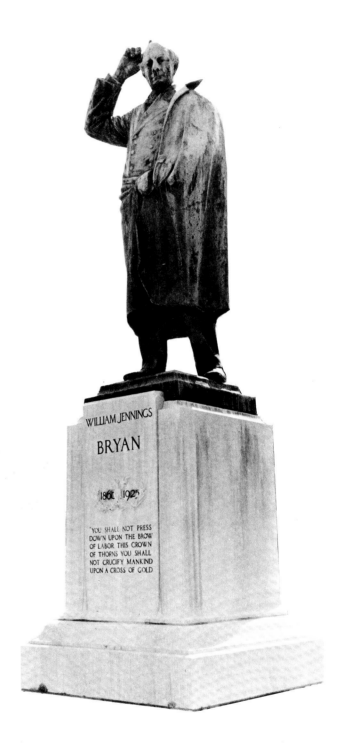

William Jennings Bryan monument sculptured by Gutzon Borglum near the "Great Commoner's" birthplace in Salem, Marion County

41

strikebreakers, to the more recent riots between whites and blacks in East St. Louis and Cairo. This is not to say that such violence is unique to Egypt. Rather, it is a part of that larger history of violence that makes up so much of our national character. But, perhaps because Southern Illinois has remained rural and small town in spirit, the protagonists in these feuds and other occasional outbursts of violence have become the subject of local legends in a way that differs from the experience of our more anonymous metropolises.

Charlie Burger was the more vicious and the more successful of two leaders of rival gangs of bootleg-gers who fought to control the Southern Illinois liquor supply in the 1920s, during Prohibition. After several bloody battles, Burger drove the Shelton gang to St. Louis. From his stronghold in Williamson County, Charlie ruled much of Southern Illinois through bloodshed and the bribery of public officials. Brought to trial in 1928 for the murder of the mayor of West City, he was eventually convicted and hanged. Like Jesse James, he was admired during his lifetime as an authentic western "success" hero. And after his death a popular ballad celebrated his story as proof of the Sunday School maxim that crime does not pay.

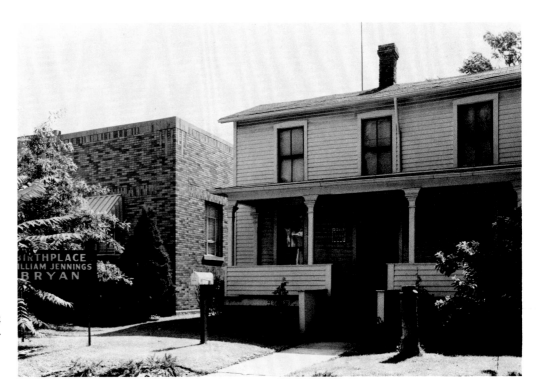

Bryan's birthplace, now a museum, 408 Broadway, Salem

I was born on the nineteenth day of March, 1860, at Salem, Illinois. . . . The house stood on Broadway about halfway between the public square and the Baltimore and Ohio Railroad—prior to 1872 called the Ohio and Mississippi. It had never been materially changed from the time when it was built in 1852. My father, then a young lawyer just starting in at the practice, helped to hew the *timbers to build the house. . . . The style of it was that which was customary in that day. It had a room on each side of a short central hall, with two rooms upstairs over these lower rooms and a dining room and kitchen in the rear. In this home the first six children were born.*

—From William Jennings Bryan's *Memoirs*, (1925)

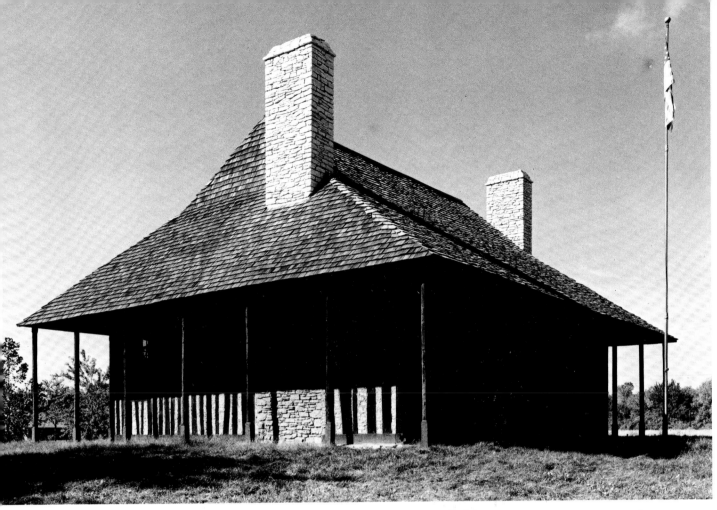

Old Courthouse, Cahokia, St. Clair County, erected ca. 1736 as a residence and later used as courthouse and jail

After 1763, when the French surrendered all the land between the Appalachian mountains and the Mississippi River, the British pursued a policy of keeping American settlers out of the country north of the Ohio River—including Illinois. The British wanted to keep this northwestern territory free for their own lucrative trade with the Indians. So far as American westward expansion was concerned, the British encouraged migration only south of the Ohio, into Kentucky and Tennessee. American resentment over this unwillingness to open up the Northwest country was one of the reasons for the War of Independence that followed.

After that war, when all the western land between the Appalachian Mountains and the Mississippi came into American hands, unfriendly Indians north of the Ohio further delayed American settlement of the Northwest Territory for a number of years. By 1800 thousands of pioneer families were filling up Kentucky and Tennessee, while as yet there were only 2,500 people in Illinois—at least half of whom were French. But gradually, by warfare, treaty, and bribery, the Indians were pushed across the Mississippi. By 1803 they had vacated most of Southern Illinois. By 1810 the population of Illinois had increased to 12,000, most of it concentrated in Southern Illinois. By 1818 there were an estimated 40,000 inhabitants, enough for Congress to grant statehood that year. By 1830 the population had gone up sharply to 157,000—with the greatest amount of migration now flowing into central Illinois. In 1833, at the end of the Black Hawk War, the Treaty of Chicago resulted in the cession of the last remaining Indian territory, mainly along the Rock River, and all of northern Illinois was now open for settlement.

Most of the early settlements in Southern Illinois formed a large triangular "V" along the three main river borders. The greatest concentration was along the Mississippi on the highlands back of the old French towns. From Kaskaskia north for ninety miles, almost to the mouth of the Illinois River, stretched a fertile flood plain known as the "American Bottom," long considered to be the richest and most productive soil in the United States. Overlooking this, on the drier uplands, Americans staked out their farms and established the villages of Alton, Belleville, and Columbia, as well as other crossroads settlements that have since disappeared. As early as the 1790s, settlers were referring to this region as "Goshen." Next to the Indians, the Holy Land was

43

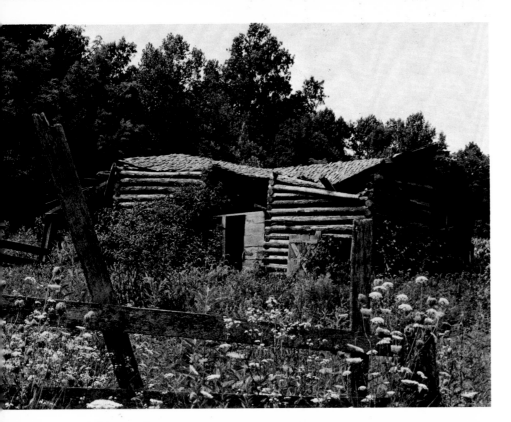

Having fixed on the north-western portion of our prairie for our future residence and farm, the first act was building a cabin, about two hundred yards from the spot where the house is to stand. This cabin is built of round straight logs, about a foot in diameter, lying upon each other, and notched in at the corners, forming a room eighteen feet long by sixteen; the intervals between the logs "chuncked," that is, filled in with slips of wood; and "mudded," that is, daubed with a plaister of mud: a spacious chimney, built also of logs, stands like a bastion at one end: the roof is well covered with four hundred "clap boards" of cleft oak, very much like the pales used in England for fencing parks. A hole is cut through the side, called, very properly, the "door, (the through,)" for which there is a "shutter," made also of cleft oak, and hung on wooden hinges. All this has been executed by contract, and well executed, for twenty dollars. I have since added ten dollars to the cost, for the luxury of a floor and ceiling of sawn boards, and it is now a comfortable habitation.

—An early Southern Illinois settler builds a log cabin. From *Letters from Illinois* (London, 1818) by Morris Birkbeck, one of the founders of the English settlements in Edwards County

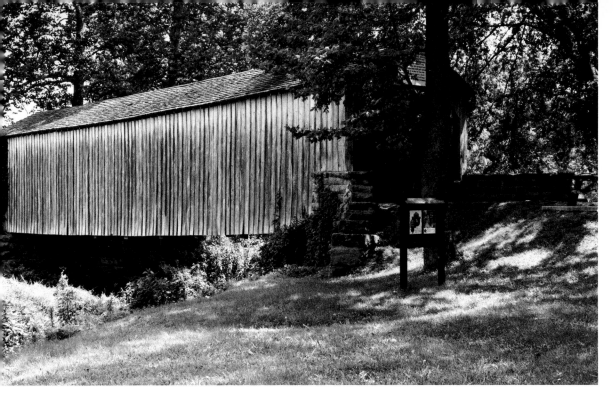

Covered bridge over Little Mary's River near Chester, Randolph County

the most fruitful source of names for these new villages. Not surprisingly (if one knows his Bible), the people of Goshen soon began to speak of the seasonally-flooded land to the south as "Egypt." In time "Egypt" became the familiar name for all of Southern Illinois, and continues so today. As early as 1818 the triangular delta at the junction of the Ohio and Mississippi was called "Cairo." Over the years many Egyptian and other Biblical names were borrowed for Southern Illinois communities—Thebes, Karnak, Dongola, Joppa. The mascot of Southern Illinois University at Carbondale is the royal Egyptian hunting dog, the Saluki.

The next largest concentration of early settlements in Southern Illinois occurred along the eastern border near the junction of the Ohio and Wabash rivers. Travel in those days was mainly by water; the western roads were bad, and often impassable. Settlers coming from the East boarded flatboats at Pittsburgh, Cincinnati, or Louisville and floated down the Ohio. The first important Southern Illinois river town below the mouth of the Wabash was Shawneetown, founded around 1810 near the mouth of the Saline River. Here many families got off the boats and purchased Illinois land at the Shawneetown federal land office. Others, heading for the Mississippi River and the American Bottom on the other side of the state, continued their journey on dry land. In spite of the poor condition of the roads, it was better to cross Southern Illinois by horse and wagon than to continue by boat down the Ohio and then have to struggle up the Mississippi against the current. Flatboats traveling up the Mississippi had to be pulled from the river bank by mules or gangs of men—a long and tedious ordeal.

For centuries Shawneetown had been a popular camping site with Indians, most recently with the Shawnees for whom the new American town was named. As the busiest port on the Ohio south of Louisville, it became celebrated in song and story as the gateway to Illinois. Ten miles up the nearby Saline River were the great salt springs that had served wild animals and later the Indians for many hundreds of years. After the U.S. government organized the Northwest Territory, it set aside these springs as a reservation and farmed out the making of salt to private contractors. Eventually the salt reserves were depleted and new, cheaper sources located in Louisiana; but during the early years of Illinois, salt-making at these springs was one of the state's most profitable industries.

Illinois-bound settlers who did not come by way of Shawneetown usually went overland through Kentucky, crossing at one of the ferries located further south along the Ohio. In time the trail to a ferry site became a rough road; next a tavern would spring up, and then a store; and before long a village had taken form. One of the oldest along the Ohio was Lusk's Ferry, now Golconda, the county seat of Pope County. Other ferries led to the founding of Elizabethtown, in Hardin County, and Metropolis, in Massac County, both also destined to become county seats.

Because of the universal dearth of good roads,

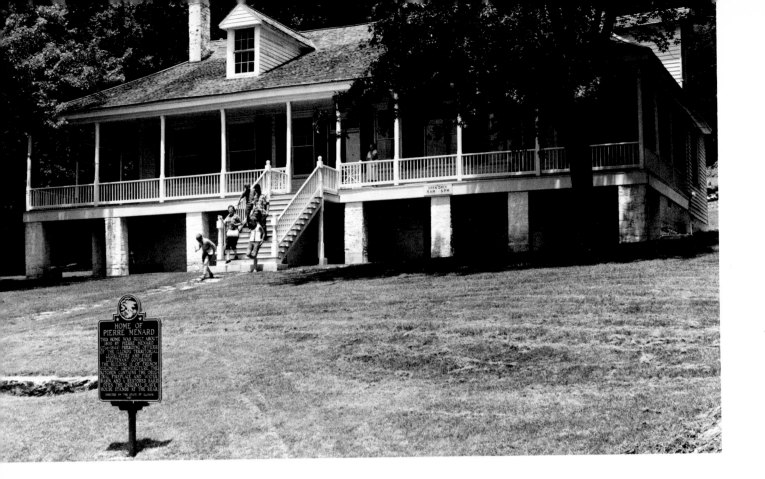

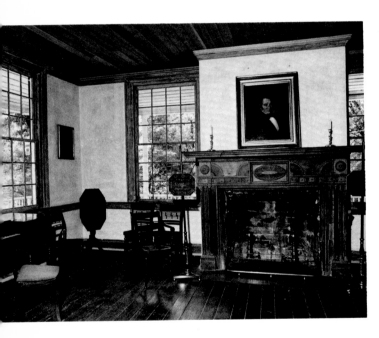

Exterior and interior of residence of Pierre Menard, Canadian-born fur trader and territorial official, erected in 1802 and now a state memorial, Fort Kaskaskia State Park, Randolph County

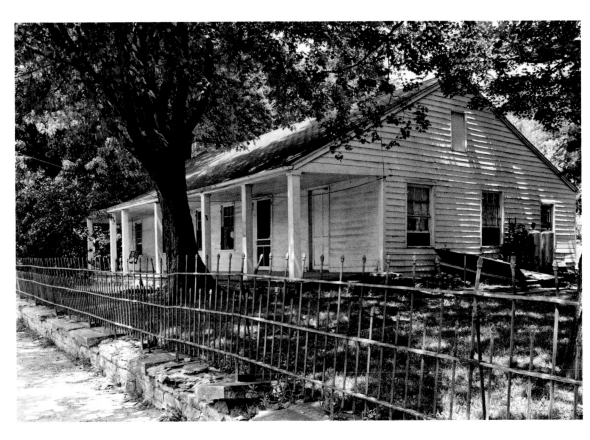

Old Creole House, ca. 1800, Prairie du Rocher, Randolph County

farm and village life centered around the nearest big river and its navigable tributaries. Farmers shipped their surplus crops by flatboat down the Mississippi, selling their boats for firewood and returning on foot or, after 1811, increasingly by steamboat. Thus, until the coming of the railroads opened up the central part of the state, the most heavily populated regions continued to be along the rivers —along the Little Wabash and Embarrass rivers flowing into the Wabash, along the Saline and Cache rivers flowing into the Ohio, or along the Big Muddy, the Mary's, or the Kaskaskia rivers flowing into the Mississippi.

What few roads there were usually began as Indian trails. Gradually they became more clearly defined by trappers and hunters, and in time were widened by pioneer wagons. In wet weather they were a hopeless morass of thick, gummy mud. Oldest were the French military trails running from Fort Vincennes to Fort Kaskaskia, and from Kaskaskia south to Fort Massac. Offshoots from the Vincennes-Kaskaskia trail led north to Cahokia and St. Louis and southwest to Shawneetown. Later, as American settlers migrated in growing numbers from Kentucky, roads developed at Lusk's Ferry (now Golconda) in Pope County leading northeast to Shawneetown and west through Vienna and Jonesboro to the Mississippi River ferry to Cape Girardeau, Mis-

souri. Apart from weather and mud, travelers also suffered from the dangers of ambush by roving bands of Indians, backwoods robbers, and horse thieves.

The first houses to be erected by the American pioneers were built of logs. Most settlers came from the Appalachian hills, where many had been accustomed to a wilderness way of life for several generations. They were understandably suspicious of the huge, mysterious prairies they found stretching north from Southern Illinois. They preferred to cling to the familiar wilderness. Where would they find the necessary timber on these lonely plains to build houses and to fence their land? They lacked the heavy plows and the metallurgical technology necessary to break the tough, root-matted prairie soil and expose the rich loam beneath. The typical Southern Illinoisan might use the prairie to graze his livestock, but he preferred to build his home close to the forest he knew so well, to clear away the great trees, and to plow up the forest topsoil, as he had always done.

In time people expanded and improved their simple log houses, often covering them with hand-hewn clapboards. In the villages the more prosperous began to build substantial homes of brick much like the Georgian brick homes they had known back East. Brick and stone were used increasingly for the larger public structures—courthouses, taverns, churches.

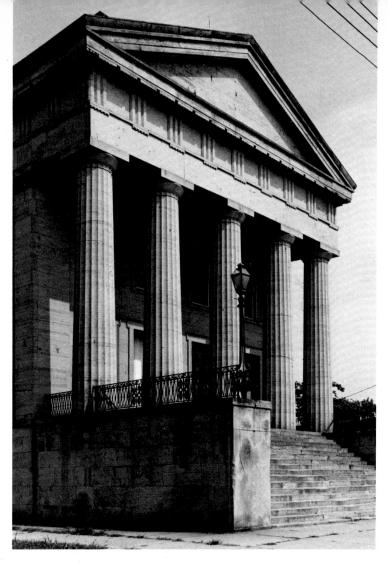

First National Bank, Old Shawneetown, Gallatin County, 1836

48

Like the early French, the Americans adapted traditional eastern styles to the mild winters and hot Southern Illinois summers; they enlarged their windows, framed them with cooling shutters, and introduced overhanging roofs and wide, shaded porches and terraces.

By 1820 the predominantly "southern" makeup of the Illinois population had begun to change. Hitherto, the bulk of the settlers had come from the southeast—from Virginia, the Carolinas, northern Georgia, Kentucky, and Tennessee. Now more and more were from New England and the Middle Atlantic states, or came over directly from Europe. This shift is to be seen dramatically in the unsuccessful attempts in 1824 by the older Southern Illinois settlers to rewrite the state constitution and legalize the institution of slavery.

Under the Ordinance of 1787, drafted by Thomas Jefferson, slavery had been prohibited in all the Northwest Territory, including Illinois. Consequently all five of the states carved from that terri-

tory entered the union as free states. But no such restriction interfered with the later development of the Louisiana Territory west of the Mississippi. Therefore when Missouri entered the Union in 1820 it did so as a slave state. Between 1787 and 1820 the invention of the cotton gin had revolutionized the slave economy, making it vastly more profitable, so that by 1824 many Southern Illinoisans of southern origin unhappily watched many of their fellow Southerners bypass Illinois and settle with their slaves in Missouri. Indeed, as the result of its slave economy, Missouri was now filling up much faster than Illinois.

Thus it was primarily Southern Illinoisans who led the agitation in 1824 for a new state constitutional convention that would legalize slavery. The proposal was beaten by a coalition of newly-arrived settlers from New England and Europe and certain Southerners who had left the South because of their opposition to slavery. But the bulk of the votes for slavery came from the southernmost counties, whereas most of the antislavery support came from the newer prairie communities to the north.

The next dramatic confrontation between Northern and Southern Illinoisans that, in a sense, marked the end of Southern Illinois's domination of state affairs, came during the 1830s with the decision of the legislature to move the state capital from its traditional home in Southern Illinois north to Springfield. Back in 1818, when Illinois became a state, it had been agreed that Kaskaskia was no longer suitable as a capital. Instead, a new site, Vandalia, had been carved out of the wilderness on the bluffs of the Kaskaskia River, further inland and more centrally located. It was believed that this new capital—named for an earlier pioneer land venture in Ohio—would help to open up the still-uninhabited central parts of Southern Illinois. In 1820 the capital was officially moved from Kaskaskia to Vandalia with the understanding that it would remain there for at least the next twenty years.

As 1840 approached, there was increasing agitation to move the capital further north. The completion of the Erie Canal in 1825 had opened up a new waterway to Chicago direct from New York and New England. Illinois, which for so long had been filling upwards from the bottom like a vase, now began to fill downwards from the top. The most popular new regions for settlement were along the Illinois and Sangamon river valleys. Southern Illinois politicians fought to retain the capital at Vandalia. But in 1837 a coalition of Sangamon valley legislators, led by Abraham Lincoln, successfully persuaded their colleagues to move the statehouse to the new town of Springfield.

*My father and mother, Mrs. Short, Tom and myself leaving the
tavern one morning, in our carriage, crossed the Kaskaskia River
on the flatboat ferry and drove to Col. Menard's mansion to spend
the day. The hearty, cheerful hospitality of the Colonel and his
family, the perfect weather and charming surroundings, made the
visit an occasion of rare pleasure and enjoyment. While the grown
folks spent the time in social converse and hilarity in the parlor
and on the broad front porch, Tom and I rambled at will about the
spacious premises, finding amusement and interest in all we saw.*

—A nine-year-old boy visits the Pierre Menard mansion in 1839. From *John
Francis Snyder: Selected Writings*, ed., Clyde C. Walton (1962)

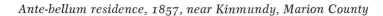

Ante-bellum residence, 1857, near Kinmundy, Marion County

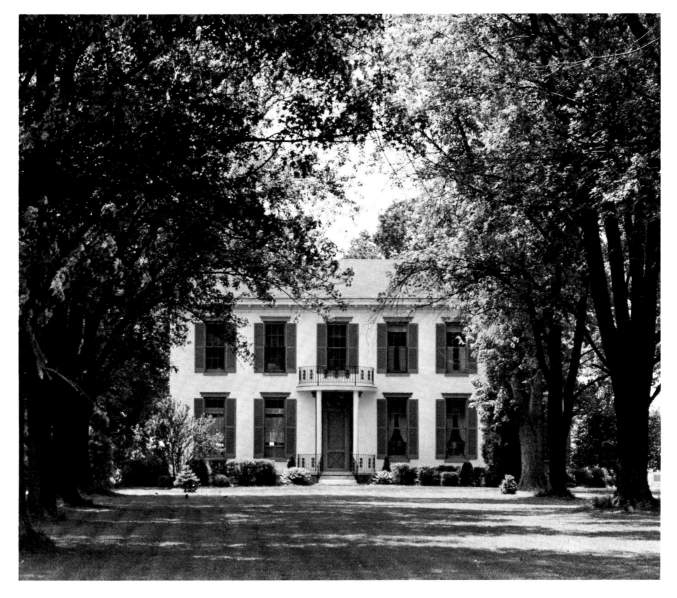

Former Alexander County Courthouse erected in 1844, Thebes

The departure of the capital northward in a sense marks the end of the period during which the history of Illinois was primarily that of Southern Illinois. Henceforth the destiny of the state would lie in the hands of men of vision whose values were those of a more "northern" culture—one more technological, industrial, urban, and "modern." Southern Illinois now devoted its energies to the consolidation of an essentially preindustrial, rural, and small town way of life. This had the effect for many years of isolating Southern Illinois from the dynamic thrust of the northernmost reaches of the state. To a visitor from Chicago, "Egypt" often seemed a backwater, a land that time forgot. The culture of Southern Illinois was often mistakenly confused with that of the older American South, although Southern Illinois was always different from the South in that it had never known to any great extent the tribulations of a primarily slave economy.

Today, when we are beginning to question more

critically than ever before the values of our increasingly urbanized society—with its smog, pollution, slums, and metropolitan *angst*—the Southern Illinois way of life no longer seems as quaint or irrelevant as it once did. Indeed, its comparative tranquility, its slower pace, easy accessibility to rugged nature, and its natural democracy and hospitality (except, perhaps, toward its black brothers) can be seen as unique assets. This is not to say that Southern Illinois is without its social or economic problems. But it means that, in planning for its future, Southern Illinois no longer feels that it must blindly follow the paths taken by other communities. Perhaps it can best serve itself and the state of Illinois by conserving and developing the many physical and cultural resources with which it has been so generously endowed.

As we have already seen, the pioneers who created many of these early traditions and habits of mind were largely Southern hill people. English, Scottish, Scotch-Irish, Irish—whatever their origins—they shared in common the assumptions, beliefs, and prejudices of the eighteenth-century Anglo-Saxon yeoman farmer. Hard-working, independent, canny, unintellectual, often illiterate, they brought with them a way of life that proved unusually hardy in overcoming the wilderness. They created a system of values that was, above all, self-sufficient. To this they added a rugged independence and a faith in egalitarian democracy that was nourished by the classless society of the frontier. They had never known a superior class to whom they must bow subserviently. Many aristocratic foreign visitors to Southern Illinois found this obnoxious, but all agreed as to its reality. It was the existence of this classless society perhaps more than anything else that set off the pioneer yeoman from his European peasant counterpart. The Southern Illinoisan's early traits were embodied symbolically in a popular hero like General Andrew Jackson. Until after the Civil War, Jacksonian democracy was the universal political faith of Southern Illinois.

The gradual shift in Midwestern loyalties away from this frontier point of view, during the later nineteenth century, can be seen in the example of Abraham Lincoln. Lincoln came from the same background as many Southern Illinoisans. But by going north to Sangamon County, he exposed himself to somewhat different, New England-oriented values. Later, as a politician, he would weave both systems into a new philosophy that was to triumph with the Civil War and become the dominant political faith for the nation as a whole for the next several generations. But Lincoln was never really accepted by the majority of Southern Illinoisans. In-

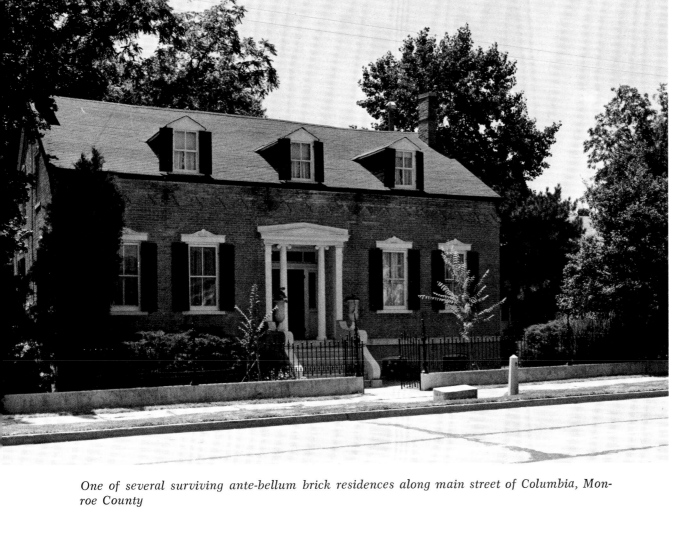

One of several surviving ante-bellum brick residences along main street of Columbia, Monroe County

The Rose Hotel, 1814, Elizabethtown, Hardin County
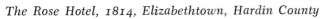

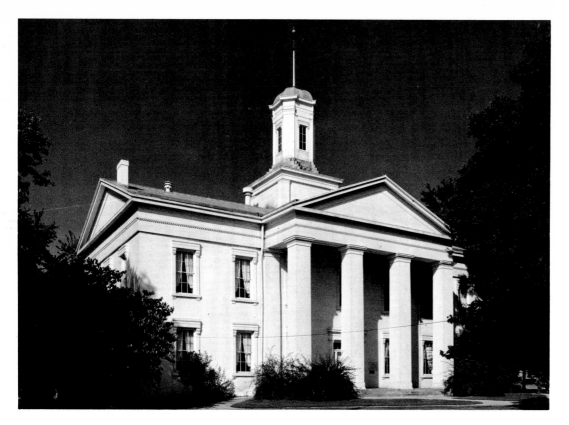

Old State Capitol, 1836, Vandalia, Fayette County, where Lincoln served as a state legislator

Appellate Court Building, 1854, Mount Vernon, Jefferson County

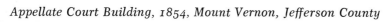

We encamped near a solitary log-house, for the sake of its water, and dined upon the plain. . . . The meal was delicious, and the entertainers were the soul of kindness and good humour. I have often recalled that cheerful party to my pleasant recollection since, and shall not easily forget, in junketings nearer home with friends of older date, my boon companions on the Prairie.

Returning to Lebanon that night, we lay at the little inn at which we had halted in the afternoon. In point of cleanliness and comfort it would have suffered by no comparison with any English alehouse, of a homely kind, in England.

—Charles Dickens visits Looking Glass Prairie, Madison County, and stays overnight at the Mermaid Inn in Lebanon. From Dickens' *American Notes* (1842)

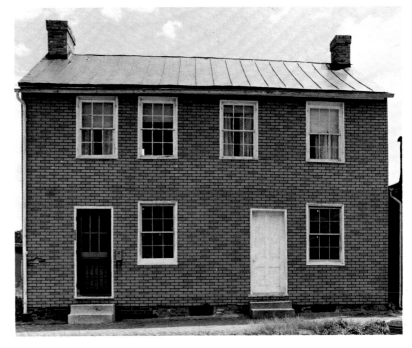

Mermaid Inn, Lebanon, St. Clair County, where Charles Dickens stayed in 1842

"Riverlore," built in 1865, Washington Avenue, Cairo

53

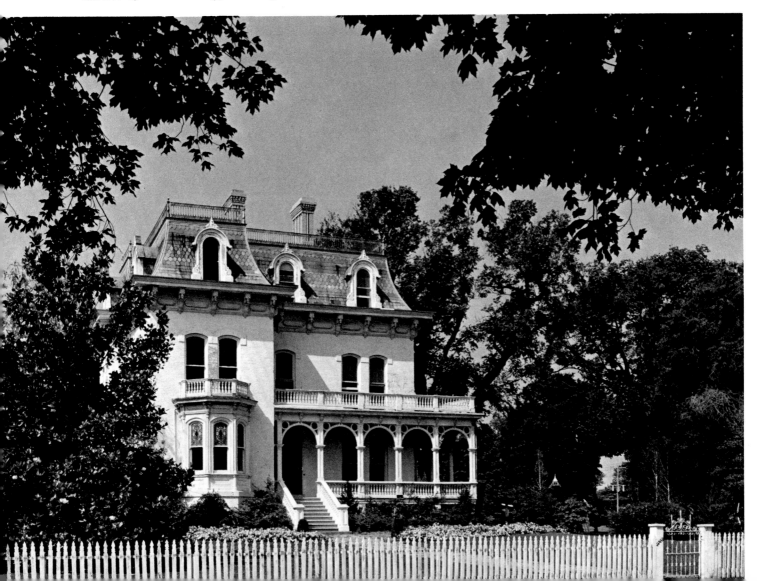

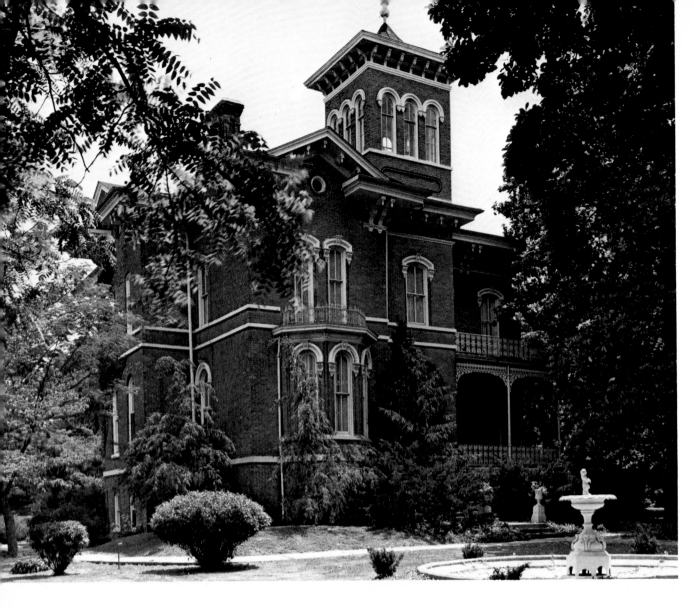

Exterior and interior of "Magnolia Manor," 1869, erected by a Cairo magnate and typical of the city's Victorian elegance

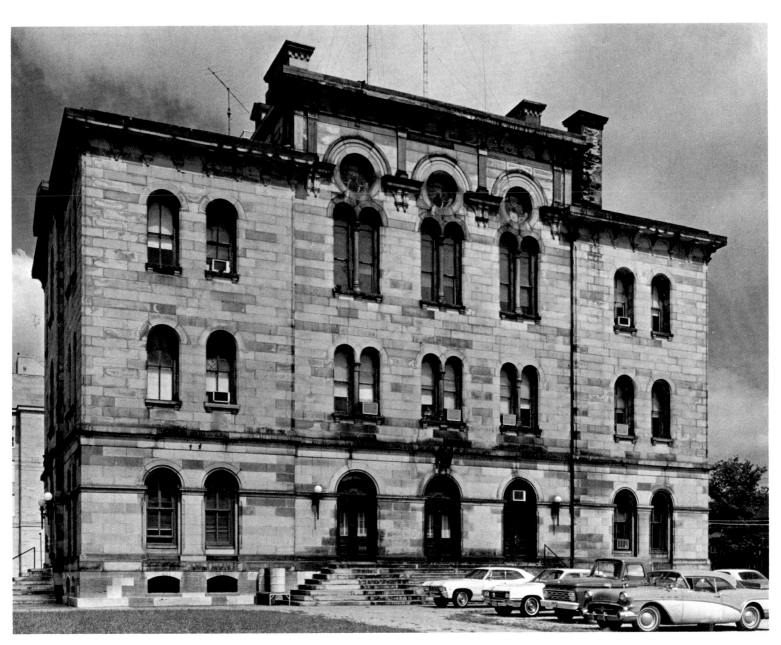

Old Custom House and Post Office, Cairo, 1872

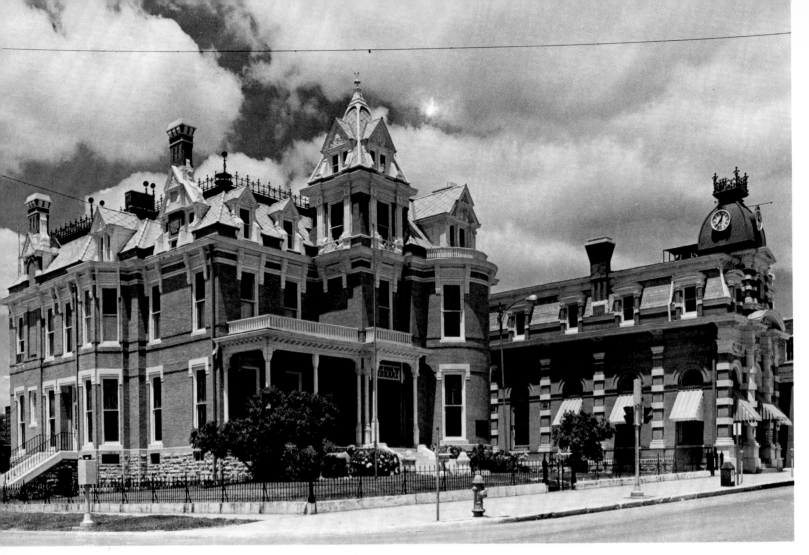

People's National Bank, 1881, McLeansboro, Hamilton County. Next door is the residence of the bank's founder, now the McCoy Memorial Public Library

deed, long before the Civil War, many natives of Egypt were accustomed to speaking of their northern Illinois neighbors as "Damyankees," just as the people north of Vandalia often referred condescendingly to the residents of Southern Illinois as "white folks."

Until recently, there have been very few towns in Southern Illinois with more than 10,000 inhabitants —few with more than 5,000. The prevailing pattern is one of small farms and small villages. The first major cultural change was the coming of large numbers of Germans during the 1840s and 50s, accentuated especially by the collapse of the German revolutionary uprisings of 1848. Most of these newcomers settled in St. Clair, Madison, and Monroe counties in what is called "the St. Louis milkshed." They brought with them the know-how of scientific German agriculture, establishing prosperous farms and solid German towns with names like Millstadt, Hecker, Darmstadt, New Minden, long known for their good eating as well as their encouragement of music. In time other Germans, attracted by the success of these earlier immigrants, settled in many other Southern Illinois communities.

The arrival of the railroads in the 1850s, and especially in the 1870s and 80s after the Civil War, was responsible for the long-awaited opening up of the central portions of Southern Illinois to farming. By 1900 a series of railroads crisscrossed the region, creating many new railroad and market towns as well as making the shipping of farm produce easier and more profitable. These new centers attracted more Germans, and also a large number of Irish settlers who had first come to lay railroad tracks and decided to remain permanently.

The conversion of wood-burning locomotives to coalburners did a great deal to stimulate the development of Southern Illinois's rich coal reserves. The tremendous fuel needs of the industrial revolution by the end of the nineteenth century completed the job of transforming Southern Illinois into the richest coal-producing region in the state. Most of Illinois, of course, is underlaid with coal. But

these rich deposits lie exceptionally close to the surface in Southern Illinois, and therefore are more easily extractable. They extend in a great curve from St. Clair and Randolph counties through Perry and Franklin to Williamson and Gallatin counties. The opening up of new mines brought an influx of newcomers from England, Wales, and Cornwall, as well as from many countries of eastern Europe. Some black miners were also brought in from Kentucky and Tennessee, many of whom settled in the larger railroad or mining centers—notably Centralia, Du Quoin, Marion, and Carbondale.

Needless to say, the adjustment of the earliest Southern Illinoisans to these successive waves of outlanders has not been without its stresses and strains—not to say its occasional violence. But what remains perhaps the most striking feature of the region, in contrast to so much of the Midwest, is Southern Illinois's surface homogeneity: its distinctively rural, small-town society, as well as its well-preserved natural resources—its lakes, hills, and diversified recreational activities. The spirit of its past is perhaps best expressed visually in its architecture, beginning with the few surviving covered bridges and log cabins, its sturdy farm houses and charming brick antebellum homes, and later the more sumptuous public edifices and the mansions of the rich river merchants. Now that Southern Illinois has been rediscovered as a refuge from the hectic pace of city life, more and more outlanders are also retiring here to build handsome homes of native stone and hardwoods beside shaded lake shores, in wooded valleys, or on high ridges that look out across spectacular, rolling vistas.

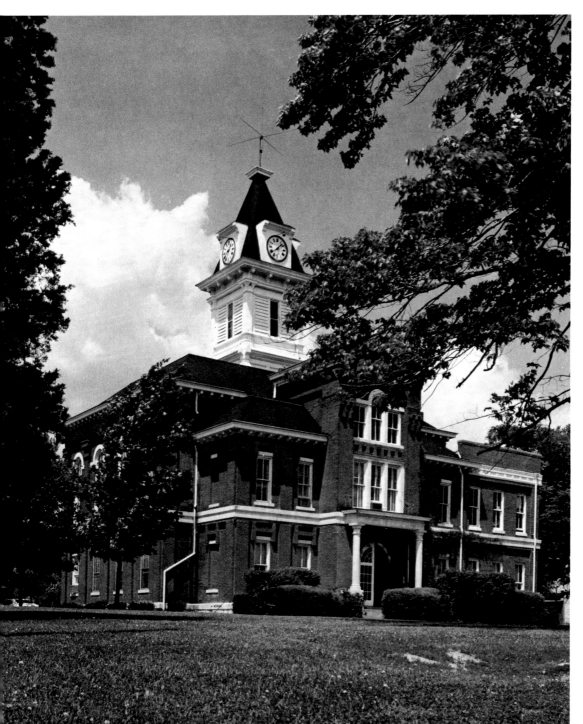

*Edwards County
Courthouse, Albion*

57

Domed Maintenance and Repair Shop of the Union Tank Car Company, Wood River, Madison County, designed by R. Buckminster Fuller of Southern Illinois University

The Houses in the Illinois country generally are built of one storey, & a garrot, with a celler under about ⅓ of the whole, & no back buildings. They have a very large front with considerable depth, all their rooms are on one floor; some are built of Stone, & others of Logs & placed upright & tenoned into a plate at top & bottom, the joints filled up with stone & mortar; all with a Piaza from 6 to 12 feet wide all round; which gives them a very airy appearance, like the Chinese Taste or Stile.

—An early visitor comments on Southern Illinois architecture. From *The Western Journals of Dr. George Hunter* (1796)

Contemporary residence built from native field stone near Cobden, Union County

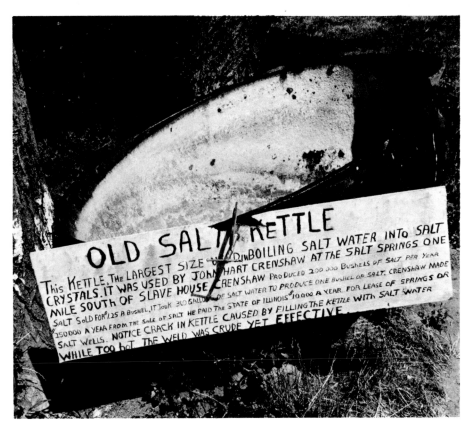

Old Indian Salt Springs near Equality, Gallatin County

Early Iron Furnace, Hog Thief Creek, near Rosiclare, Hardin County

59

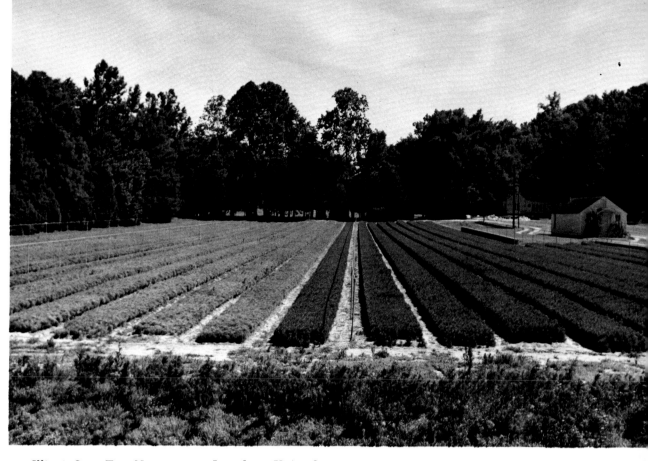

Illinois State Tree Nursery near Jonesboro, Union County

OPPOSITE PAGE: *Fire Trail, Shawnee National Forest*

I remember the old saw mill,
The heaps of sawdust
On a summer day,
An engine churning back and forth,
With steam in a wistful wind,
The green stalks of corn, row on row,
The old, hermit-like bridge
Creaking and rattling as a team of horses
Crossed.
And one morning I saw a red bird
Flitting around in the woods,
The clear Bob-White call I recall,
And meadow-larks.
I remember the wagon bumping over
Rutty roads,
Threshing time when the women folk
Prepared long tables of food in a grove
Of trees.

From *Poems of Little Joe* (1957) by the late Joseph E. McGovern, Jr., of Christopher

61

LEFT: *One of few surviving stands of virgin hardwood timber in Illinois, Beall Woods, Wabash County*

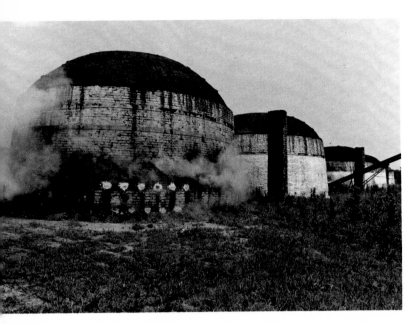

Old charcoal kilns near Murphysboro, Jackson County

My father moved up here after the Civil War. I can remember that my grandfather said that he bought this land for 75 cents an acre from the railroad. Of course, that wasn't much money in those days but the land wasn't too good either.

Everything by hand. You didn't have no plows of no kind that was any good. You had an old turning plow to turn the dirt over. It was made of wood. I don't know how they fixed it but they twisted it some way. I don't know what kind of timber it was. It had a steel point, but what turned the dirt over, it was made of wood. You just shoved the dirt across the field. In those days you done farming by walking all the time instead of riding. We had teams of oxen. I learned how to drive oxen. We had to break our ground by walking a ten- or twelve-inch plow.

—From the reminiscences of a Southern Illinoisan reported by Herman J. Lantz in *People of Coal Town* (1958), Southern Illinois University Press

Sawmill at Jonesboro, Union County

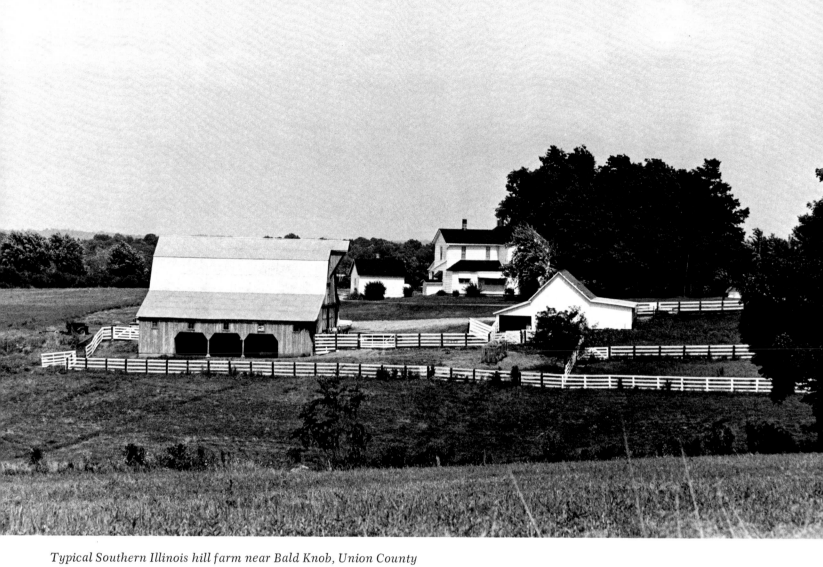

Typical Southern Illinois hill farm near Bald Knob, Union County

63

Trappist Fathers' farmer-monk near Ruma, Randolph County

Making a living in Southern Illinois has often been a matter of making do—barely getting by. There has never been great wealth or, with some exceptions, excruciating poverty. The exceptions have usually been in the towns where a sudden decision to cut back factory or mining operations might throw dozens of people abruptly out of work. This was especially true during the Great Depression, and it intensified the traditional rural distrust of the city. You might not get rich by farming, but at least you had a place to live and something to eat. But farming, too, has often been an uncertain livelihood because of wide differences in the quality of the soil. The rich bottom land is more productive than the clay uplands or rocky hills. Then there is the matter of cultural backgrounds; a German farmer with centuries of old-world know-how and discipline in his past may farm more prosperously than the native

Perry County farm and adjoining strip-mine

American next door who was brought up in the slap-dash ways of hill farming. But only a rash sociologist would venture to say whether the untrained marginal farmer would be better off if he moved to the heartless city. Winters in Egypt are mild, the growing season is long, people are friendly, the fishin' is fine. It is hard to say whether the people of Southern Illinois have adapted themselves to the land, over the years, or the land has adapted itself to the ways of the people.

The earliest industries in Illinois—now pretty much extinct—were fur trapping, salt making, and iron making. Salt was the major source of taxable income when Illinois became a state in 1818. The "Salines," as they were called, near the town of Equality and twelve miles up the Saline River from Shawneetown, have already been described. Most of the menial work at these wells was done by slaves—

(*continued on page 72*)

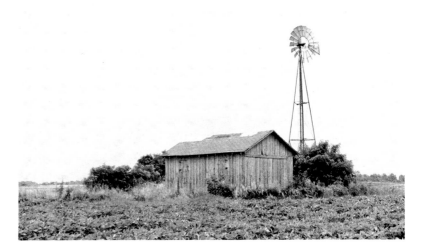

*Cotton blossoms, cotton boll, and one of the few surviving
Southern Illinois cotton gins, Alexander County*

Blacksmith and shop, Murphysboro, Jackson County

Jack Storme was the local cooper and blacksmith of Thebes. He had a cat that stayed around his shop. The cat was the best mouser in the whole country, Jack said. . . . But one day the cat got a fore-paw cut off. After that he began to grow poor and thin and didn't take any interest in anything because he wasn't getting enough to eat. So one day Jack decided to fix him up a wooden paw. . . . After dark the cat got down in front of a mouse-hole and waited. Pretty soon a mouse peered out cautiously. Quick as a flash the cat seized it with his good paw and knocked it on the head with his wooden one. In no time that cat had eighteen mice piled up before the hole.

—"The Cat With the Wooden Paw" from *Tales and Songs of Southern Illinois* by Charles M. Neely (1938)

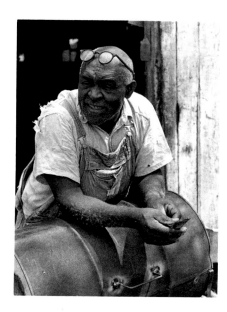

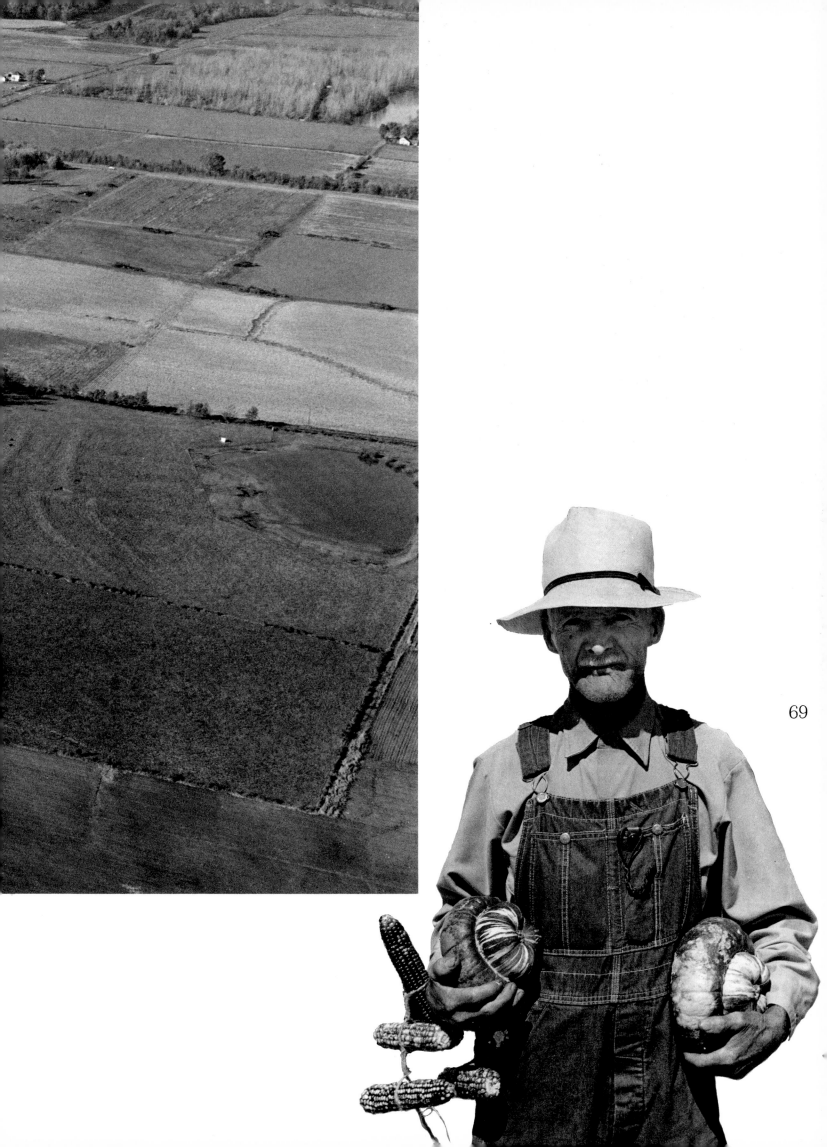

The mosquitoes got very bad on the farm in Eldorado. . . .
I was frightened, but I didn't have time to do anything,
for I heard a noise overhead just like airplanes. I looked
up and saw the air almost black with enormous mosquitoes.
Some were coming from the north and some from the south.
Evidently, they didn't like the looks of one another, and
it seemed as if they were going to fight. After a while,
there was a pile of legs and wings in my field as big as
a haystack. It took me so long to haul the pile away that
I had several days' work to do.

—"The Super-Mosquitoes," a tall-tale of the Wabash River Valley reported by Grace Partridge Smith in the *Journal of American Folklore*, Vol. 54 (1941)

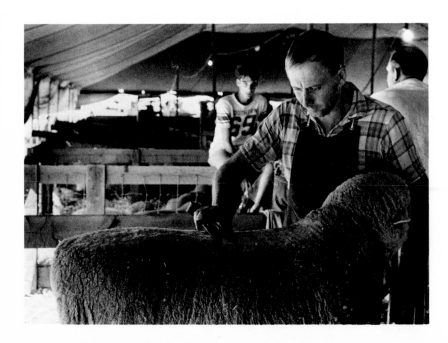

*The soil is a light vegetable mould, of no great
depth in general; the under soil is a fat loam
or clay, of considerable depth, that retains
moisture, and prevents the land from burning.
The land is easy of culture, much more
so than any I was ever accustomed to, and
dry enough to plough in a day after
heavy rain; this is the case with most of the
land round the prairies. Prairie land is hard to
break up the first time, and requires four
horses to do it effectually, it being so full of
strong roots. . . . Land planted with corn is
attended with some trouble the first year of
breaking it up, as the furrows are too tough to
work with a plough, but it is managed with a
hoe. When it has been thoroughly broken up,
in a wet or dry season, it will work well; but
it is injurious to work it in very wet weather.*

—John Woods, *Two Year's Residence in the Settlement
on the English Prairie, in the Illinois Country* (London,
1822).

Peach orchard, Jackson County

or "indentured" servants as slaves were called after Illinois became a free state. Of the various contractors who operated these wells for the United States government until after the Civil War (when they began to run dry) the most celebrated was John Hart Crenshaw, who built the mansion "Hickory Hill" in 1834 on a rise overlooking the Saline Valley. He kept his Negroes in small cubicles in the attic of his home, so the story goes, and his house and slave quarters can still be visited.

Iron ore was smelted in several places in Southern Illinois during the early years. At Devil's Backbone, near Grand Tower, two iron furnaces smelted Missouri ore with coal brought from Murphysboro until the 1870s. The limestone also needed for smelting was plentiful, of course. (It is said that Andrew Carnegie once even thought of making Grand Tower the Pittsburgh of the West!) Another furnace—the

Illinois Furnace—used local ore and coal and was located near Hog Thief Creek, a few miles north of Rosiclare in Hardin County. Established in the 1830s, it continued operation until 1883. It has recently been restored by the U.S. Forest Service and is also well worth a visit.

Of the earliest industries, outside of farming, one that has continued to thrive down to the present, is lumbering. The great virgin forests of walnut, beech, maple, cherry, hickory, and oak are no more. But thanks to a long growing season, scientific methods of reforestation, and the proximity of the Jonesboro state tree nursery with its inexpensive seedlings, a thriving hardwood lumbering industry has now returned to Southern Illinois. Many abandoned farms and worked-over strip mine sites are being converted into new forests. At Southern Illinois University the Forest Service of the U.S. Department of Agriculture

maintains a forestry science and wood products research laboratory to combat diseases, as well as to develop new and improved wood products and new ways of using the region's valuable timber resources. With proper planning and supervision, there is no reason why Southern Illinois will not continue to enjoy the greater portion of the state's hardwood timber reserves, both as an economic resource and a recreational asset.

Over the years, farming has been the most conspicuous economic activity of Southern Illinois. Seventy percent of the area is farmland. On the fertile bottom lands corn is the primary crop, supplemented by wheat and soy beans (and, in the old days, by sorghum cane which—with native maple syrup—was the main source of sugar. Small amounts of sorghum molasses and maple syrup still continue to be processed today.) On the less fertile clay uplands the raising of beef cattle is a major activity. There is some dairying near the metropolitan St. Louis market, and there are sheep and, of course, the ubiquitous hogs. Livestock, which accounted for only one-third a century ago, now accounts for over one-half of all farm products raised in the region.

Once the forests had been cleared, the sunnier south-facing slopes of the Shawnee Hills proved

(*continued on page 78*)

Picking and sorting peaches, Jackson County

73

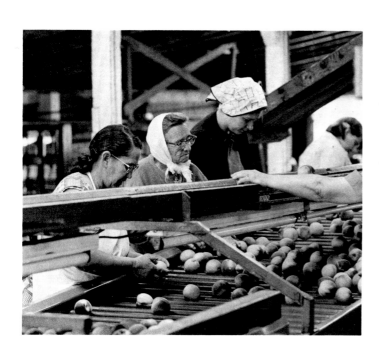

After the cider was made, we would go back to the farm for half a load of Winesaps to be used in making apple butter. In our back yard one or two large copper kettles were set over an open fire made in a small trench in the ground. . . . The apples, together with plenty of cider, almost filled the kettle and as the mixture began to boil down, more apples were added. The spicing of apple butter was a matter of taste, but cinnamon predominated in the flavor. . . . Constant stirring was necessary to keep the butter from scorching. We used a wooden paddle with holes in it, attached to a long, broom-like handle, long enough to prevent the stirrer from scorching her face too much. . . .

74

Making apple butter, Jackson County

As summer waned, when there was a touch of crispness in the morning air and the dew felt cold to our bare feet, the Jonathans were ready; perfect, and royally flavored, with an aroma like a flower, their glorious dark red almost too beautiful to be real. Of course gone now were the Huntsman's Favorite—a sweet memory; and the White Winter Pearmain, most delicious of all apples grown in southern Illinois. Now came the abundant Ben Davis apples, not highly prized; then the royal Winesaps, which would keep a year; and finally, the Rusty Coats and Nick-a-Jacks, rough coated and wooden until six or eight months after picking.

—From *This Is All I Remember* by Frank Hickman of Benton (1954)

Apple cider press, Outdoor Education Laboratory, Southern Illinois University at Carbondale, Little Grassy Campus

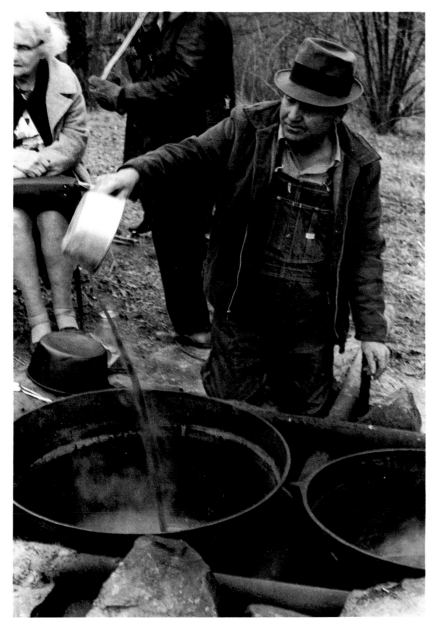

75

Making maple syrup, Jackson County

Beefsteak when I'm hongry,
Whiskey when I'm dry,
Greenbacks when I'm hard up,
Sweet heaven when I die.

I went on down to Cairo,
Callin' fo' Sue,
Police got after me,
Tore my long tailed blue.

Sleigh bells is a-ringin',
Snow is a-fallin' fast,
Got my mule in the harness,
You got him hitched at last.

Green as greenbacks,
What do you 'sider me to be?
I'm a little boy frum the country,
You can't git away with me.

"Beefsteak When I'm Hongry," From
*Steamboatin' Days: Folk Songs of the
River Packet Era* (1944) by Mary
Wheeler

Sorghum cane makes sweet sucking!

Making sorghum molasses, Williamson County

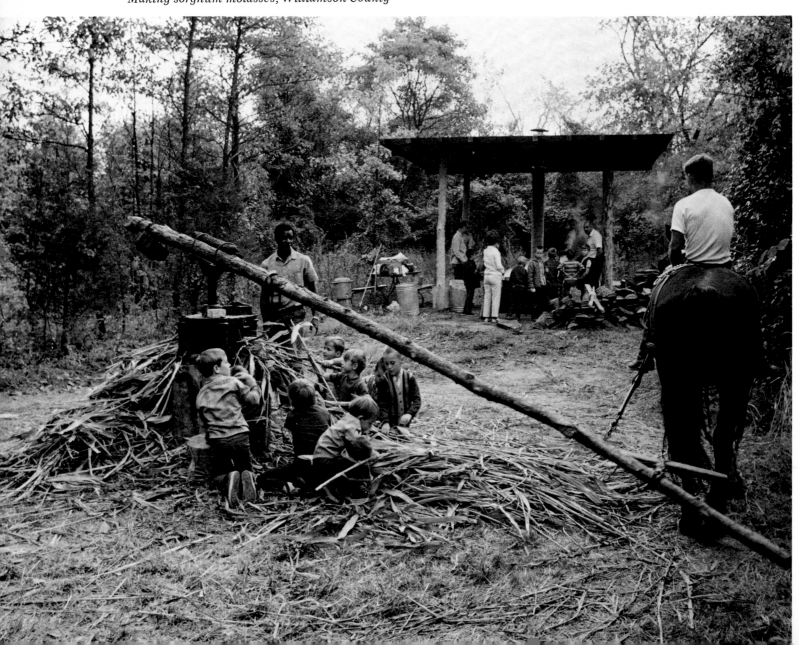

77

Pigs are numerous, being easily raised: they are of various sorts; but many of them are of a sandy colour, and some with wattles; that is, a piece of flesh, about two inches long and half an inch thick, growing out on their cheeks. . . . During the summer, when grass and herbs are dry, and before the masts begin to fall, it is almost impossible to describe how excessively poor they are. Most of them run till they are two, and sometimes three years old, before they are killed; and, in general, they have but little fattening. Some years, when there is a large quantity of acorns, hiccory-nuts, &c., they are said to get good pork.

—John Woods, *Two Year's Residence in the Settlement on the English Prairie, in the Illinois Country* (London, 1822)

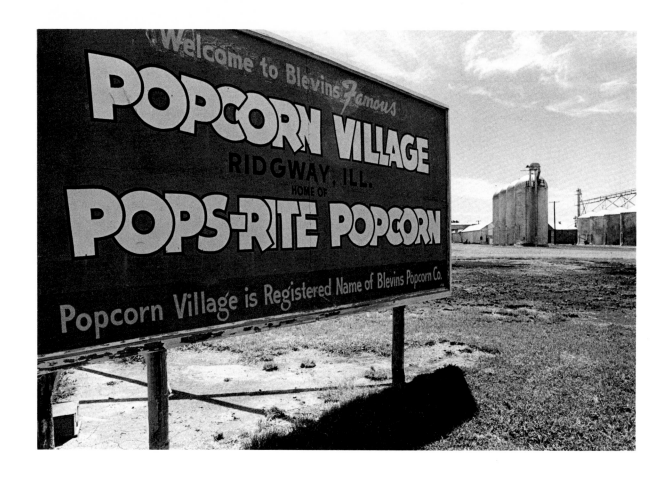

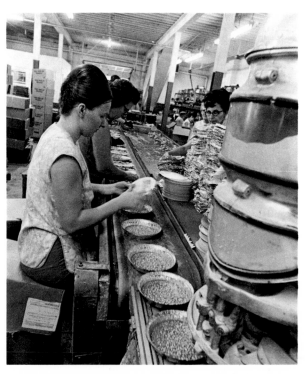

Packing popcorn in Ridgway, "Popcorn Capital of the World," Gallatin County

ideal for orchards. If the season turns out right, Southern Illinois peaches reach the big city markets just after Georgia peaches and before those from Michigan. Whether Egypt's apples are more flavorful than those of Wisconsin continues to be a highly controversial issue. More and more, domesticated berries are becoming lucrative crops—strawberries, blueberries, blackberries, raspberries. Fruits and nuts, negligible fifty years ago, now make up 10 percent of all Southern Illinois's agricultural products. With the advent of the railroads, local ingenuity found ways of using ice to refrigerate box cars. It is said that the first refrigerated shipment of fruit by rail in the United States originated in Cobden.

Closely associated with farming have been many related industries—usually centered in the nearby market towns: blacksmithing, farm machinery sales and repair shops, meat and fruit processing plants, flour mills, popcorn and other food product industries, storage elevators, auction and other livestock markets, and also the various seasonal state, regional, county, and local agricultural fairs and carnivals.

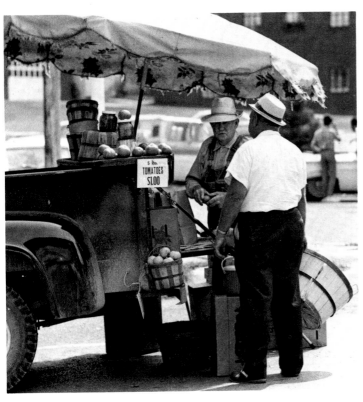

Tomatoes grow like weeds in Southern Illinois!

79

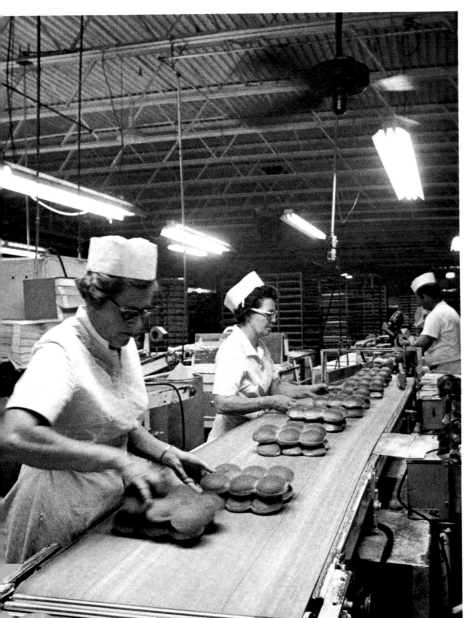

Bunny Bread Company bakery, Anna, Union County

DuQuoin Packing Company feeder lot
and packing plant, Perry County

There have been no saloons in the county, except at Carterville, since 1872. General Davis, who was one of the best friends the county ever had, ran a still-house and saloon until 1837, when John Newman got drunk and the hogs ate him; and in 1838, Essex Edmonson got drunk and rode off into the Saline and froze to death. About this time Davis went to the Legislature, and while there, heard A. Lincoln deliver a lecture on temperance. He came home and closed the door of his saloon forever.

—From *The History of Williamson County, Illinois* (1876), by Milo Erwin

Exterior and interior of "Ma" Hale's family-style restaurant at Grand Tower, Jackson County, near the Mississippi River

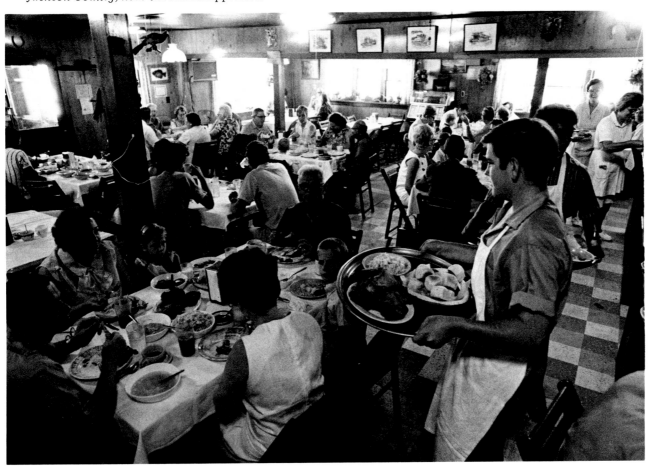

Mississippi River Music Festival, Southern Illinois University at Edwardsville

There was an old girl who lived in Cairo town,
And I wish to the Lord that she was dead.
She puts so many notions into my girl's head
That we can't get along, we can't get along,
We can't never get along no more.

 Great God ain't that hard?
 Me to love a girl who don't love me.

Come all the way from Cairo town,
And I never had but one dime to spend.
All the money I ever had
I done spent it on that little girl of mine,
Spent it on that little girl of mine,
Done spent it on that little girl of mine.

83

"The Old Girl of Cairo," A song dating from the days
when Cairo was one of the gayest and wickedest towns
on the river. From *Tales and Songs of Southern Illinois*
by Charles M. Neely (1938)

"Country Store" booth at Homecoming Day summer festival, Jacob, Jackson County

Uncle Jack was one of the characters of the whole county, strong and shrewd, and considered one of the best horse traders in this part of Illinois. . . . One Saturday afternoon he was arrested and fined five dollars and costs for being drunk. When haled before the same court the following Monday on the same charge, the court fined him again. He mildly asked the judge if it was the rule in his court to punish a man twice for the same offense. The court replied "no." The prisoner then said to his honor that this was the same drunk for which he had been fined on Saturday, and the judge, appreciating his witticism, gladly remitted the second fine.

—From *This Is All I Remember* (1954) by Frank Hickman of Benton, Franklin County

Scenes at Union County Fair, Anna

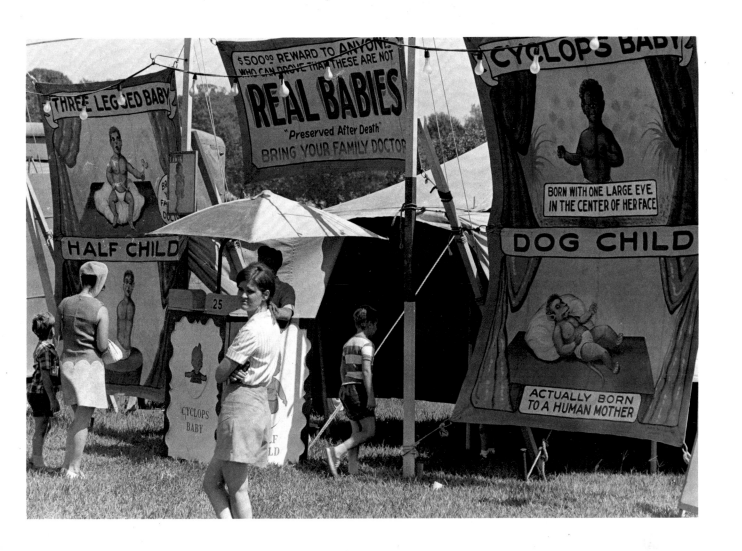

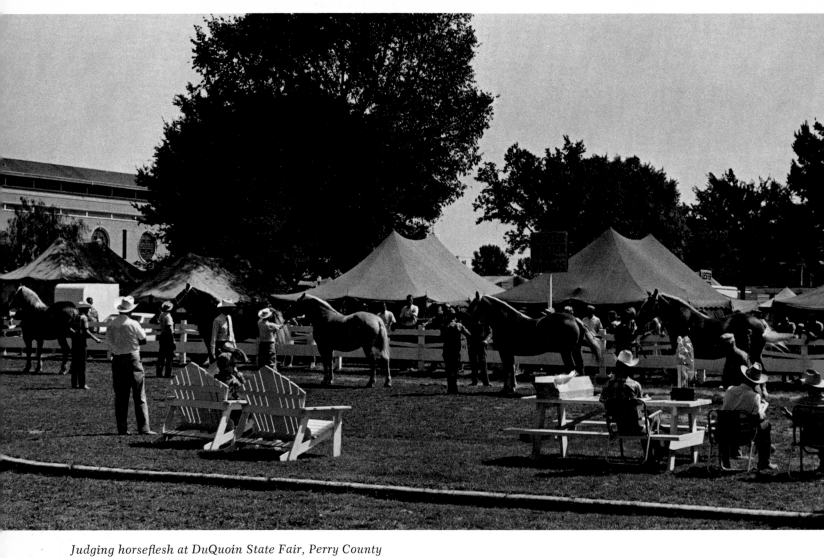

Judging horseflesh at DuQuoin State Fair, Perry County

Livestock auction, Murphysboro, Jackson County

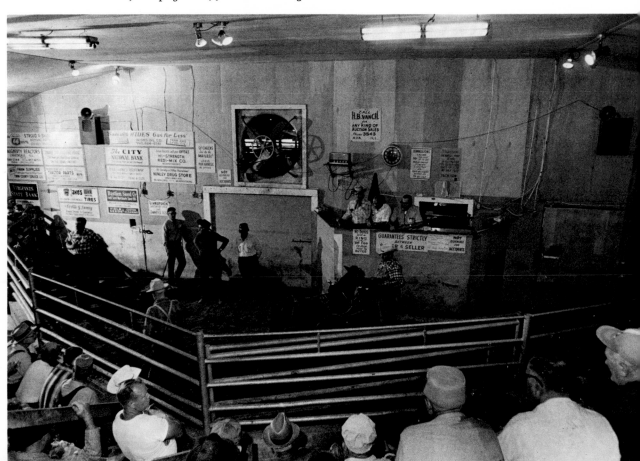

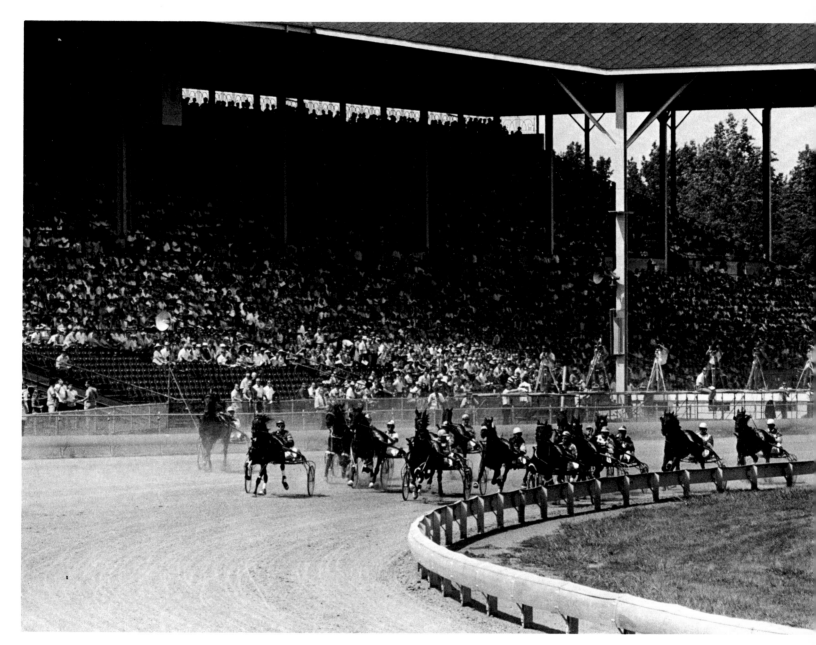

Running the "Hambletonian," Queen of America's Trotting Races, DuQuoin State Fair

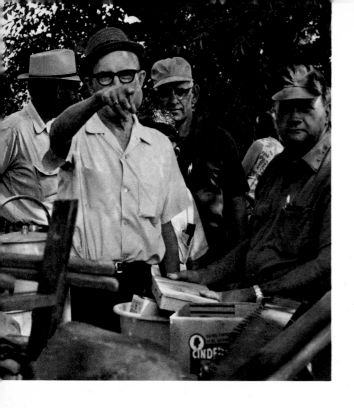

I was lately at an auction, of a little livestock and household furniture belonging to a person leaving this neighbourhood. The auctioneer was no less a person than a justice of the peace, and he was an excellent auctioneer, the terms of sale much the same as in England, except three months' credit on all purchases above three dollars, on giving bond and security. But the most striking contrast in this sale from an English one was, the auctioneer held a bottle of whiskey in his hand and frequently offered a dram to the next bidder. As I made some biddings, I was several times entitled to a sip out of the bottle. And though I much dislike the taste of whiskey, I took a sip for the novelty of the thing. But I found the auctioneer had taken good care to keep his company sober by lowering his whiskey considerably with water.

—An English visitor attends an auction during the early years. From *Two Year's Residence in the Settlement on the English Prairie in the Illinois Country* (London, 1822), by John Woods

Auctions are popular summer entertainment in Southern Illinois. This one was near Vienna, Johnson County

88

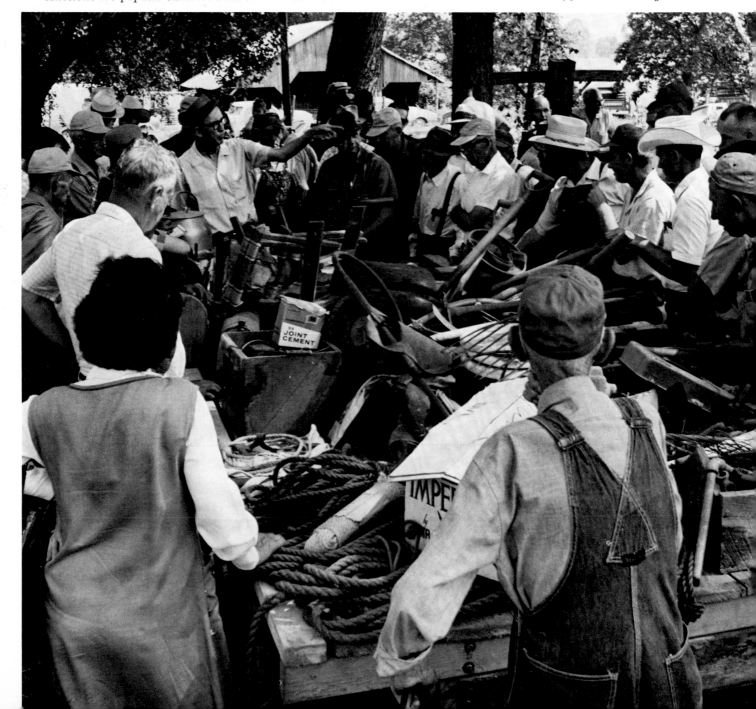

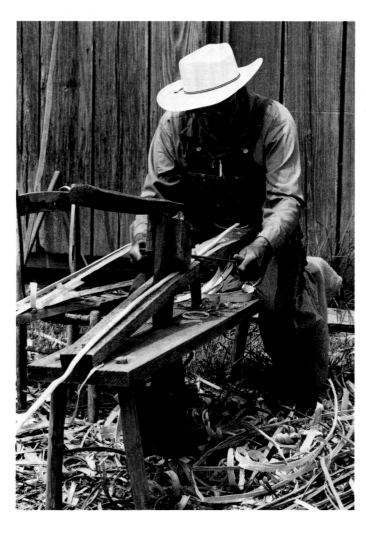

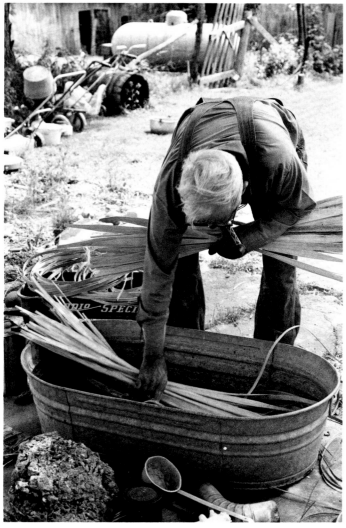

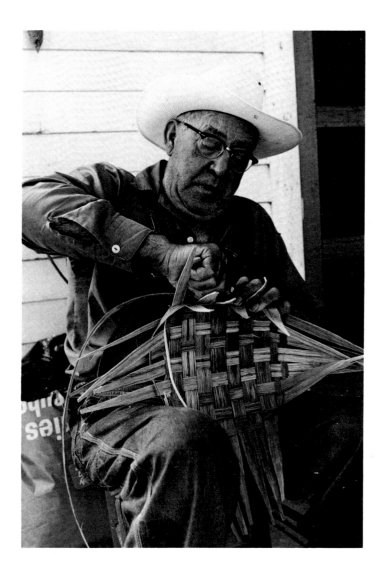

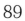

Splitting and soaking white-oak withes and weaving a basket on a farm in White County

Clyde Thomas: Iuka, Ill.
Marion Co.

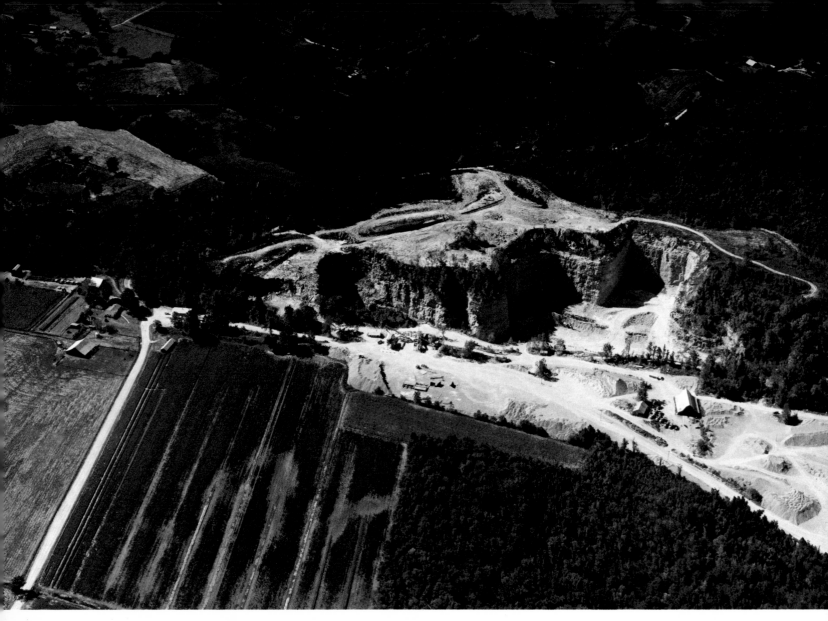

Limestone gravel quarry near Ullin, Pulaski County

90

So far as heavy industry and manufacturing are concerned the bulk of these activities has been confined to St. Clair and Madison counties, with their proximity to metropolitan St. Louis. Access to a large urban population, as well as good highways, railroads, and river transportation have made the cities of Wood River, Alton, Belleville, and East St. Louis the most heavily industrialized in Southern Illinois. The next greatest concentration of manufacturing is to be found in the so-called "dispersed city" of some 150,000 people living in or near the half-dozen towns located along Illinois Route 13, from Murphysboro and Carbondale in the west to Herrin, Marion, and Harrisburg. Local Chambers of Commerce, in association with such agencies as Southern Illinois, Inc., Southern Illinois University's Institutes of Labor, Transportation, and Community Development, and the Illinois Department of Economic Development are continuously involved in planning for the further industrial development of the region.

(continued on page 94)

Limestone finishing plant, Union County

Shaft of small-scale fluorspar mine, Hardin County

Cutting limestone for building purposes, Union County

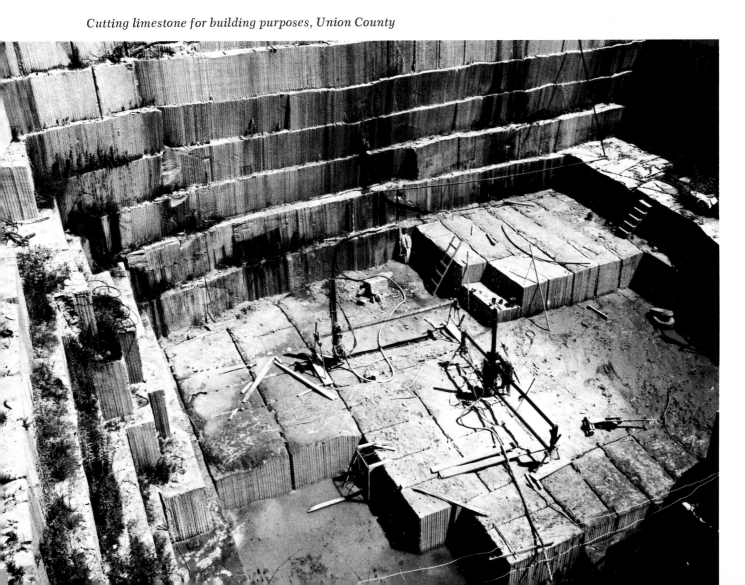

91

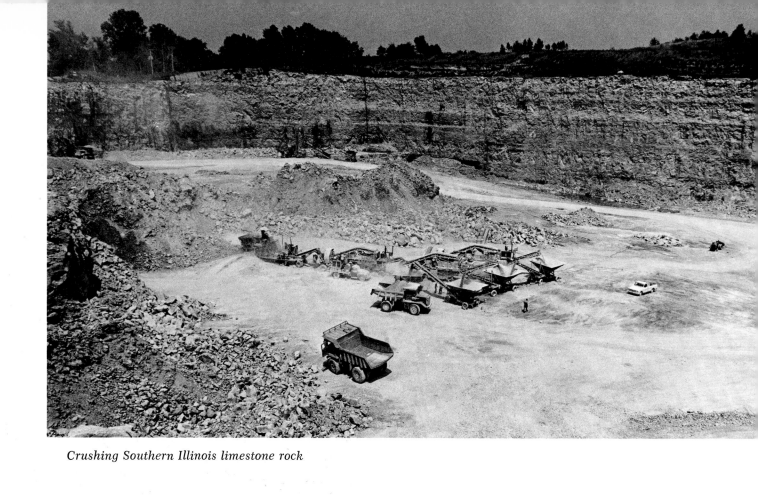

Crushing Southern Illinois limestone rock

Flour mill along Mississippi River at Chester, Randolph County

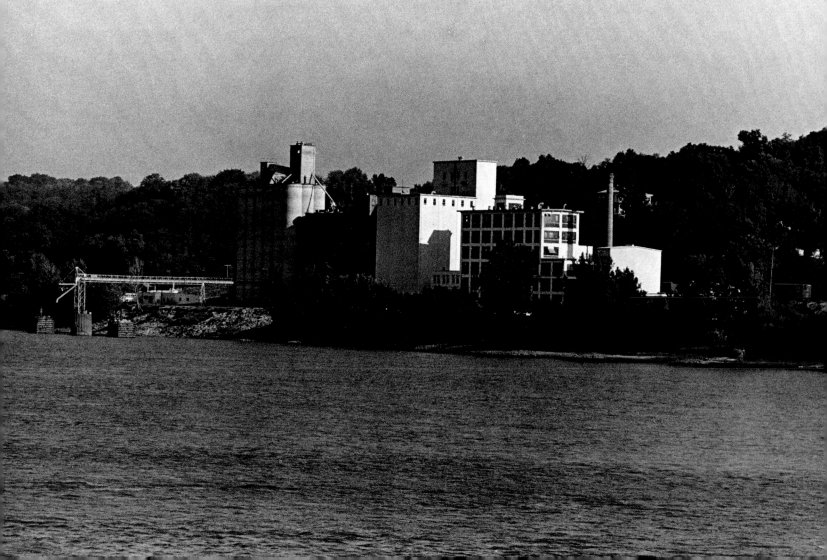

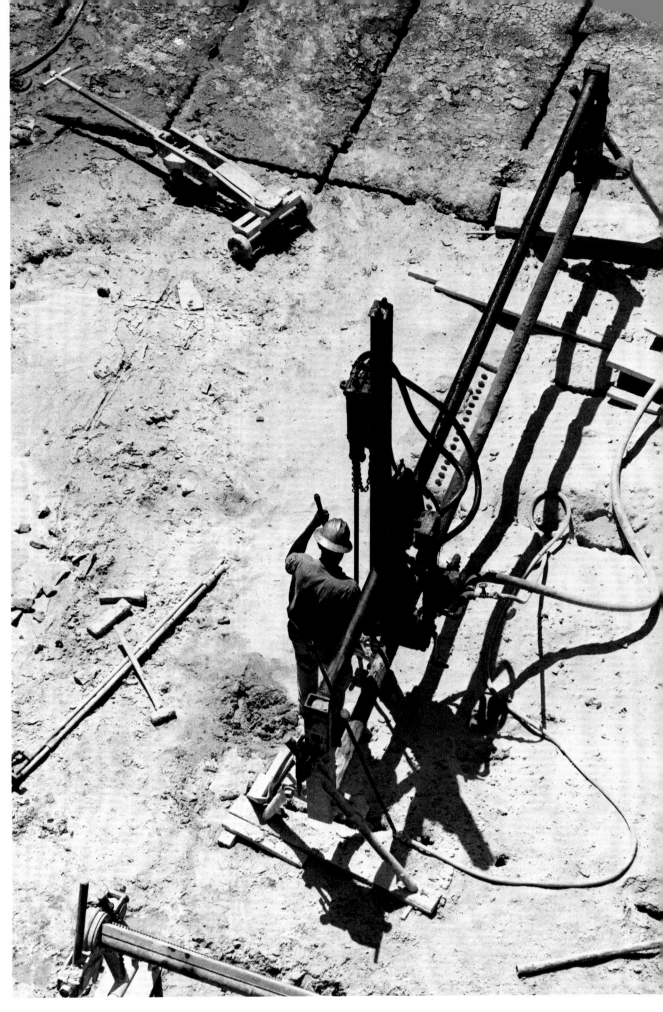

Cutting limestone at a Union County quarry

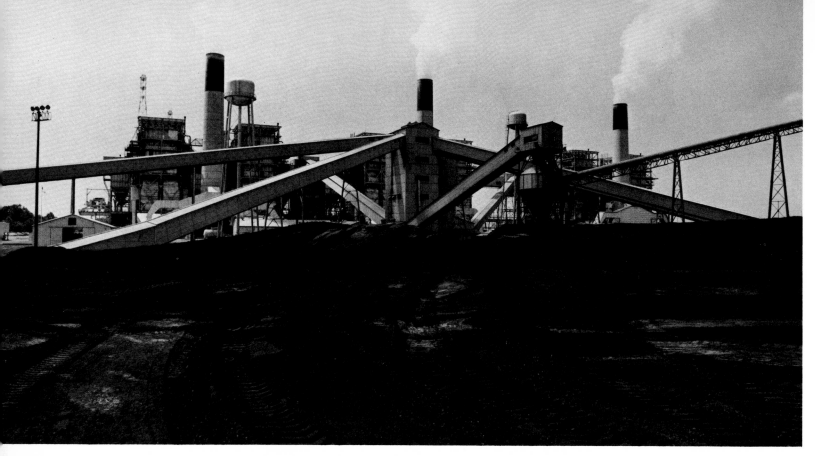

Coal conveyors at the huge Joppa Electric Energy Company plant on the Ohio River, Massac County

In doing so, they hope especially to attract a balanced diversity of light and other types of industry that are in harmony with the area's recreational, residential, and other unique advantages.

An excellent example of the establishment of a successful industrial complex ideally suited to take advantage of Southern Illinois's resources has been the Electric Energy Company's mammoth electricity generating plant and the adjacent Missouri Portland Cement Company's plant near Joppa, in Massac County. Located along the Ohio River on land of negligible agricultural or recreational value, this power plant every day transforms several trainloads of Southern Illinois coal into electricity that is distributed to industry in Tennessee and Kentucky. The fly ash from this plant, instead of being scrapped as waste, is blown through an underground tunnel to the new Portland Cement plant next door, where it becomes an important raw material in cement manufacture. Another major ingredient for cement is limestone, supplied cheaply and quickly by barge from the Hardin County limestone quarries nearby. The cement product is loaded mechanically onto river barges for delivery to distribution centers at St. Louis and Memphis. This careful planning and utilization of waste products, as well as of local raw materials which would be expensive to transport over great distances, have made the manufacture of Portland Cement at Joppa an extremely successful economic undertaking.

Over the years, Southern Illinois's farm products have stimulated the creation of many kinds of food manufacturing plants, ranging from flour mills and bakeries to canning, candy manufacturing, popcorn packaging, meat packing, and related activities. Examples of heavier industry includes several shoe manufacturing factories, women's and men's apparel plants, a large washing-machine assembly plant, and two large aluminum fabricating plants. An outstanding instance of local mechanical ingenuity has been the establishment of a large and successful plant devoted to the design and manufacture of custom-built pipe organs. The existence of the region's fishing and recreational opportunities is reflected in the recent establishment of a large-scale boat manufacturing concern. There are several sizeable printing plants in Southern Illinois, one of which has become the world's largest printer of comic books and other pulp-paper publications. In general, all of these comparatively recent industries have been relatively clean and pollution-free and employ well-educated and highly-skilled workers, who themselves constitute one of the most valuable resources of the region.

94

Come all young men who have a mind for to range,
Into the western country your station for to change,
For seeking some new pleasures we'll altogether go,
And we'll settle on the banks of the pleasant Ohio.

The land it is good my boys you need not to fear
'Tis a garden of Eden in North America:
Come along my lads and we'll altogether go
And we'll settle on the banks of the pleasant Ohio.

There's all kind of fish in that river for our use,
Besides the lofty sugar tree that yields us their juice,
There's all kinds of game besides the buck and doe,
And we'll range through the wild woods and hunt the buffalo.

This river as it murmurs it runs from the main,
It brings us good tidings quite down from New Spain:
There's all kinds of grain there and plenty it doth grow,
And we'll draw the Spanish gold right from Mexico!

From "The Banks of the Ohio," popular song of the early frontier

Loading fresh-made cement onto Ohio River barges, Missouri Portland Cement Company plant, Joppa, Massac County

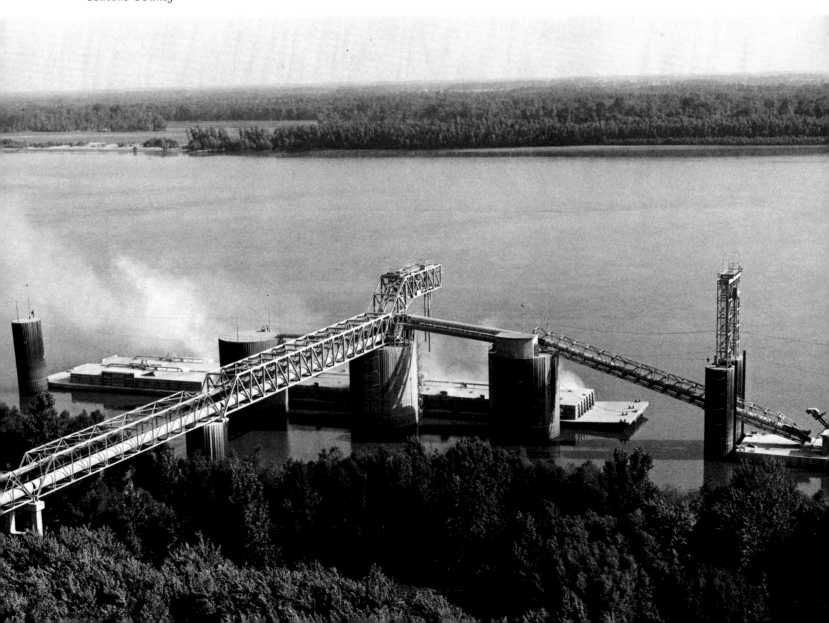

TOP AND LOWER RIGHT: *Manufacturing washing machines in Herrin, Williamson County*

Loading freshly-made ice into fruit truck, Anna, Union County

Henry Dillinger and George McKinney of Murphysboro were great story tellers in pioneer days. They were famous for their tall tales and yarns about their own exploits. One of their popular stories was about digging the channel of the Big Muddy River with their own hands. They were often asked why they dug such a crooked channel. McKinney replied to this challenge, "Well, you know we were in a hurry, so we had to dig day and night. The straight sections of the river are what we dug by day, but the parts we dug by night, as we couldn't see, we had to dig by guess. That's why some sections of the River are crooked."

—"Why the Big Muddy Is Crooked" in "Egyptian 'Lies'" by Grace Partridge Smith, *Midwest Folklore*, Vol. 1 (1951)

Interior of World Color Press, "Largest Printer of Comic Books in the World," Sparta, Randolph County

97

98 *Shoe manufacturing plant at Murphysboro, Jackson County*

Making pipe organs in Highland, Madison County

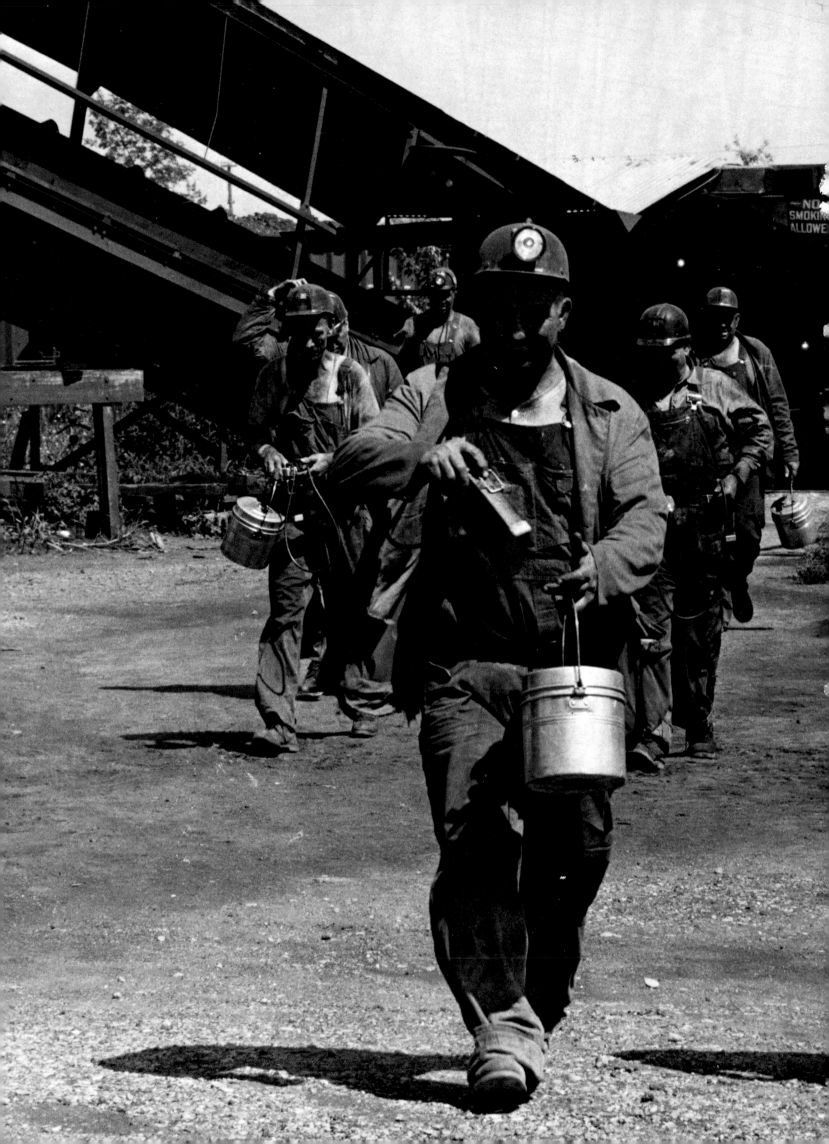

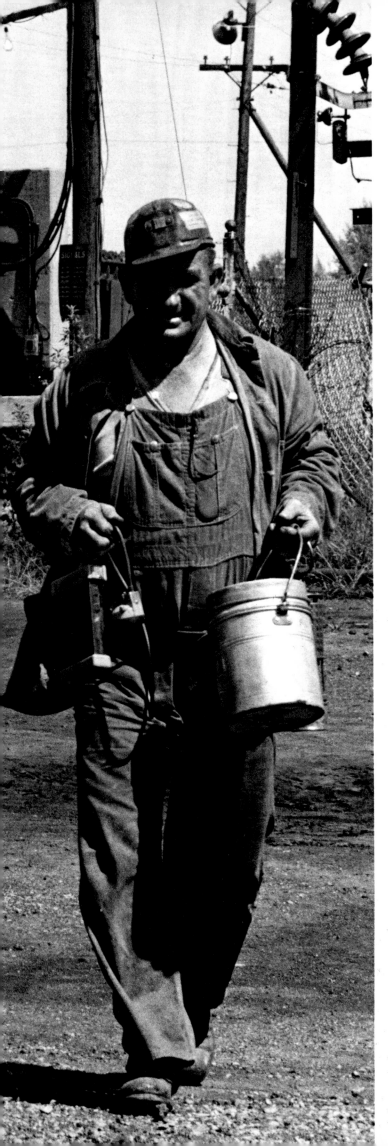

We lived in the Bottoms, in one of these little cottages at the extreme end of South Walnut Street. Dad was a coal miner. He had come up through the hard school of experience from a green "trapper" to one of the best entry drivers in southern Illinois.

He was the eldest son of an ex-slave, but because mining coal was a hard and dangerous job, no one was too concerned about a miner's background. If he knew his business he was accepted as a fellow worker, and that was his admittance card into the great fraternity of free men.

When I look back on my childhood, I am conscious again of the security that comes from growing up in one neighborhood, knowing everybody in town, living almost two decades in the same house, and being surrounded by the same people. . . .

Life in Du Quoin wasn't for the timid or pampered. The men who crawled about underground, by the faint glare of a carbide light fastened onto their caps, by-passed death a hundred times during the day as they adjusted props to hold up roofs of hanging coal, sidestepped a slide, or eluded the well-aimed hoof of a vicious mule.

The strength of the women matched the fiber of the men as they worked in their homes, cared for their many children, boiled their white clothes in a zinc tub over an open fire in the yard, and hustled the oldest boy off to Frank Knight's saloon for a cool bucket of beer at noon.

When there was an explosion at White Ash mines, the colored people weren't too bothered. They talked about it, to be sure, but all agreed that God was venting his wrath upon the operators who never permitted Negroes to work there. Their summarization of the disaster was, "God sho' don' love ugly."

—From *It's Good to Be Black* (1953) by Ruby Berkley Goodwin, a native of Du Quoin

101

"End of the shift!" Miners emerging from underground coal mine near Harrisburg, Saline County

Although farming continues to be the most conspicuous economic activity in Southern Illinois, mineral products—coal and oil—are actually the most lucrative and important factors in the region's economy. A century ago, agriculture, accounted for three-fourths of Southern Illinois wealth; today it accounts for less than one-fifth. Mineral products, a negligible factor a century ago, now account for more than one-fourth. Not only that, but the greater part of the state's mineral wealth is to be found in Southern Illinois.

Until recently, the most important mineral product in the region, in terms of dollars, has been oil, most of which comes from the northeastern counties along the Wabash River. Crude oil was first discovered in 1907, but really large production began only after the location of several large shallow reservoirs around 1937. Since 1940, Illinois oil production has gradually fallen off—although its dollar volume continues to make Illinois the eighth largest oil-producing state.

In contrast to its limited oil reserves, the state has coal reserves that—at present rates of consumption—should last well over a thousand years. Although most of Illinois is underlaid with coal, many of the

Interior of large-scale fluorspar mine near Rosiclare, Hardin County

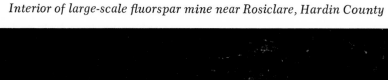

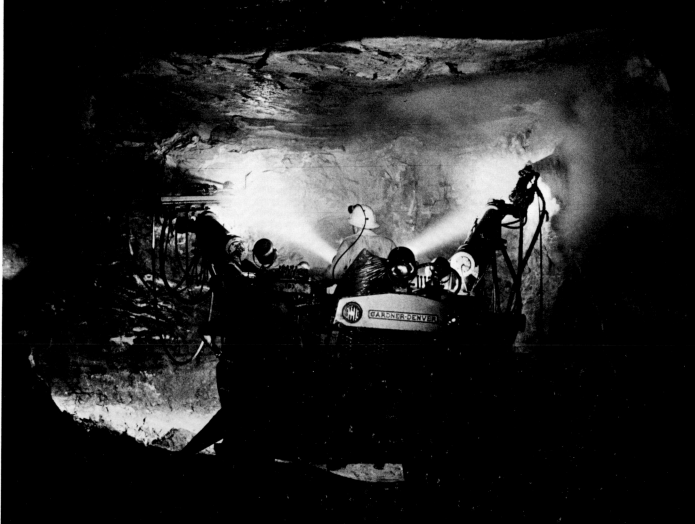

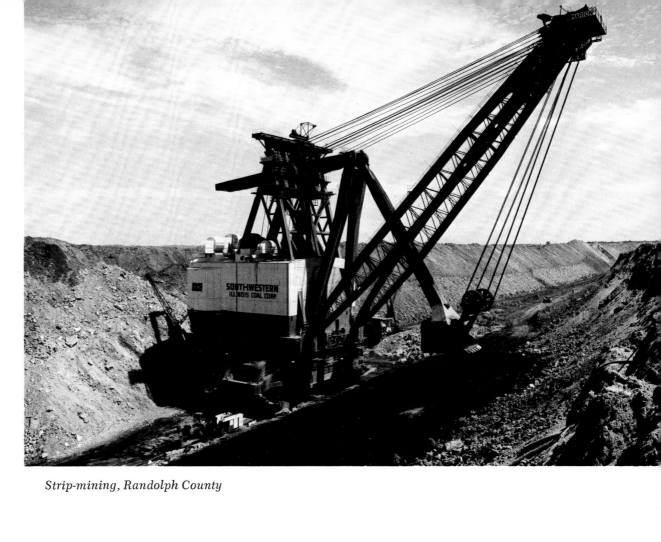

Strip-mining, Randolph County

Miners entering underground mine, Saline County

103

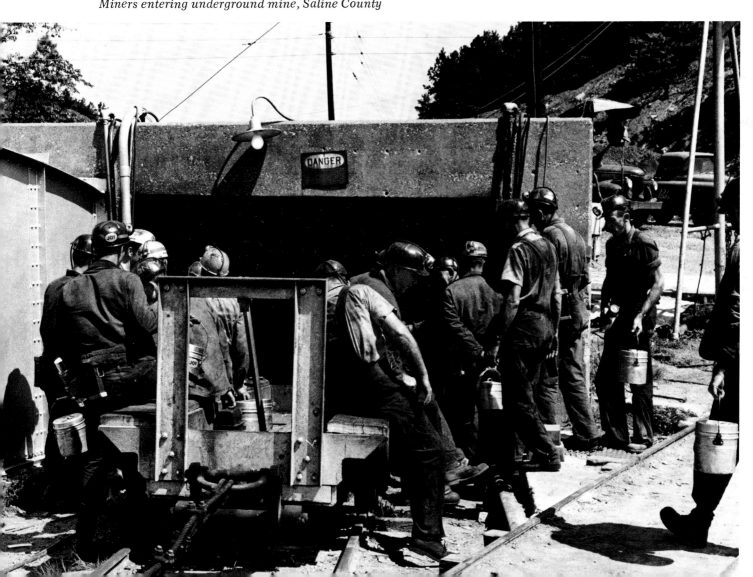

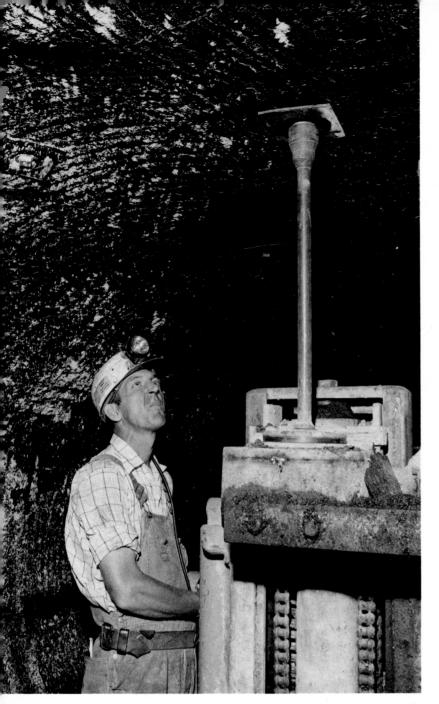

Roof-bolter in underground coal mine

*I am a happy, happy boy, and glad
 as glad can be.
For if the days are good or bad it's all
 the same to me:
O little of the world I know, and care
 less for its ways,
For where the bright stars never glow,
 I wear away my days.*

*Down in a coal mine, underneath
 the ground,
Where a gleam of sunshine never can
 be found;
Digging dusky diamonds all the
 season round,
Down in a coal mine, underneath
 the ground.*

*Then cheer up, boys, and make as much
 of every day you can
But let your joy be always great as that
 of any man,
However we may dig and delve we'll still
 be happy souls.
What would our country be without the lads
 that look for coals?*

From "Down in a Coal-mine," *America Sings,* edited
by Carl Carmer (1942)

biggest seams come closer to the surface in Southern Illinois, and it is here that some two-thirds of the state's annual production is now mined.

Coal has been mined here for over one hundred and fifty years. But the great upsurge in production began only after the Civil War with the development of railroads and the national iron and steel industries. Southern Illinois production reached major proportions only around 1900, and did not begin to boom until World War I. It suffered seriously from the Depression and did not approach its former levels until World War II. Then it dropped off again, and this trend has been reversed only since 1960, as

the cost limitations of atomic energy, together with the decline of oil reserves, have made industry turn once more to coal as a major fuel. It now seems likely that Illinois coal production will continue to expand for the foreseeable future.

Coal productivity per miner is much higher now than it was back in the peak days of the early 1920s. In 1920, 95 percent of all coal came from deep shaft mines; now over half comes from strip or "surface" mines where huge shovels dig up in one huge gulp an area the size of a tennis court. The result has been a radical reduction in the number of mines, the elimination of uneconomical operations, a big shift

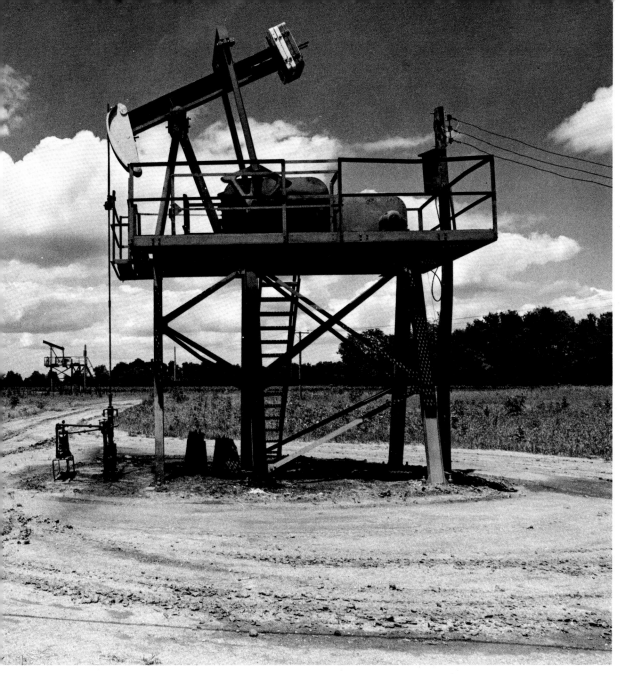

105

from manpower to automated machinery, a severe contraction in the labor force, and a tremendous economic displacement of workers. In 1920, 85,000 miners produced 73 million tons of coal from 373 mines, working an average of 160 days per year. In 1969, 13,000 miners produced 98 million tons from only 96 mines, working an average of 203 days per year. The miners who remain get better pay, work more days, and enjoy far safer and cleaner conditions than they did fifty years ago, but thousands have had to find other jobs. Many inefficient mines are closed, shabby towns have been abandoned, and people generally appear more prosperous. But it has been at the price of mass migration of families elsewhere, or extensive retraining programs for those who have remained.

After years of violence and bloodshed, unionization has finally established itself, and working conditions are immeasurably better. The government and the unions have drawn up better safety laws, and there is better inspection and enforcement. There is still room for improvement, of course—in productivity as well as working conditions and other incentives. But life is easier all round. Mining in Southern Illinois is more prosperous than ever before. It has shifted from a dangerous, unhealthy kind of work to a more stable, more remunerative, and more dignified occupation.

Despite these changes, coal mining continues to present serious problems for Southern Illinois in the way of reclamation of abandoned and mined-out sites. Because of the closeness of so many coal seams

(continued on page 108)

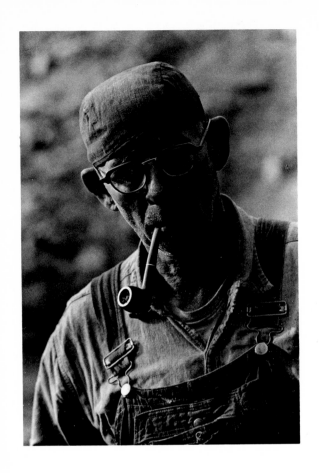

I will tell you this, Congressman: I have worked in coal mines for many years. . . . I know the psychology of the coal miner. . . . I have lived with them, because I am one, because my family has been associated with the mining industry for a century and a half, and it is inbred in me, if anything is inbred in me. . . . Anyhow, I have had some experience in the coal industry. I don't suppose you have. I don't suppose you have ever laid down in a mine tunnel with your face in a half inch of water, and pulled your shirt up over your head, expecting to die the next minute from an explosion you hear coming toward you. I have, and when God performed a miracle and stopped that explosion before I died, I think it gave me some understanding of these things.

—Statement by John L. Lewis, President of the United Mine Workers, who began his public career in Panama, Bond County. From *Testimony Before the U.S. House of Representatives Subcommittee on Education and Welfare, April 3, 1947, Regarding the Centralia Mine Explosion in Southern Illinois*

106

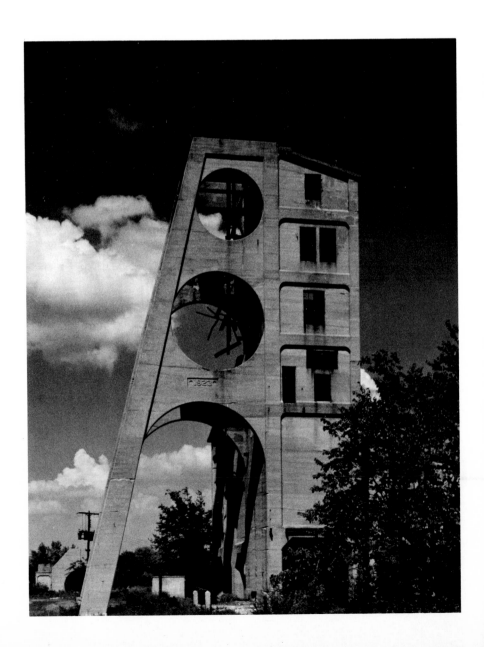

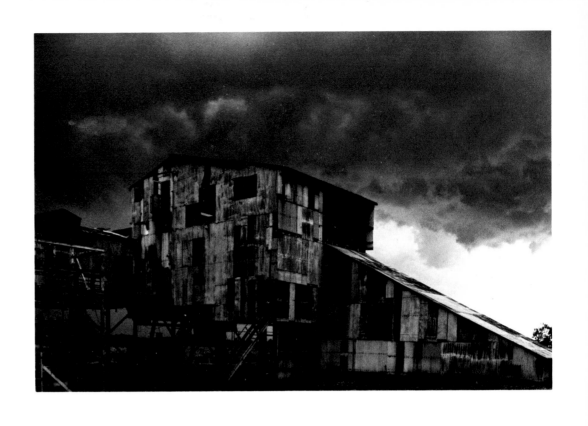

BELOW AND OPPOSITE: *Abandoned coal tipples*

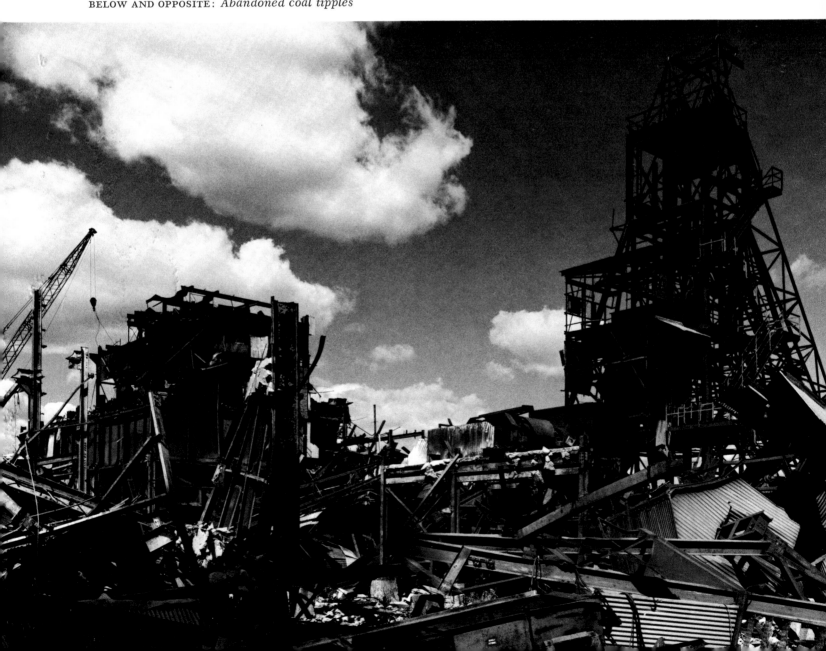

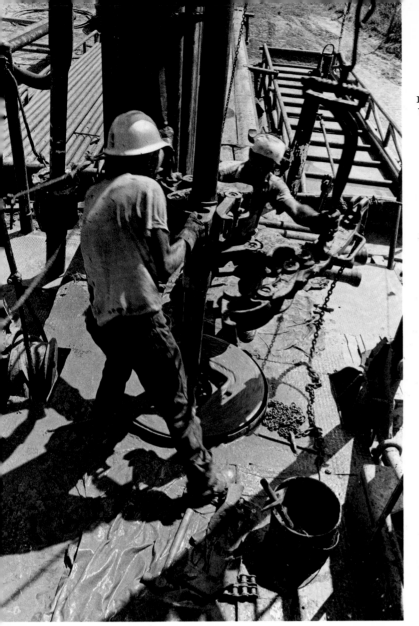

Out at Deepwater No. 9 Coalmine, the day shift rise up out of the workings by the cagefuls, jostle like tough but tired ballplayers into the showers. Some will go to homes, some to hunt or talk about it, some to fill taverns, some to card tables; many will go to the night's ball game against Tucker City. In town, the night shift severally eat, dress, bitch, wisecrack, wait for cars or warm up their own. A certain apprehension pesters them, but it's a nightly commonplace. Some joke to cover it, others complain sourly about wages or the contents of their lunchbuckets.

—From *The Origin of the Brunists* (1966) by Robert Coover, a novel about life in a Southern Illinois coal-mining town in Williamson County

to the surface, surface mining is far outdistancing the old shaft or underground method as the most profitable technique. The result has been the creation of large, ugly, polluted wastelands that must be carefully reclaimed if they are to be returned to other, more fruitful, uses. In most cases the surface soil is fertile enough to be put back into remunerative farming. But mined-out land is sometimes so poor it must be reforested or, if there is sufficient available water, developed as lakes for boating and fishing. Under a recent Illinois law, 100 percent of all mined lands must now be reclaimed, and mining companies must post bonds to guarantee funds for such restoration. Numerous state agencies are available to assist the mining companies to meet obligations, as well as to help in the reclamation of old sites. The state Departments of Conservation and Economic Development, as well as Southern Illinois University's programs in conservation, fisheries, wildlife, and outdoor education, have all been cooperatively involved in the planning and implementation of reclamation activities. New farms, orchards, new hardwood forests, hay pastures, fields, and attractive fishing and recreation sites have been developed as the result of these enlightened policies.

Although coal is the mineral mined most widely in Southern Illinois, the extraction of fluorspar ore has been a major industry in the southeastern region bordering the Ohio River, especially in Hardin County. Compared with coal, the mining of fluorspar is a much cleaner operation. The crude ore, often mixed with zinc, lead, or other metals, is first brought to the surface from deep pits, then crushed and concentrated by a "flotation" process which removes the undesirable materials and makes further refining cheaper and easier. Hardin County possesses not only the largest flotation mills but the largest fluorspar mines in the world. Fluorspar is an important ingredient in the manufacture of glass, galvanized iron, and many other useful products.

Besides coal and fluorspar, limestone is also an important Southern Illinois mineral. It is extracted in large open quarries. Depending on the condition of the rock, it is removed in large blocks for building construction purposes, or crushed for roads, cement, concrete aggregate, agricultural fertilizer, and other purposes.

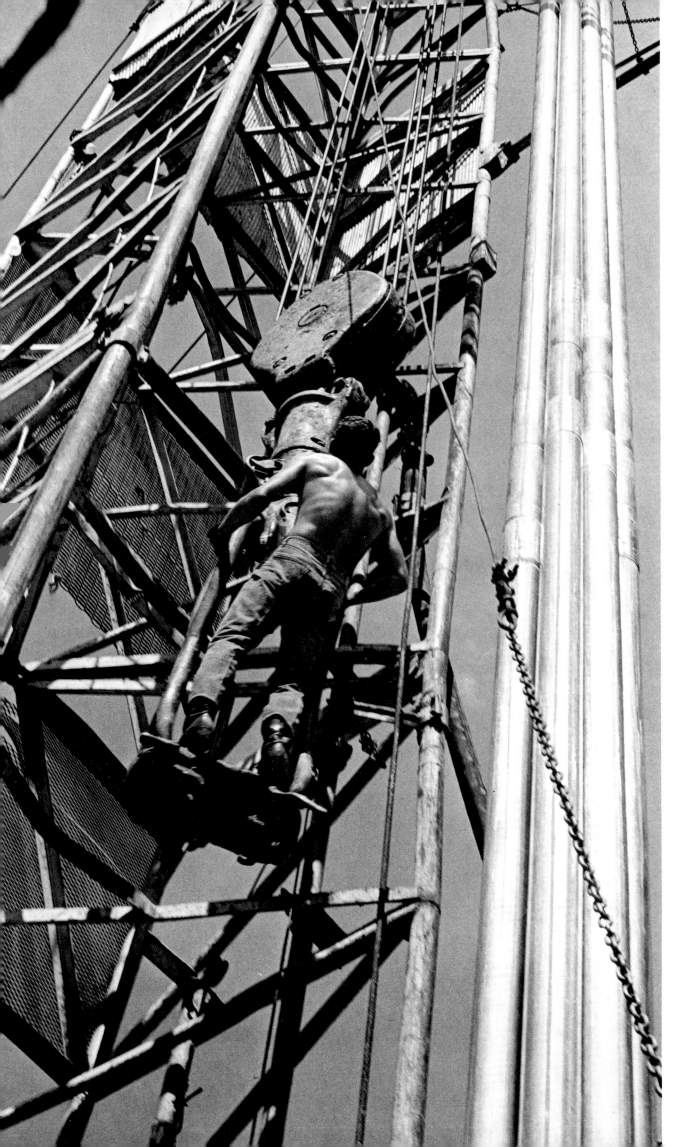

'Way down upon the Wabash,
 Sich land was never known,
If Adam had passed over it,
 The soil he'd surely own,

He'd think it was the garden
 He'd played in when a boy,
And straight pronounce it Eden
 In the State of El-a-noy.

She's bounded by the Wabash,
 The Ohio and the Lakes,
She's crawfish in the swampy lands,
 The milk-sick and the shakes;

But these are slight diversions
 And take not from the joy
Of living in this garden land,
 The State of El-a-noy.

Then move your fam'ly westward,
 Bring all your girls and boys,
And cross at Shawnee Ferry
 To the State of El-a-noy.

Then move your family westward,
 Good health you will enjoy,
And rise to wealth and honor
 In the State of El-a-noy.

"El-a-noy." From *The American Songbag*,
edited by Carl Sandburg (1927)

Oil refinery at Wood River, Madison County

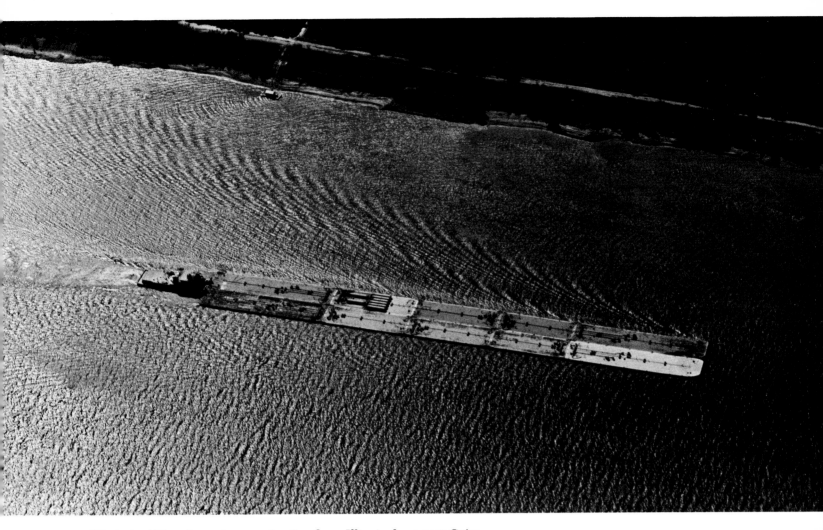

Mississippi River barge tow passing Southern Illinois shore near Cairo

Pilot on enclosed bridge, Mississippi River towboat

Southern Illinois has been aptly called "the land between the rivers." Next to its hills and valleys, its three great waterways are its most distinguishing physical features. The Southern Illinoisan is rarely far from the call of the river. Of the three rivers—Wabash, Ohio, and Mississippi—the Wabash river is probably the least known. For most of its life it flows through Indiana; indeed, it is Indiana's most important river, and is often thought of as exclusively Hoosier property. But it also forms the eastern border of Southern Illinois and has served for almost two centuries as an important highway in the life of that region. The Wabash bottom lands on the Southern Illinois side are so low and easily flooded that no large river towns grew up there, as did Terre Haute and Vincennes on the Indiana side. The only large town of any consequence is Mount Carmel, in Wabash County, although there are also two smaller ports of considerable antiquity: St. Francisville, in Lawrence County, and Grayville, in Edwards County.

Most of the early pioneers followed the Wabash

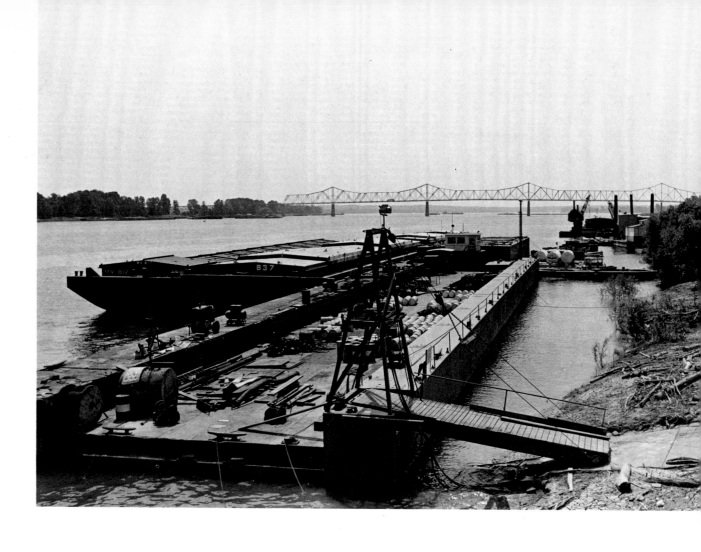

Far out at the end of the tow, often a thousand feet from the end of the boat itself, there were peace and stillness and sunshine, and a wind that was flavored with river water, willows and whatever was blossoming on the banks. The noise and vibration of Diesel engines stayed far back in the boat. Out here was only the gentle swish of water curving in a satin comber past the rake of the forebarge. With my back against a barrel-shaped hatch, I could sit for hours to watch the river go by and, with it, the wild things, the endlessly mobile surface pattern of eddies and boils and curvets and currents, and the every-varying shores.

—From Virginia Eifert, *River World: Wildlife of the Mississippi* (1959)

up to its navigable tributaries—the Embarrass ("Ambraw") River, the Little Wabash River, and Bonpas Creek—and settled on higher ground. They depended on the Wabash to carry their surplus farm produce down to the Ohio and Mississippi, and eventually to New Orleans. But after the coming of the railroads, river traffic along the Wabash River ground slowly to a halt. Today one rarely sees more than a fishing boat or small pleasure craft ruffling its placid surface.

The Wabash valley's most important early settler was an idealistic Englishman named Morris Birkbeck, who came to Edwards County with a group of friends in 1817. His glowing accounts of life on the Southern Illinois frontier, especially his book, *Letters from Illinois*, published the following year in both London and Dublin, brought over many other emigrants. Accompanying Birkbeck was a young man named George Flower, who also successfully propagandized for the region. The two later quarreled, and Birkbeck subsequently drowned in the

(*continued on page 117*)

Tightening up cable turnbuckle to secure a tow of river-barges

Barge-tows passing near Grand Tower, Jackson County

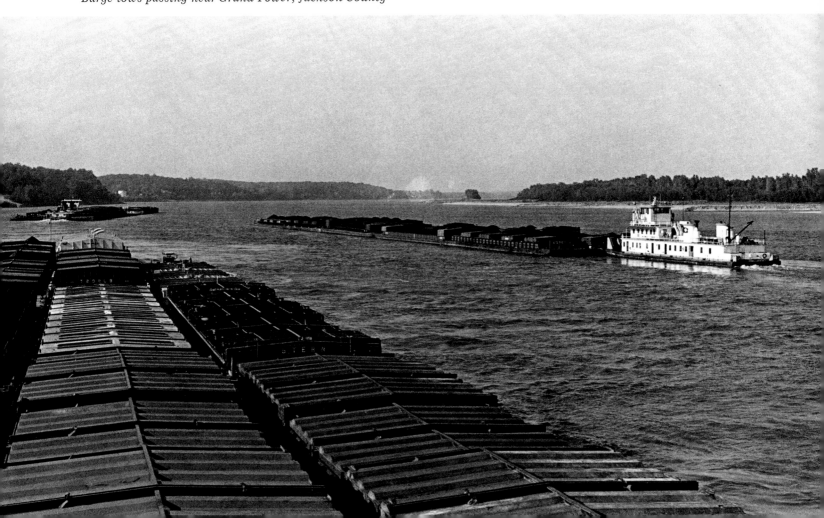

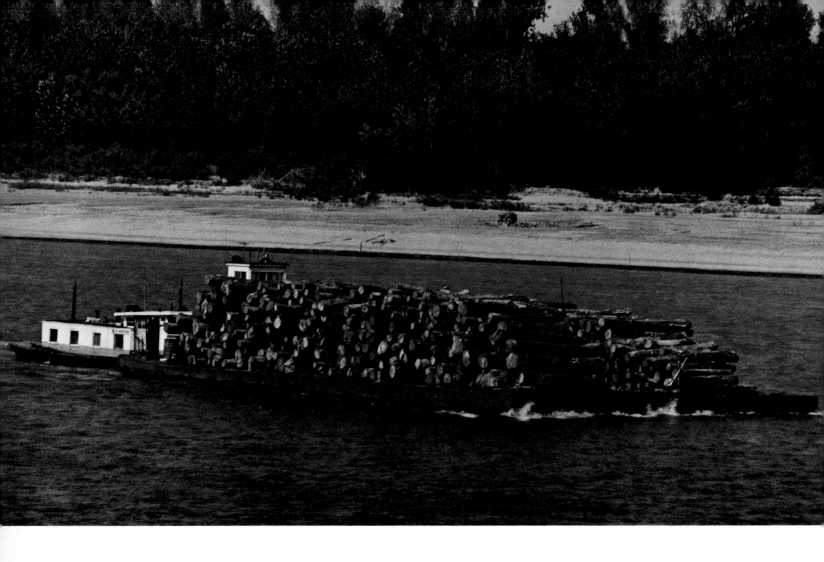

*The scenery from St. Louis to Cairo—two hundred miles—
is varied and beautiful. The hills were clothed in the fresh
foliage of spring now, and wore a gracious and worthy
setting for the broad river flowing between. Our trip began
auspiciously, with a perfect day, as to breeze and sunshine,
and our boat threw the miles out behind her with satisfactory
despatch.*

*We found a railway intruding at Chester, Illinois; Chester
has also a penitentiary now, and is otherwise marching on.
At Grand Tower, too, there was a railway; and another at
Cape Girardeau. The former town gets its name from a huge,
squat pillar of rock, which stands up out of the water on
the Missouri side of the river—a piece of nature's fanciful
handiwork—and is one of the most picturesque features of
the scenery of that region.*

—Mark Twain describes the Southern Illinois shore in *Life on the Mis-
sissippi* (1875)

114

*We mark a very obvious difference between the aspect of
the Ohio and the Mississippi. The breadth of the two rivers
is nearly the same; and they present at their junction nearly
the same appearances of swamp and inundation. They have
much the same growth on their banks; and yet they have a
character very unlike each other. The Ohio is calm and
placid, and except when full, its waters are limpid to a
degree. The face of the Mississippi is always turbid; the
current every where sweeping and rapid; and it is full of
singular boils, where the water, for a quarter of an acre,
rises with a strong circular motion, and a kind of hissing
noise, forming a convex mass of waters above the common
level, which roll down and are incessantly renewed. The
river seems always in wrath, tearing away the banks on
one hand with gigantic fury, with all their woods, to deposite
the spoils in another place.*

—An early visitor describes the meeting of the Mississippi and Ohio
Rivers at Cairo. From *Recollections of the Last Ten Years* (1826) by
Timothy Flint

Car ferry crossing Mississippi at Grand Tower

Mississippi River, Downtown St. Louis and Gateway Arch seen from East St. Louis, St. Clair County

Floating fish markets on Ohio River, Old Shawneetown, Gallatin County

Wabash, but Flower prospered and helped to found the town of Albion, now the county seat of Edwards County. Between them, Birkbeck and Flower are credited with having brought over some seven hundred British settlers, many of whose descendants still reside in Southern Illinois.

Much more important as a waterway than the Wabash was the Ohio River, long the main thoroughfare from the East to Southern Illinois. The first steamboat to sail from Pittsburgh to New Orleans appeared on the scene in 1811. Before long the old unwieldy flatboats and keelboats had been replaced by a flourishing steamboat trade. Then after the Civil War the railroads gradually made the steamboat obsolete. The great barrier to the development of extensive river traffic along the Ohio during modern times has been its unpredictable fluctuations in depth. An unexpected drought could dry up the shallower spots and make the channel impassable for boats of any size. But, thanks to the continued endeavors of the federal government, especially the efforts of the U.S. Army Corps of Engineers, starting around 1910, funds have been provided to build a system of locks and dams that provides a minimum slack-water depth of nine feet all the way from Pittsburgh to Cairo. Plans are now in progress to

Catfish restaurant, Cairo

117

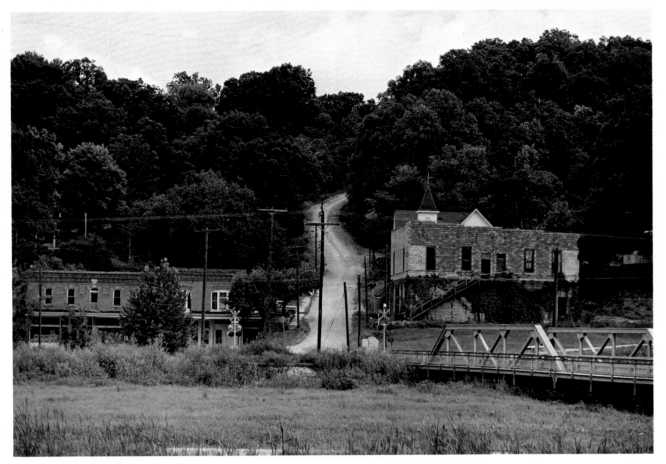

Main street of Makanda, Jackson County, illustrating popular Southern Illinois proverb: "As exciting as a day in Makanda!"

deepen this system for larger boats. As a result, the Ohio has once again become one of our most important arteries of interstate transportation. Most river freight is now carried on barges pushed by towboats (actually "push" boats) capable of shoving a multiple line of barges equal in capacity to several long freight trains. Annual tonnage along the Ohio today is more than twice that through the Panama Canal and three times that along the St. Lawrence Seaway!

Although passenger-boat traffic along the Ohio has declined sharply, good roads will take you to most of the interesting sites along the river. Entering Southern Illinois from the east, the first important port to greet the river traveler for many years was Shawneetown, now hidden from view by levees. More romantic is Cave-in-Rock, a great cave overlooking the Ohio twenty miles south of Shawneetown. Today it is an attractive state park with picnicking and camping facilities, but a century and a half ago it was feared as the home of a series of murderous outlaws and river pirates. Samuel Mason, a former Revolutionary War officer, lived there during the 1790s and advertised it as a tavern, in which he robbed and killed unsuspecting river trav-

elers. Most of his victims were pioneer families traveling by flatboat down the river, or settlers coming overland from Kentucky into Illinois by way of a nearby ferry run by James Ford. Ford himself is reputed to have been the leader of a gang of thieves in league with Mason's men.

Near Ford's ferry, on the Southern Illinois side, was a tavern kept by another notorious innkeeper, William Potts. Potts's son Billy ran away to make his fortune and—according to the old story—returned some years later so rich and changed in appearance that his parents did not recognize him. He revealed his identity to his former cronies at the ferry crossing, but he decided to keep the secret from his parents until next morning. Unfortunately, they murdered poor Billy in his sleep. It was only afterwards that Ford's gang disclosed the truth to his mother and father. Billy's tragic story has been told and retold many times along the river, most memorably in a long ballad by the distinguished poet and novelist, Robert Penn Warren.

Several other brigands were associated with the Cave-in-Rock country, including a counterfeiter named Sturdevant, the mysterious riverboat pirate known as "Colonel Plug," and the two Harpe brothers

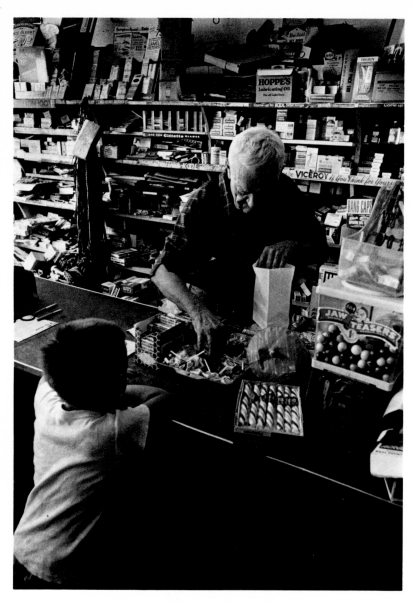

who long terrorized the Ohio River valley, until they were finally killed by a band of "Regulators."

Law and order were so difficult to maintain during those early years that the more respectable settlers formed themselves into posses of vigilantes or "Regulators" to defend themselves against the depredations of outlaws, thieves, and the other flotsam and jetsam of the frontier. Many of these troublemakers lived in the canebrakes along the river shore and were popularly known as "Flatheads." The Regulator–Flathead wars grew so violent during the 1840s in Massac, Pope, and Hardin counties that for a time they enjoyed national notoriety. But gradually, as the region filled up with substantial settlers, and stronger local governments evolved, the violence died down.

The Regulator tradition, however, has not entirely died in Southern Illinois. There are still those who feel strongly that when local law enforcement agencies break down it is up to the local citizenry to organize and take over. For good or bad, the Regulators left behind a legacy that still exercises power over the Southern Illinois imagination.

From the beginning, the earliest French explorers along the Ohio were enchanted by its beauty and named it "La Belle Rivière." The Mississippi River, on the other hand, possesses a very different kind of personality. What has impressed visitors most about the Mississippi has been its power and its treacherous unpredictability—especially at flood stage, when it rolls and surges and haunts onlookers with the sound of its ominous roar. One can understand how T. S. Eliot, the expatriate American poet who spent

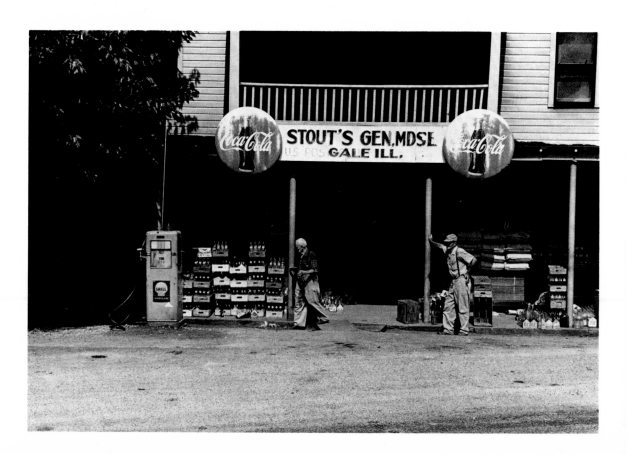

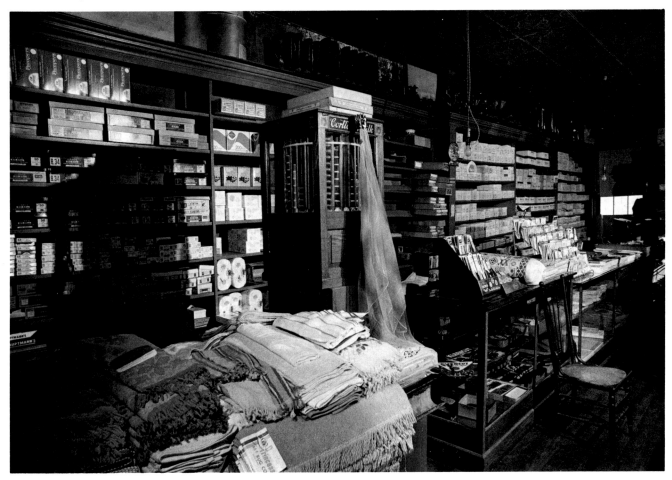

121

most of his life in London, was unable to forget the river beside which he had been reared as a child in St. Louis. He describes it in his "Four Quartets" as a "strong brown god—sullen, untamed and intractable." Walt Whitman was a very different kind of poet from Eliot, yet he too was haunted by the same treacherous qualities of the river, and described them in "Sailing the Mississippi at Mid-Night," a poem written after his first trip down the river.

But it took a writer like Mark Twain—someone who had not only lived long beside the Mississippi, but had studied its many moods as a licensed river pilot—to express fully its fascinating and complex personality. No American river has inspired two more remarkable books than Mark Twain's *Life on*

the Mississippi and *Adventures of Huckleberry Finn. Huck Finn* is the greater work of art. But *Life on the Mississippi* continues to be the best introduction that has ever been written to the part of the river between St. Louis and Cairo that forms the western border of Southern Illinois.

One of the great sights invariably mentioned by early travelers to Southern Illinois was the spot where the clear waters of the Ohio blend with the mud-colored Mississippi. It is still a spectacular vista, particularly when seen from the air. Many of these visitors were also struck by the similarity between the long tip of land jutting out between these two rivers and the situation of New York City at the junction of the Hudson and East Rivers. Some reck-

(continued on page 127)

Yard sales are a popular form of Southern Illinois entertainment

Most of the McLeansboro stores, facing the square, have shed roofs extending out over the sidewalk. These are constructed of wood or galvanized iron and supported by iron poles, and they reflect the Southern traditions of the town. Subsequently I told a McLeansboro merchant that I considered these shed roofs to be unsightly, and he agreed with me, and I asked why they were not torn down.

"When it rains here," he said, "it rains cats and dogs. And when it comes on summer, you never see the like of such blazing heat. If we was to tear down them roofs, we'd have a revolution on our hands. Where could people loaf at if they didn't have that protection from the sun and rain?"

—From *Lo, the Former Egyptian* (1947) by H. Allen Smith, former resident of McLeansboro

And so is rock-collecting!

123

Typical shaded store-fronts on a hot August day

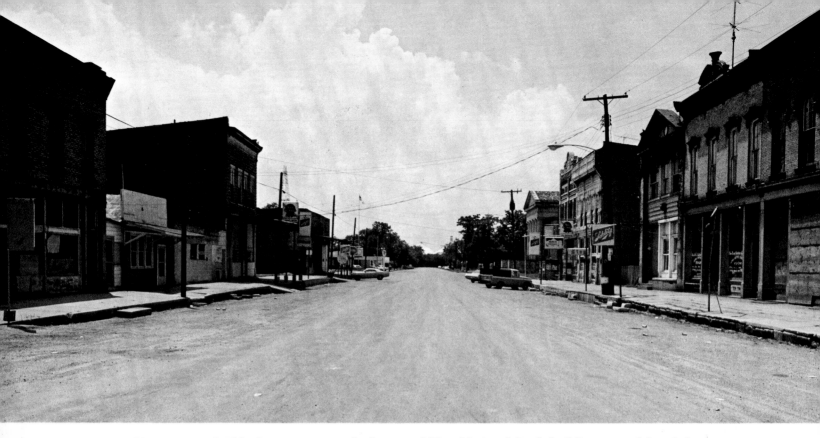

Main street of Old Shawneetown with closeup of First National Bank building erected in 1836

In the town of Shawneetown,
When the evening shades came down,
On a quiet Sabbath evening, cold and gray,
While the people walked the streets,
Some in dear communion sat
Within their peaceful homes at the close
of day.

All at once the bells were ringing,
With a wild and awful ring,
As the fearful flood broke over one and all,
Oh! that faithful levee broke,
Pale the lips of those who spoke
While that roaring, crashing, awful flood
came in.

There were heroes in that day,
Franklin Robinson, they all say,
In his little boat brought many safe ashore;
While they struggled with the waves,
He rode on their lives to save,
Working bravely till that awful flood
was o'er.

Father Bikeman saw it coming,
Like a giant mountain high,
And he knew what awful danger,
In its pathway lie.
Oh! he did his duty well
As he boldly rang the bell,
Warning all within the danger line to fly.

On it came with mighty force,
Spoiling all within its course.
Wrecking homes and snatching loved ones
from their friends.
There they found a watery grave,
Beneath the cold and silent wave,
To be covered over by the drifting sand.

There are broken hearts and homes,
There are sorrows, there are groans,
Where was trouble, now is anguish and
despair.

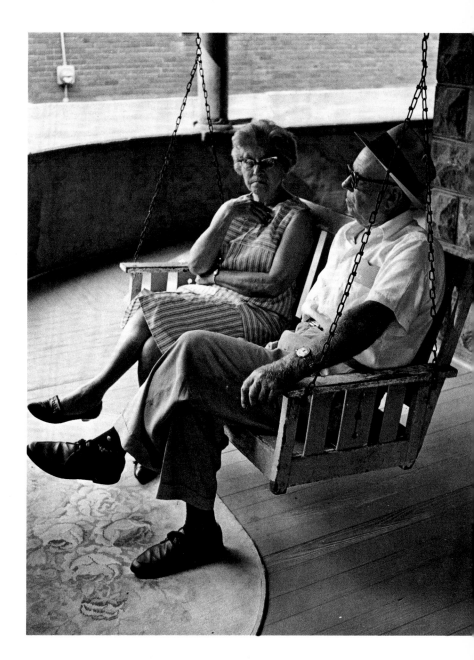

Where was once all smiles and light,
Now is darkness, now is night.
Where was once a happy city, wreck appeared.

"The Shawneetown Flood," a local ballad of unknown
authorship celebrating the disastrous flood of 1913.
From *Tales and Songs of Southern Illinois* by Charles
M. Neely (1938)

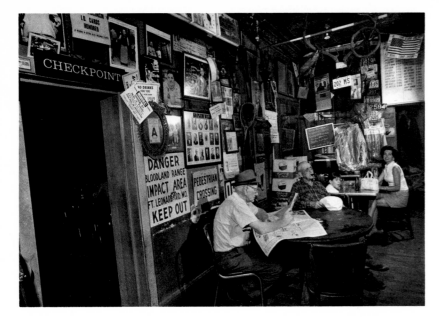

Tavern, Edwardsville, Madison County

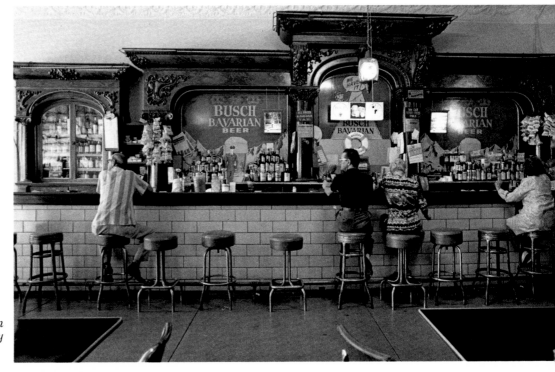

*Old-time saloon
in Herrin, Williamson County*

*Iron Kettle "serve-yourself" restaurant
near Anna, Union County*

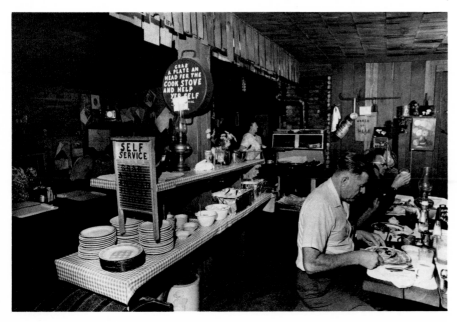

*Saturday nights the German and Polish people had their own
dances. Albert Beutcher had made a small pavilion under his
grape arbor. Here they would gather at dusk. A small keg of beer
was put on tap. The shelf above it was filled with imported stein
mugs. Frank Molsen who played the violin never dreamed that
years later his son Yeets would play first violin with the Chicago
Symphony Orchestra. The accordion was the only other instru-
ment that was used. We always stood by the fence and watched
until we were called home. We heard the music of Strauss and
Liszt, quaint Bohemian folk songs that set the older people among
the familiar lands of their childhood.*

—Ruby Berkley Goodwin, *It's Good to Be Black* (1953), a memoir about
growing up in DuQuoin, Perry County

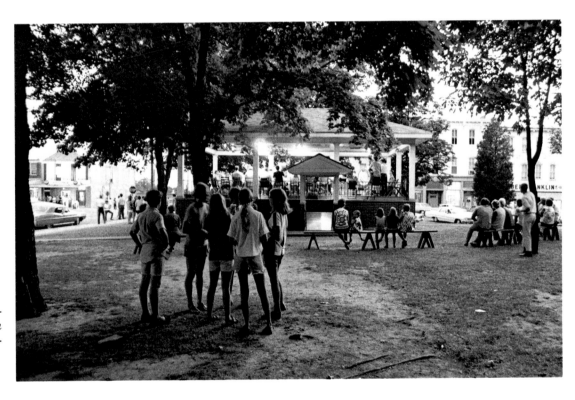

*Traditional summer eve-
ning band concert in
Courthouse square, Wa-
terloo, Monroe County*

lessly predicted a brilliant future for the great me-
tropolis that would one day rise where the city of
Cairo now stands. This dream also captured the
imagination of many Southern Illinoisans. As early
as 1818, the territorial legislature chartered "The
City and Bank of Cairo," a land bank created to de-
velop 1800 acres at the tip of this peninsula. The
land was surveyed, lots were platted, and plans were
made to use some of the profits to build levees against
the periodic floods. Then the promoter died, and the
land reverted to the state.

In 1837 a second attempt was made. "The Cairo
City and Land Company" was chartered, and over
two million dollars of bonds were sold, mostly to
overseas investors. But the depression of 1837 forced
the company into bankruptcy, and most of the
money evaporated. One of the disgruntled English
investors was the novelist Charles Dickens. In 1842,
when Dickens made a triumphant lecture tour of the
United States, he insisted on visiting the scene of
the "crime" and was understandably disappointed by
Cairo. His impressions were recorded in acid in his
journal, later published as *American Notes*. He re-
turned to his unhappy theme again in the novel
Martin Chuzzlewit, where the land around Cairo is
unflatteringly portrayed as "Eden." Fortunately,
Dickens had an opportunity to see more of Southern
Illinois during his visit, including the famous Look-

Former Williamson County Courthouse and market square, Marion

The courthouse square lay quiet in the warm June darkness. . . . and in the exact center of the square, high above the four corner lights, the illuminated faces of the courthouse clock recorded time's inexorable passage. Here and there dim night lights burned in the rear of such commercial temples as The New York Store, Miller's Bootery—Wholesale & Retail; Levant Brothers—Fine Wines & Liquors; Conover's Drugstore; Deshler's Cigar Factory; The One-Price Clothing Store For Men, et cetera. At the square's northwest corner the lobby lights of the Windsor House were dimmed but still functioning for the benefit of any late traveler.

—From *Years of Illusion* (1941), a novel about small-town Southern Illinois life by Harold Sinclair

ing Glass Prairie in Madison County. Here he found an excellent tavern (still standing and awaiting preservation) in the nearby town of Lebanon. Unfortunately, it is Dickens's churlish accounts of Cairo that most readers remember, rather than his pleasant night's stay in Lebanon. To balance the picture one needs to reread Mark Twain's charming account of Cairo in *Life on the Mississippi*.

The coming of the railroad awakened new hopes for Cairo's future. A railroad from Chicago to Cairo was chartered by the legislature as early as 1843, but it was not until shortly before the outbreak of the Civil War that a line was finally completed. Then the war brought Cairo more problems than it could cope with. Most severe of these was the influx of hundreds of refugees from the south—poor mountain whites from the Kentucky and Tennessee hills who refused to fight for the Confederacy, as well as many penniless escaped slaves. After the war the whites were gradually absorbed into the Illinois community, but almost as one body the towns of Illinois refused to welcome or to provide for the blacks. Instead, most black refugees from the South remained in crowded slums in or around Cairo. Little provision of any kind was made for their welfare. Where Cairo had some fifty blacks in a population of six

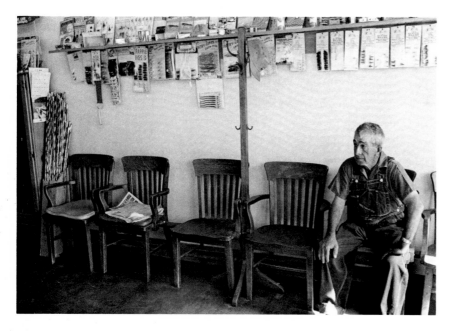

ABOVE AND LEFT:
Barbershop snapshots

Spit and Whittle Club, McClure, Alexander County

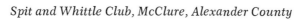

thousand before the war, by the end at least half of its population was black.

Some relief came during the 1880s and 90s, when the steamboat traffic along the rivers reached its zenith, and Cairo enjoyed a brief boom. During those years an average of five hundred boats docked at Cairo every month. The city became a busy shipping and passenger center, and a great deal of money was made by the energetic merchants and bankers at the top of the ladder. The city developed a proud aristocracy, modeled on the Southern tradition, with sumptuous homes, an orchestra and a theater, a fine library, and many other refinements and amenities. But it was an unstable economy with a large amount of poverty at the bottom. One of the most lucrative sources of wealth was the entertainment of the steamboat crowds, and for a while the Cairo riverbank was one long, festive carnival. No less than ninety bars and saloons catered to a variety of tastes. There were usually private rooms at the back for gambling and other lively amusements. Uncle Joe's, My Brother's, The Glad Hand, The Three States, were especially well-known establishments. It was said that Cairo averaged at least one murder a week.

When the railroads began to cut into the steamboat traffic, hope was that the completion of the Illinois Central through to New Orleans would make Cairo a great railroad center. The opening of the Illinois Central's still-impressive four-mile-long bridge over the Ohio marked the high point of Cairo's confidence. But once more it suffered disappointment. The great transcontinental trains now thundered across the bridge, but most of them passed right on by. Gradually the town sank once again into a lethargy and exhaustion from which it has never fully recovered. It still clings proudly to its past dreams and hesitates to admit its failure to solve its problems all by itself. It has one of the highest rates of welfare cases in the state of Illinois. Were Cairo part of a poorer state, perhaps it might accept its fate more willingly, but attached as it is to one of the largest and richest states in the nation, it lacks that alternative. Only the most vigorous and imaginative local, state, and national leadership, working together, can cure Cairo of its historic illness. In an important sense, Cairo is one of the neglected victims of a civil war that theoretically ended over a century ago. In our subsequent concern for the victims of later American wars—often our former enemies— we have ignored the price that Cairo has paid as the "Ellis Island" of Illinois. A further irony is that Cairo, still suffering from the aftermath of the Civil War, fought on the "winning" side!

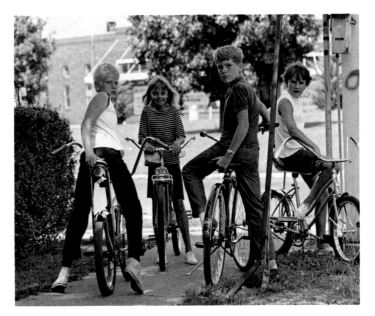

School's out!

City park, East St. Louis

Isolated as Southern Illinois has been for so long from the dynamic changes of industrial society, it is not surprising that it continues to be one the most interesting regions in the Mississippi Valley for the study of American folklore. It is noteworthy that Richard Dorson, one of the leading authorities on the subject, singled out Southern Illinois from the other parts of the Midwest as the only region to be included in his collection of representative American folk songs and folktales, *Buying the Wind* (1964). Dividing the United States into seven major sections, Dorson chose Southern Illinois as the region that best illustrates the folklore of the upper Mississippi Valley. Most of the information about Southern Illinois in his book came from a group of folklore scholars and collectors centered for many years on the Carbondale Campus of Southern Illinois University, including Charles and Julia Neely, John W. Allen, Grace Partridge Smith, Edith Krappe, David McIntosh, Harold E. Briggs, Jesse Harris, William Simeone, and Frances Barbour. In 1946 the Illinois Folklore Society was founded at Carbondale.

As might be expected, a great deal of the folklore material collected in Southern Illinois is not indigenous, but merely part of the pervasive folklore of nineteenth-century America. For example, Lelah Allison, Eva Gersbacher, and other local collectors have reported the existence of some six hundred popular traditions regarding the curing of sickness, predicting the weather, determining dates for planting and harvesting, and so forth. Occasionally the collector stumbles upon a story or saying that has a uniquely Southern Illinois flavor or reference. Similarly, the bulk of the songs and games sung and danced to over the years in Southern Illinois were brought from the East, and analogues can be found from many other parts of the country. Yet the diligent collector will now and then find a singing game such as "Goin' Down to Cairo," or the old river song, "The Old Girl of Cairo," or ballads like "The Shawneetown Flood," "The Belleville Convent Fire," of "The Death of Charlie Burger," or will hear tales about "Billy Bryan," the famous train conductor, and know that he has struck an authentic vein of indigenous Southern Illinois folklore.

Exterior and interior of Arts and Crafts Center, Makanda, Jackson County

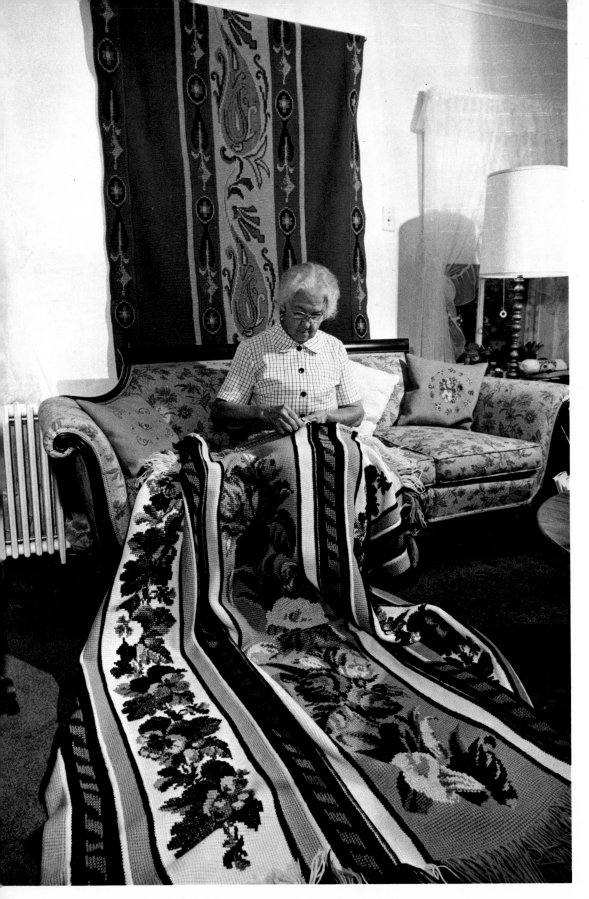

Making an afghan wall-hanging, Jackson County

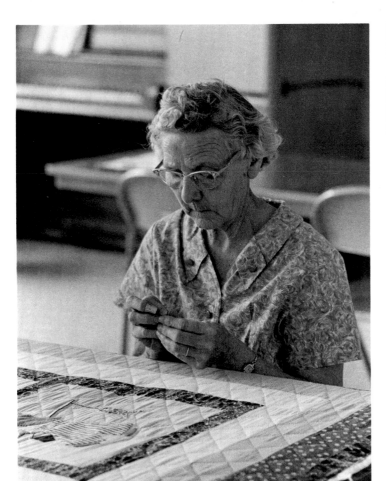

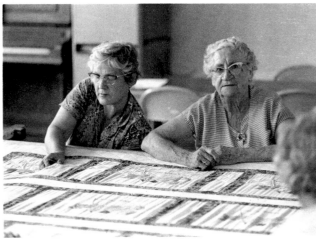

L to R:
Mrs. Jarrett
Clemmie Leinicke

Minnie Bunselmeyer

Church quilting party, Cora, Jackson County

My Grandpap told me about a man in his settlement who had the fastest team of buggy-mares in the district. He said that one day as they were coming home from the County Fair there came up an awful rain storm. "It sure came a gully-washer," said the farmer and went on; "My team started for home as fast as they could go and when they reached the barn, the two young shoats I had in the back of the buggy in a crate were drowned, but d'ye know, that team never got wet."

—Jackson county version of a story told widely in Southern Illinois. Grace Partridge Smith, "Egyptian 'Lies,'" *Midwest Folklore*, Vol. 1 (1951)

135

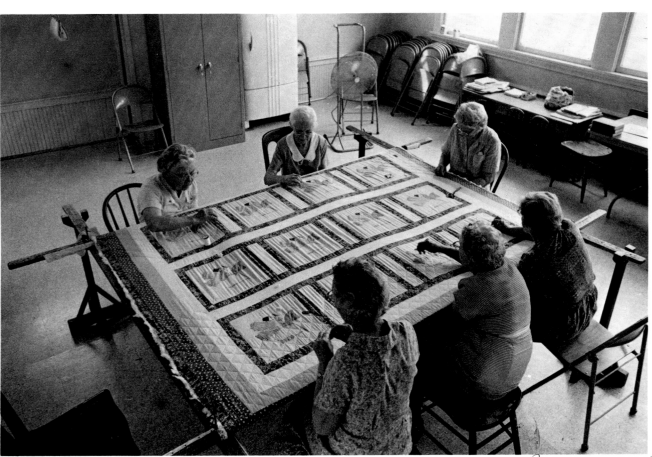

Clockwise: Clara Downen, Lizzie Anghouse, Myrtle Bunselmeyer, Mrs. Jarrett, Clemmie Leinicke, Minnie Bunselmeyer

Hand-made Christmas wreaths

I'll tell you of a bandit,
Out in a Western state,
Who never learned his lesson
Until it was too late.
This man was bold and careless,
The leader of his gang,
But boldness did not save him
When the law said, "You must hang.". . .

On the 19th day of April in 1928
Away out west in Benton
Charles Burger met his fate.
Another life was ended;
Another chapter done;
Another man who gambled
In the game that can't be won.

From "The Death of Charlie Burger" in *Tales and Songs of Southern Illinois* by Charles M. Neely (1938). Although Charlie's name was often spelled "Burger" in the local newspapers, he is said to have preferred "Birger."

136

Weaving a rag rug on a Buncombe farm, Johnson County

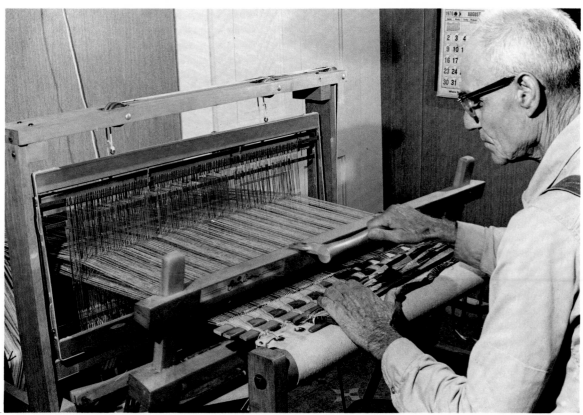

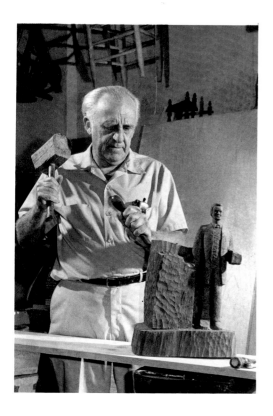

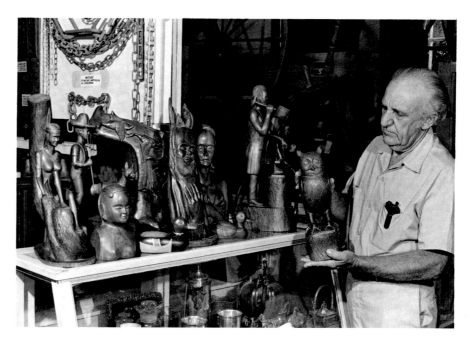

Wood carver in Cobden, Union County

Despite universal signs of change, Southern Illinois retains—and hopefully will continue to retain—the most attractive features of its traditionally rural, small-town atmosphere. One thinks especially of the ice cream socials, church suppers, homecoming celebrations, carnivals, seasonal and crop festivals, corn huskings, barbecues, apple peelings, wurstmarkets, and "burgoos" (big stews), as well as the carnivals and the state and county fairs, that bring families and friends together during the more seasonable times of the year. These are usually advertised in advance in the newspapers, including the widely-read daily *Southern Illinoisan,* and often listed in that useful monthly magazine, *Outdoor Illinois* (published in Southern Illinois at Benton). The newcomer, however, is also urged to make his own local inquiries. While strangers are hospitably welcomed, advertisement of many local affairs is sometimes only by word of mouth. An excellent home-cooked church supper or community pork breakfast may slip by unheeded unless you have neighborhood sources of information.

One of the most interesting introductions to Southern Illinois life is through the work of local artists, artisans, and craftsmen. There are numerous exhibitions of these works at fairs and other community gatherings. In Makanda, Jackson County, near the entrance to Giant City State Park, a permanent arts and crafts center has recently been founded, and plans are underway to organize similar retail outlets in other communities.

Home-made dried apple doll for sale at Makanda Arts and Crafts Center

Violin maker at work, Johnston City, Williamson County

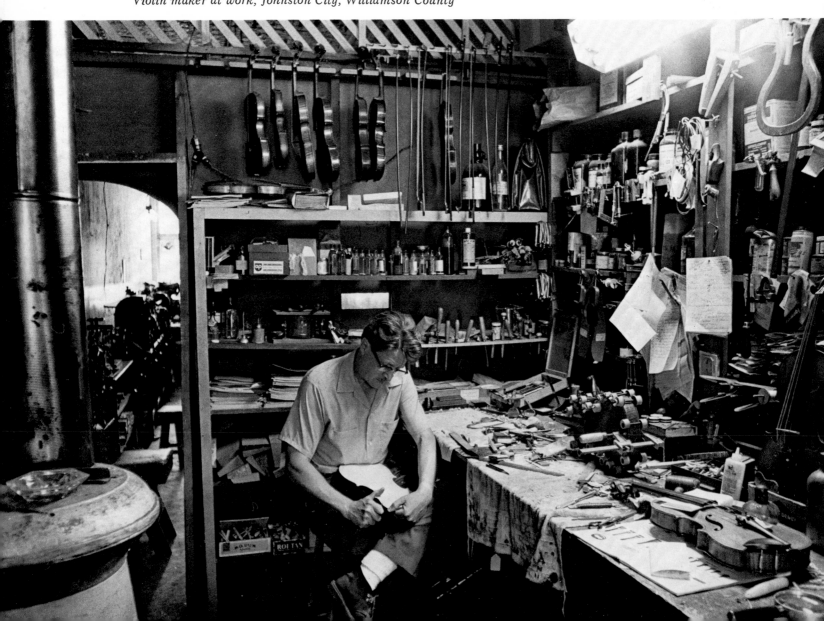

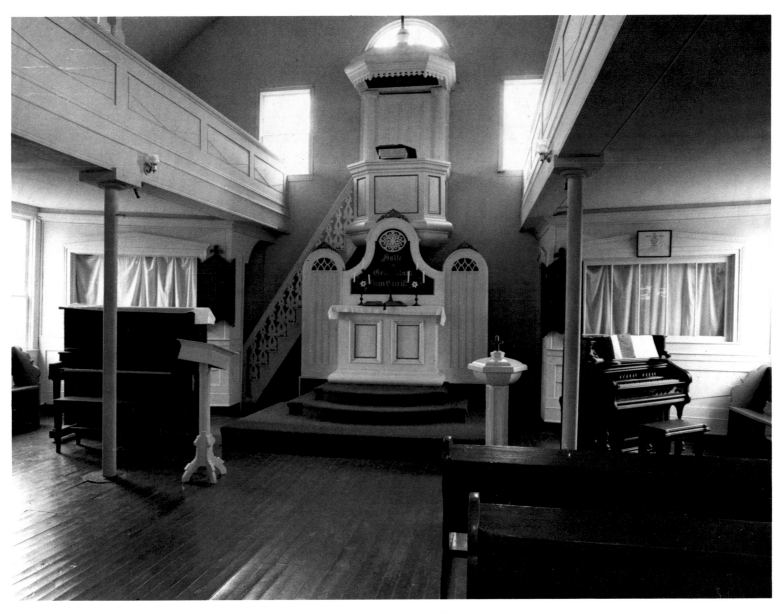

Hand-carved pulpit of Old Kornthal Church, 1860, near Jonesboro, Union County

From the time of the earliest French explorers, churches and organized religion have played important roles in the history of Southern Illinois. The first French settlements on the Mississippi were founded either by Roman Catholic priests or Jesuit missionaries. Over the years these communities have continued to maintain their traditional bonds with the Catholic faith. In 1809, for example, a group of Trappist monks, originally expelled from France because of the Revolution, attempted to establish a monastery near the Indian mounds back of Cahokia (hence the designation of the largest of these as "Monks Mound"). But, after several years, illness and financial problems drove them back to Europe.

In 1818 the oldest English-speaking Catholic parish in Illinois was founded at the O'Hare Settlement near the present town of Ruma, in Monroe County.

In 1833 a Convent of the Visitation was established at Kaskaskia by a group of nuns from Washington, D.C., and in 1836 a school for girls was opened by the convent, only to close in 1844 after flooding by the Mississippi River. Another convent and children's home at Belleville was later the scene of a terrible fire, memorialized in a local ballad.

In 1870 the parish of St. Patrick's at Ruma invited a group of German sisters of the Order of the Adorers of the Most Precious Blood to found a convent and mother house near Ruma. Several years later this group, devoted to training of women as school teachers, took over the nearby empty building of the former College of the Sacred Heart. Since then the convent has flourished and expanded, sending out women to work in schools, hospitals, homes for the aged, and other educational and welfare institutions in the United States and many foreign coun-

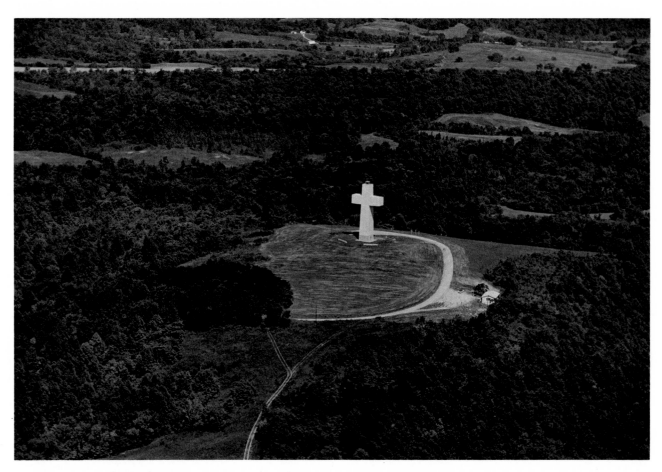

Cross atop Bald Knob, Union County, scene of annual Easter Sunrise Service

140

tries. In 1965 the community was augmented by the arrival of a group of Trappist monks who operate a farm nearby.

While the old French towns along the Mississippi north of Kaskaskia have long been associated with the Catholic faith, the greater number of churches founded by American pioneer settlers have been Protestant, primarily Baptist and Methodist. The earliest backwoodsmen—trappers, squatters, and often fugitives from justice—were notoriously unreligious. But the families who followed in their tracks, intending to settle and farm the country, were a churchgoing people. They set about at once to hold services, first in their homes and later in log-cabin churches, in order to create a more civilized atmosphere in which to raise their children. These early churches were usually served by circuit-riding preachers who were often obliged to ride great distances, sometimes not returning to a particular com-

munity for several months. Of these, the two most notable early Southern Illinois ministers were Peter Cartwright (1785–1872), the Methodist circuit rider and missionary, and John Mason Peck, (1789–1858), his Baptist counterpart.

Cartwright, probably the most famous of all the early western preachers, moved from his Kentucky home to Southern Illinois in protest against slavery. His first circuit covered most of Illinois, from Shawneetown to Galena. It took him three months to make the round trip journey through a wilderness without roads and bridges and with only an occasional ferry. He was as well known for his fighting and wrestling as his eloquent camp meeting sermons. He was also the subject of many legends describing his victories over Mike Fink, the infidel keelboatman, and Abe Lincoln, whom he defeated for a seat in Congress. It has been estimated that Cartwright was responsible for over 10,000 conver-

(continued on page 144)

*Now, I like to hear good short sermons, something good. I
like to hear something that hits you just right where it
would do you the most good. . . . They use too many
modern illustrations of some of the meanings of the Bible. I
think that most of the people in my church would want the
pastor to stick to the Bible. You sort of feel better
when you come back from church. I know I do.*

—Comments of Southern Illinois coalminer reported in *People of Coal
Town*, by Herman Lantz.

"When the outlook isn't good try the uplook." Popular local saying, from Proverbs and Proverbial Phrases of Illinois *by Frances M. Barbour*

Convent of the Sisters of the Most Precious Blood near Ruma, Randolph County

The Illinois [Indians] are much less barbarous than other Savages; Christianity and intercourse with the French have by degrees civilized them. This is to be noticed in our Village, of which nearly all the inhabitants are Christians; it is this also which has brought many Frenchmen to settle here, and very recently we married three of them to Illinois women. These Savages do not lack intelligence; they are naturally inquisitive, and turn a joke in a fairly ingenious manner. Hunting and war form the whole occupation of the men; the rest of the work belongs to the women and the girls,—it is they who prepare the ground which must be sowed, who do the cooking, who pound the corn, who set up the cabins, and who carry them on their shoulders in the journeys.

—Letter from Father Gabriel Marest who visited the Kaskaskia Mission in 1712

Spectators at Mississippi River Music Festival,
Southern Illinois University campus at Edwardsville

Trappist farmer-monks, Randolph County

Kind friends, give attention to what
 I relate,
And ever remember those poor children's
 fate.

In full health and vigor they retired
 for the night,
Not thinking of fire that raged with
 its might.

When the loud cry of "Fire" was heard
 in the air,
Fathers and mothers were seen everywhere.
When the firemen arrived, alas, 'twas
 too late,
For all in the convent had met their
 sad fate.
A girl stood at the window, three
 stories high,
"O, save, me, Dear Mother," in vain did
 she cry.
Just then an explosion, we grieve to
 relate,
And all in the convent had met their
 sad fate.

But like a brave hero she stood to her
 post
When she was sure that the children would
 shortly be lost.
She rushed up the stairway with
 a fearful cry,
Praying to God with her children to die.

We know they have gone to a far better
 shore,
Where the death-dealing fire fiend can reach
 them no more,
Let us hope we shall meet them up there again
Where there is no sorrow, anguish, or pain.

No one to help them, no one to bless,
No one to save them in their sad distress.
It was in Belleville City; sad grief did abound
On the night that the convent was burned
 to the ground.

"The Belleville Convent Fire." From *Tales and Songs
of Southern Illinois* (1938) by Charles M. Neely

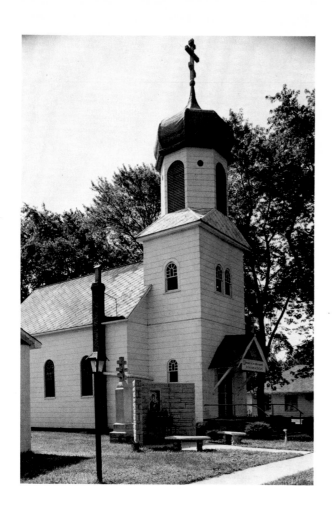

sions and 12,000 baptisms, and that he delivered 500 funeral sermons as well as some 15,600 regular sermons.

John Mason Peck came out from Massachusetts as a Baptist missionary preacher in 1822, settling in Illinois at Rock Spring, in Madison County. Like most New England missionaries, he was more scholarly than the Kentucky-bred Cartwright and more interested in education. In 1827 Peck founded Rock Spring Seminary and High School, which he moved to Alton in 1830, and which shortly thereafter became Shurtleff College. By then the Baptist faith was well established in Southern Illinois, services having been held in the homes of James Lemen and other early settlers well before 1800.

Lemen, a Virginian, settled with his family along the American Bottom in 1786 and founded a now-vanished community several miles south of Waterloo in Randolph County, which he named "New Design." His comfortable home is today a shrine of the Baptist Church. Four of his sons became circuit-riding preachers.

It is said that Lemen was encouraged to come to Illinois by his fellow Virginian, Thomas Jefferson, who urged him to go west to help keep the territory free from slavery. Later, when Lemen's New Design neighbors opposed his anti-slavery stand, he broke with them and helped found an independent church called the "Friends of Humanity," now the Bethel Church, near Collinsville. The present "Old Bethel" Baptist structure, built in 1840, was an important stop on the underground railroad. A trap door in the

144

St. Mary's Russian Orthodox Catholic Church, Royalton, Franklin County, showing treasured icons over altar

Congregational Church erected 1854, Godfrey, Madison County

On a warm summer afternoon, as I was riding from Mt. Carmel, turning a point of wood, I came suddenly on a scene that arrested my attention; and, as a stream of people were going in one direction, I joined them and went on. We were soon in front of the Methodist camp. . . . The preacher ascended the stand, and began his discourse in a voice scarcely audible. As he raised it to a higher pitch, a sort of groan-like response could be heard from a few in the audience, and now and then an emphatic "amen!" As the preacher raised his voice from bass to tenor, so the responses, in groans, amens, and shouts of glory, increased in number and intensity.

—George Flower, *History of the English Settlement in Edwards County, Illinois, Founded in 1817 and 1818,* quoted in *Prairie Albion: An English Settlement in Pioneer Illinois* by Charles Boewe, Southern Illinois University Press (1962)

Old Kornthal Church, 1860, near Jonesboro, Union County

Chapel in the Woods, a popular spot for student weddings, Southern Illinois University's Little Grassy Campus, Jackson County

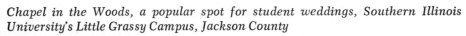

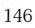

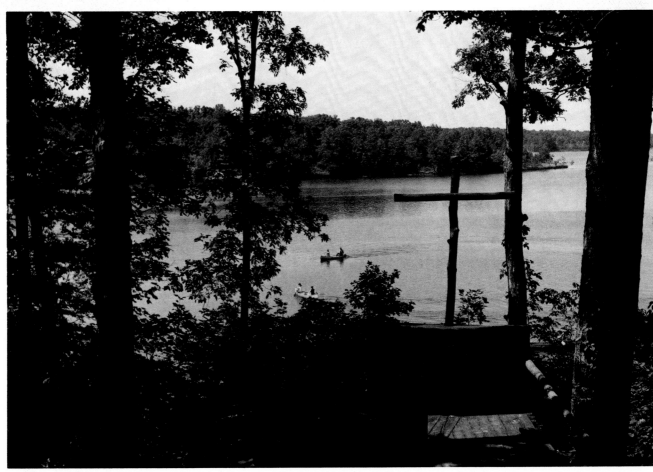

Evening service, Shrine of Our Lady of the Snows, Belleville, St. Clair County

chancel floor leads to a "slave hole" where escaping blacks could be hidden until safe arrangements had been made to help them on their way toward Canada and freedom.

The migration of American settlers into Southern Illinois coincided with the spread of "revivalism" throughout the United States, beginning around 1815. This simple, direct, and highly emotional form of worship was an understandable reaction against the cold rationalism of eighteenth-century theology, and was especially fervent on the frontier, where weekly church services provided a welcome emotional release from the grinding labor of everyday work.

The next important Protestant denomination to become established after the Baptists and Methodists was the German Lutheran, which arrived with a large influx of German farmers during the 1840s and 50s. Of these, old Kornthal Church—the Evangelical Lutheran Church of St. Paul's—is perhaps the most charming and picturesque. It was built by a group of Austrians who settled the "Korn Thal"—Corn Valley—several miles south of Jonesboro in 1852. Designed as a typical Austrian "Betsaal,"

complete with an elaborate hand-carved wooden canopy pulpit, the edifice was completed in 1860. Until 1923 all services here—as in many other Southern Illinois Lutheran churches—were conducted in German.

By the 1850s a number of New England Congregationalists had filtered into Southern Illinois. Of their many New England colonial style churches, one of the earliest and most striking is the Congregational edifice at Godfrey, in Madison County, dating from 1854.

Railroad building in the 1850s brought in many Irish laborers who later settled in the various railroad towns and helped to found Catholic churches. Indeed, a group of Irish settlers from Tennessee was holding Catholic services at Shawneetown on the eastern side of the state as early as 1818. The upsurge in coal mining around 1900 accounted for the arrival of many eastern European miners of the Greek and Russian Orthodox faiths. The Russian Church dedicated to the Virgin Mary in Royalton, Williamson County, with its characteristic onion-like dome, is especially interesting because of its collection of colorful religious ikon paintings.

147

Rock Hill Baptist Church, Carbon-dale, Jackson County

Children's choir and Sunday morning service,
Rock Hill Baptist Church

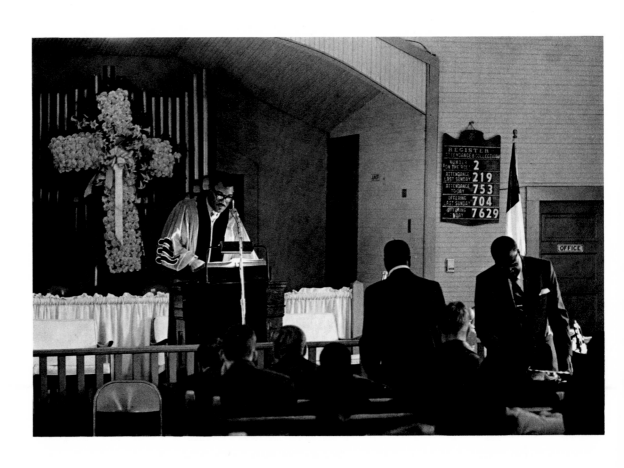

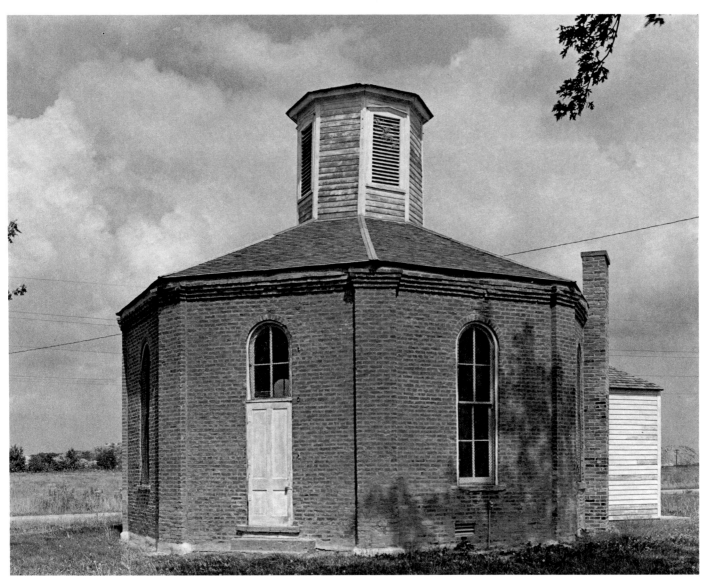

Unusual eight-sided Charter Oak School near Sparta, Randolph County, erected in 1873 and now being restored by county historical society

It was early one beautiful morning that I found myself approaching the village of Lebanon, though many miles distant in the adjacent plain; appropriately named for its loveliness the "Looking-glass Prairie."... Located in its immediate vicinity is a flourishing seminary, called M'Kendree College, ... with about fifty pupils in the preparatory department.... As is usually the case with these little out-of-the-world villages, when any object comes up in the midst around which the feelings and interests of all may cluster, upon this institution is centred the heart and soul of every man, to say not a word of all the women and children, in Lebanon; and everything not connected, either remotely or immediately, with its welfare, is deemed of very little, if of any importance.

—From *The Far West* (1838) by Edmund Flagg

One of numerous abandoned one-room school houses in Southern Illinois

Formal education came slowly to Southern Illinois. Most of the early Appalachian hill people did not take book learning very seriously—it was not a readily marketable skill. This was true not only for the southern part of Illinois, but for the rest of the state as well. Public education was not recognized as a state responsibility until the 1850s. Until then, schools were often hit-or-miss affairs. A younger scholar or minister in need of money might hold classes in a parlor, a church, or perhaps a log house provided by the community.

The establishment of private academies served to stimulate the demand for further advanced studies, and led in time to the creation of colleges. Around 1830, when John Mason Peck was founding Shurtleff College as a Baptist school, the Methodists were establishing Lebanon Seminary in the town of Lebanon, St. Clair County; this was later strengthened and expanded and named McKendree College in honor of the presiding bishop. Shurtleff is considered to be the first college to have been founded in Illinois; it has since closed, and its facilities are now occupied by Southern Illinois University as its East Alton Campus. McKendree is not only the oldest college in continuous operation in Illinois, but the oldest Methodist institution of higher education in the Midwest—indeed, it is said, in the nation. About

this same time the Presbyterians were establishing Illinois College at Jacksonville, farther north. All three schools were formally chartered by the state legislature in 1835.

Generally speaking, the impetus for higher education came from New Englanders. John Mason Peck's efforts to establish Rock Spring Seminary near Alton in 1828 (out of which Shurtleff College evolved) were vigorously opposed by many local clergy, who were understandably fearful lest their own more limited educational qualifications result in their losing power and influence. Indeed, the Illinois legislature never did issue a charter to Rock Spring Seminary because of continued political opposition from the clergy.

In 1869 the first state-supported institution of higher education in Southern Illinois was established, with the chartering of Southern Illinois Normal University at Carbondale. Although its purpose was primarily that of teacher training, it attracted from the beginning a faculty of considerable distinction, especially in natural history. Mention has already been made of Cyrus Thomas, "Southern's" first professor of natural history, who, like Robert Ridgway and Lucien Turner, two other native Southern Illinois scientists, went on to a distinguished career at the Smithsonian Institution in Washington.

(continued on page 156)

153

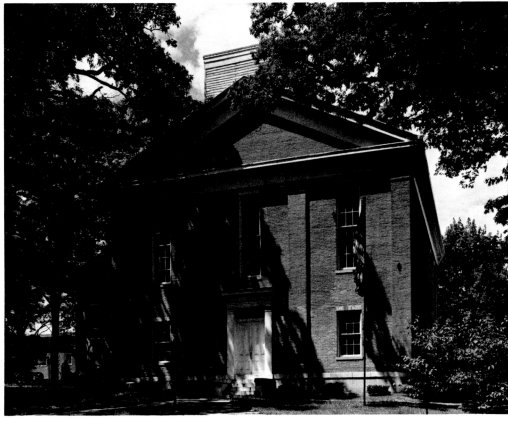

Chapel of McKendree College, 1856, Lebanon, St. Clair County

Your grandfathers were huge with dreams,
Crossed an ocean and half a continent,
 breathing hope;
When corn failed further North
 after a drought,
Migrated down to this hot and fertile land
And named it Little Egypt, Bible in hand,
Brought with them a tradition of fierce work,
Saw cities rise in the wilderness,
 Thebes and Cairo,
Governed themselves, invented States
 and rules,
Imagined the marvelous rich life sure
 to grow
When the ground was cleared, the hard work
 done,
And on summer evenings, sitting Bible in
 hand,
Dreamed of a great teacher or poet grandson.

From "Poet-in-Residence—Carbondale: The Students,"
by May Sarton, *The Lion and the Rose: Poems* (1948)

154

Campus of Southern Illinois University at Carbondale, with Campus Lake in foreground and western shore of 9,000-acre Crab Orchard Lake in distance

President-emeritus Delyte W. Morris and the Morris Library, Southern Illinois University at Carbondale

Thomas was followed at Southern by George Hazen French, a nationally-known biologist and taxonomist, in whose honor a rare Southern Illinois wildflower was named "French's Shooting Star."

In 1947 "the Normal" at Carbondale was made Southern Illinois University; the following year its new president, Delyte W. Morris, embarked on the program of development that resulted in the creation of three additional Southern Illinois "campuses" at East Alton, East St. Louis, and Edwardsville, and an expanded enrollment of some 35,000 students. Among the University's achievements have been the creation of a number of new teaching and research departments devoted particularly to the study of problems directly related to Southern Illinois. These include the Center for Black American Studies, the Center for the Study of Crime, Delinquency, and Corrections, and Institutes for Community Development, Rehabilitation, Transportation, and Labor. The natural resources of the region have been

the particular interest of the School of Agriculture, and the Departments of Forestry, Conservation, Recreation, and Outdoor Education, the Outdoor Laboratories, and graduate programs in Wildlife and Fisheries Management. Inevitably, these concerns have also been reflected in the programs of the more traditional departments, including life sciences, the School of Business, the College of Education, and a wide spectrum of other disciplines.

Closely associated with the development of the University has been the establishment and expansion of a number of state and federal health and welfare institutions and agencies which have had a fruitful reciprocal relation with Southern Illinois University, especially in cooperative research, staffing, and training. In the field of crime and corrections, for example, the Menard State Penitentiary at Chester, the new federal maximum-security prison at Marion, and the new state minimum-security prison at Vienna are closely associated with the

(*continued on page 160*)

The spontaneous unfettered and informal contact of Southern Illinois University students with the best-informed men in almost every line of human intellect's inquiry, as well as in all the self-disciplines for the objective use of the knowledge, opens the way for swift realization of the effective and continuing self-education of the students. Upon that regenerative capability the fate of humanity is dependent.

—"Southern Illinois University," an address (1969) by R. Buckminster Fuller, architect, engineer, and inventor

Bust of Irish novelist James Joyce, whose books and papers are in the Rare Books and Special Collections Room in Morris Library

The Mall, Southern Illinois University at Carbondale

Classroom Building, Southern Illinois University at Edwardsville

158

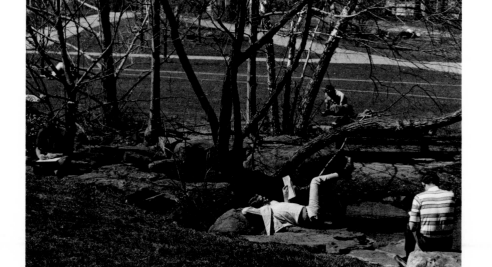

*Finding from experience that my education was not good
enough to fill the Common School Law, I entered Shurtleff
College, a Baptist institution at Upper Alton. As I was
financially short, I had to economize, so with three other
young men, we rented a house and boarded ourselves. Our
household and kitchen furniture consisted of two straw
beds, two cheap comforts, coffee pot, frying pan, and four
tin cups. . . . We baked our bread on a board set before
the fire. Mrs. Willis, who lived on the same lot, used to get
me to milk her cow and gave us new milk for our coffee and
sometimes gave us milk to drink. In July, 1843 I graduated
from Shurtleff College. My entire expense including house
rent, tuition and books was $15.00. The rent of the house
for all of us was 75¢ per month.*

—The high cost of a college education in 1843! From the unpublished
"Reminiscences" of W. S. Palmer, Morris Library, Southern Illinois University

Interior, Student Union Building, Southern Illinois University at Edwardsville

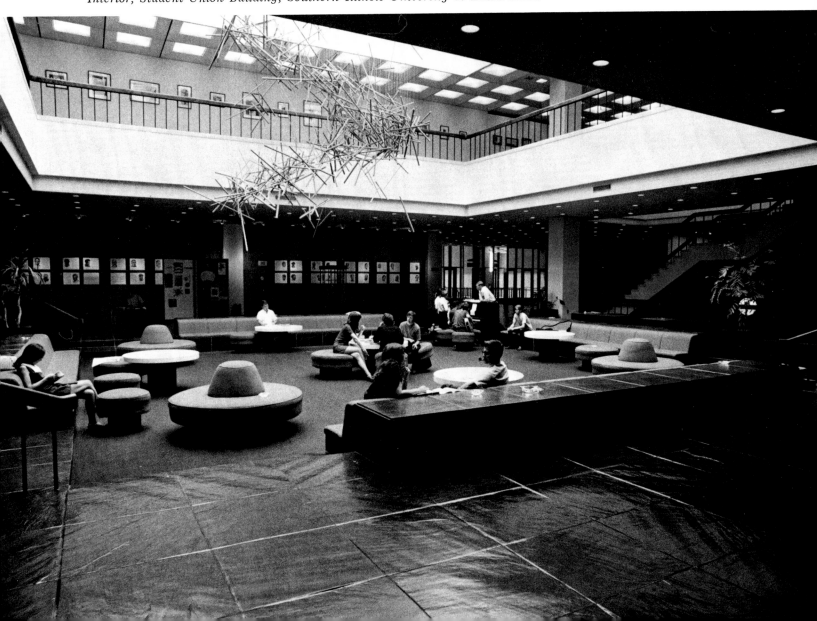

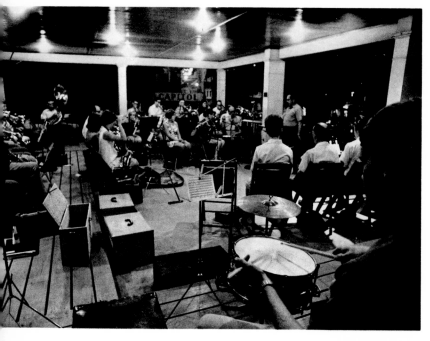

Center for Crime, Delinquency, and Corrections, the Rehabilitation Institute, and other relevant programs at the University. In a similar manner, the University's programs in psychology, sociology, social work, and counseling have cooperative relations with such welfare institutions as the state mental hospital at Anna, the U.S. Veterans Administration Hospital at Marion, and the Bowen Center for mentally handicapped children at Harrisburg. This policy of establishing cooperation between the University staff and the specialized welfare institutions in Southern Illinois has increased the intellectual and professional, as well as the cultural, resources of the region in a great many ways. Two recent developments at the university that will further contribute to this have been the initiation of new programs in medicine, law, and dentistry, as well as the development of centers for the study of human and natural resources.

Summer evening concert in the covered band shed, Waterloo, Randolph County

Professor Katherine Dunham, well-known dancer and anthropologist, rehearsing students at the East St. Louis Campus of Southern Illinois University at Edwardsville

160

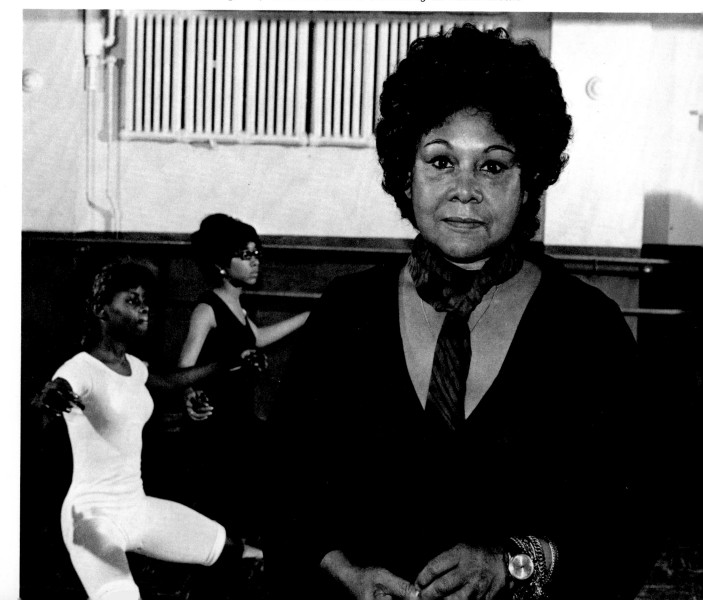

Park-like grounds of Anna State Hospital, Union County

U.S. Veterans Hospital, Marion, Williamson County

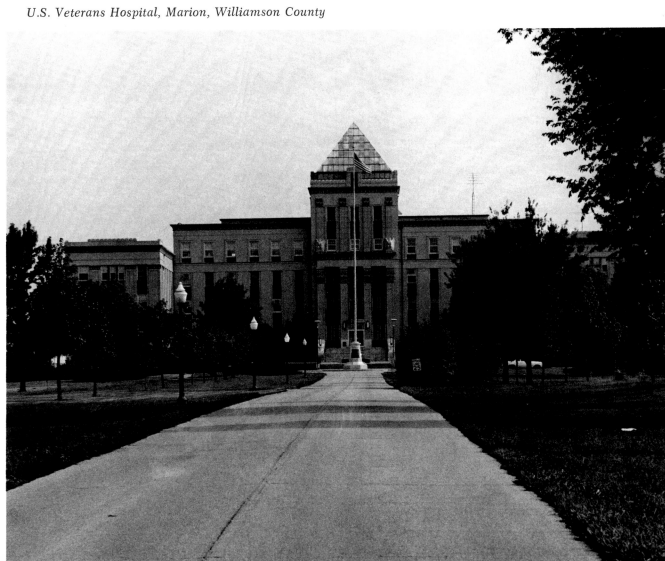

Up-to-date Cancer Treatment Laboratory, Herrin Hospital, Williamson County

A busy general practitioner in his office in Mounds, Pulaski County

The story of twentieth-century Cairo—in many ways the most charming and romantic of the Southern Illinois river towns—is so intertwined with the history of its Negro population that it seems appropriate here to say something about the condition of the blacks generally in Southern Illinois. Negro slaves from the West Indies were introduced into the region by French colonists early in the eighteenth century. Both slaves and the occasional free Negro were governed by a harsh and cruel French legal code which was later adopted by the British rulers, and by the Americans who succeeded them. Indeed, the state of Illinois did not repeal this code and formally declare slavery illegal in Illinois until 1847. Even then, Negroes enjoyed few rights of any kind.

Because of the deep-seated Anglo-Saxon–Teutonic suspicion of nonwhites (black, red, or yellow) so characteristic of the American frontier, there were comparatively few blacks in Southern Illinois before the Civil War (736 "slaves" according to the census of 1830). But after the war, as we have seen in the case of Cairo, the situation changed. Because of the general unfriendliness of most Illinois towns, the blacks who had been encouraged to leave their southern bondage and come to Illinois during the war, and who now remained, were unwelcome in most Illinois towns, and tended to congregate in slum communities along the Ohio River. Many Southern Illinois towns solved the problem simply by refusing to

New Federal High Security Prison near Marion, Williamson County

allow blacks within the town boundaries between sunset and sunup.

Toward the end of the century, with the development of coal mining, a second black migration into Southern Illinois occurred, encouraged by the mine owners. As white miners began to organize and to demand better working conditions and higher pay, trainloads of poverty-stricken, innocent blacks were brought in as "scabs" from the South to break the strikes. Predictably, violence broke out, and many blacks were needlessly murdered. Those who survived faced the augmented hatred of whites who saw them as threats to their economic security. But gradually, many black miners proved themselves, and were grudgingly accepted by the white mining community; and black ghettoes began to appear along the railroad tracks in such mining and railway towns as DuQuoin, Carbondale, and Centralia. Many black communities, in order to survive, were forced to cater to the furtive vices of the essentially Puritanical white communities, becoming centers of gambling, bootlegging, and prostitution.

In this, Southern Illinois is not different from the rest of the United States. Perhaps the most interesting comment to be made is the way the Negroes's common sense and shrewd instinct for survival, together with the typical Southern Illinoisan's basically warm-hearted frontier humanity, created a kind of mutual coexistence pact. Ruby Berkely Goodwin's readable account of growing up in DuQuoin during the early years of the present century, *It's Good to Be Black*, is a warm and humorous memoir of that comparatively simple and relaxed era.

A third influx of blacks into Southern Illinois occurred during World War I as part of that much larger emigration of Southern blacks into Illinois that carried most to Chicago to work in the new war industries. Those who stayed in Southern Illinois headed for the new ammunition factories and other war plants springing up around East St. Louis. One consequence of this instant migration was the terrible black riots in East St. Louis in 1917. Another was the subsidence of the East St. Louis black com-

163

A. L. Bowen Children's Center, Harrisburg, Saline County

munity, after the closing of the war plants, into a poverty-stricken slum culture, victimized by crime, graft, and political corruption.

Of late the situation of the blacks in Southern Illinois has been rendered more acute by two developments. One has been the intensification of poverty in many white communities, brought on by the decline in the relative value of farm income, the displacement of miners, and other similar factors of adjustment. The second, of course, has been the growing aggressiveness of blacks themselves, nationally as well as locally. It is not surprising that the resulting discontent periodically erupts in a town like Cairo that is not only 33 percent black, but that also has a higher proportion of low-income white families than any other Illinois city.

Enlightened welfare and educational programs— for whites as well as for blacks—appear to be the only solution, providing of course that the responsibility for such programs can be shared with responsible, informed leaders from the communities themselves. Fortunately, more and more of these leaders are emerging, from churches, professions, and schools. Here Southern Illinois University has played an increasingly effective role through its Black American Studies program, its Institutes of Community Development and Rehabilitation, and other service agencies and programs. Hopefully, more and younger, educated blacks and whites will stay on in Southern Illinois after their training to help with the region's economic and social development. Although there is greater recognition than ever before of the gravity of these problems, there is also growing awareness of the fact that the condition of the average native Southern Illinoisan, white or black, is continually improving. To an eighteenth-century English idealist like the poet William Blake, the Ohio River, separating slaving from free soil became an international symbol of liberty. Southern Illinoisans can repeat more confidently today than ever before Blake's memorable lines:

The Ohio shall wash my stains from me;
I was born a slave, but I go to be free.

164

Cave-in-Rock overlooking the Ohio River, Hardin County

[*As we rowed*] *along the shore with the skiff . . . one of the
finest grottos or caverns I have ever seen, opened suddenly to
view, resembling the choir of a large church. . . . It is crowned
by large cedars and black and white oaks, some of which impend
over, and several beautiful shrubs and flowers, particularly very
rich columbines, are thickly scattered all around the entrance.*

—An early visit to Cave-in-Rock, Hardin County. From *Sketches of a Tour to
the Western Country* (1810) by Fortescue Cuming

Well, the days went along, and the river went down between its banks again; and about the first thing we done was to bait one of the big hooks with a skinned rabbit and set it and catch a catfish that was as big as a man, being six foot two inches long, and weighed over two hundred pounds. We couldn't handle him, of course; he would 'a' flung us into Illinois. We just set there and watched him rip and tear around til he drownded. We found a brass button in his stomach and a round ball, and lots of rubbage. We split the ball open with the hatchet, and there was a spool in it.

—Huck and Jim catch a Mississippi River catfish off the Southern Illinois shore. From Mark Twain's *Adventures of Huckleberry Finn* (1884)

Campers on a Mississippi River sandbar

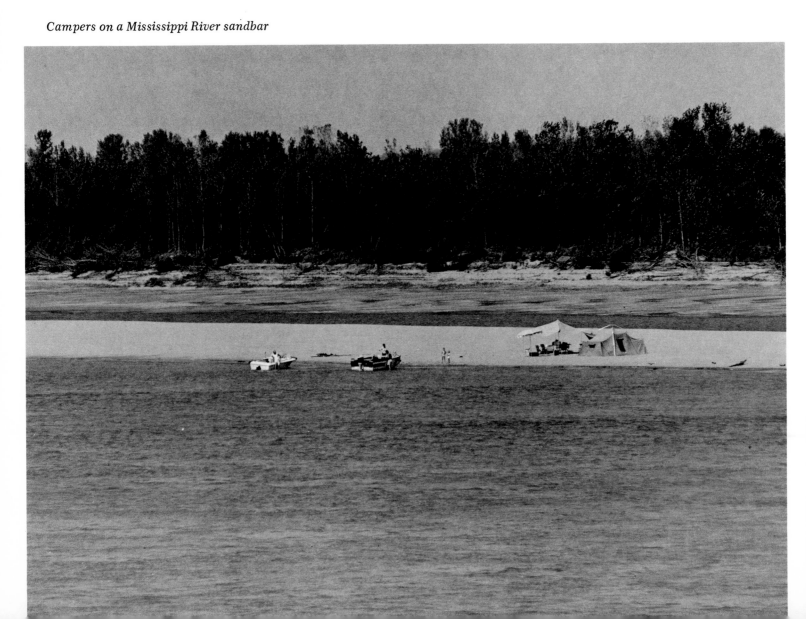

Scientist of the Fisheries Research Laboratory, Southern Illinois University at Carbondale

Outdoor recreational opportunities in Southern Illinois are not only extensive but vary greatly with the seasons. They range from challenges for the "loner" or solitary sportsman to organized activities for small and large groups. For the hiker the chief point to keep in mind in planning a new venture is that the more publicized a wilderness area becomes, the more it loses its native charm and isolation. Dozens of remote valleys and ridges are waiting to be explored, but it is up to the individual to make inquiries and find those special places that have not yet been exploited by the public. A map, or a list of state parks and recreational sites, is a first step. Park rangers, tourist centers, and other qualified persons and agencies can give you suggestions and help answer your questions.

One of the most recent developments has been the creation of a number of large man-made lakes for boating, swimming, fishing, and other outdoor activities. Crab Orchard Lake, with its 125-mile shoreline, Horseshoe Lake in Alexander County, Lake of Egypt in Wiliamson County, Pounds Hollow Lake, Carlyle Lake, Lake Glendale, and the just-completed Rend Lake in Franklin and Jefferson counties are the largest Southern Illinois lakes. Rend Lake, with a projected surface of 19,000 acres, will be almost three times as large as Crab Orchard. In addition,

there are several smaller wilderness lakes restricted primarily to fishing and canoeing—Devil's Kitchen, Little Grassy, Lake Murphysboro, and Kinkaid Lake (now under construction). The largest lakes enjoy a number of organized activities, including fishing competitions and class sailing races; they also have marinas with covered docking facilities for larger powercraft. These and many more regular outdoor recreational competitions and sporting events are regularly described in *Outdoor Illinois*.

The reader who desires more detailed information will also want to consult the numerous helpful regional and county maps prepared by *Outdoor Illinois* magazine for the Southern Illinois Tourism Council in Carterville, and other related information obtainable from such agencies as the Division of Tourism in the state Department of Business and Economic Development and the Division of Parks and Memorials in the state Department of Conservation. He may also want to get on the mailing list of the Illinois Geological Survey in Urbana, a state research agency which regularly offers excellent conducted tours during the year to noteworthy geological and natural history sites in Southern Illinois. These are especially popular with young people and families.

For the naturalist there are the 43,000 acres of the Crab Orchard National Wildlife Refuge, where

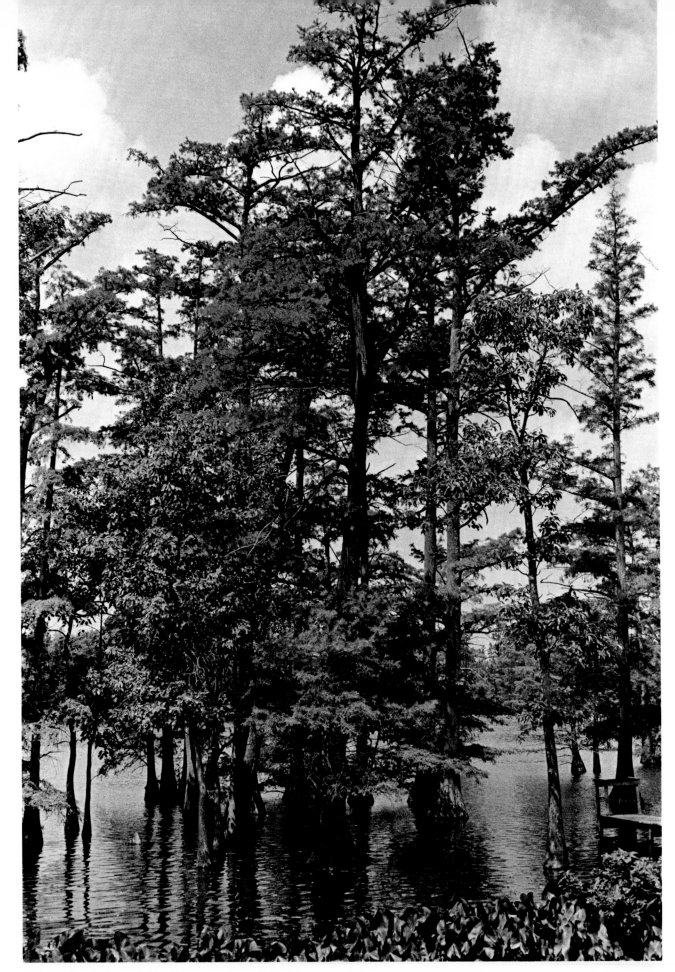

Cypress trees at Horseshoe Lake, Alexander County, winter home of thousands of Canadian Geese

several hundred species of birds nest during the year, including such relatively rare birds as the yellow heron, prairie chicken, prothonotary warbler, the wild turkey, and—during the coldest months—thousands of Canada geese and wild ducks that summer in the North. Additional wildlife refuges and nature preserves can be visited in other parts of Southern Illinois. The Crab Orchard refuge has also become a headquarters for field trials of various kinds. Here, for example, in recent years the Crab Orchard Field Trial Club, in association with the U.S. Fish and Wildlife Service, has hosted the annual autumn quail "futurity" for pointers and setters, which attracts professional trainers from all over the country.

It is impossible to list all the various recreational opportunities to be found during the year in the thirty-four Southern Illinois counties. One way to suggest this diversity is to describe the opportunities to be found in just one county—Pope County, for example, in the southeast along the Ohio River. For the camper and hiker there are good climbs and spectacular vistas in Pope County, from Williams Hill (the highest point in the state), War Bluff, Wallace Bluff, Sand Hill, and Millstone Knob (which also has some curious Indian petroglyphs). The birdwatcher and wildflower fancier will find much to interest him at Burden Falls—reputed to be the most beautiful waterfall in the state—Moyer Falls, and the deep gorges and rocky creek beds of Lusk Creek, Martha's Woods, Indian Kitchen, Cave Hollow,

(continued on page 172)

Cool glade in Bell Smith Springs State Park, Pope County

169

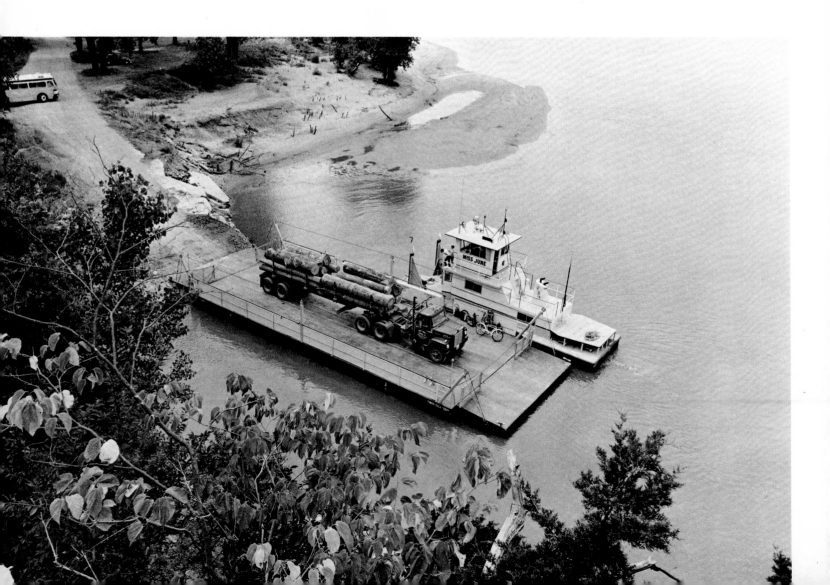

Outdoor dining is popular summer entertainment in Southern Illinois. Views of Homecoming Day barbecue at Jacob in Jackson County and an ice-cream-and-cake social, Round Knob Lutheran Church, Massac County

Recipe for West Salem Homecoming Chowder

675 lbs. Beef
30 Squirrels
80 Fat Chickens
20 lbs. Bacon
20 lbs. Butter
115 gals. Dried Potatoes
95 gals. Tomatoes
150 gals. Shredded Cabbage
50 gals. Green Broken Beans
50 lbs. Fried Lima Beans
10 lbs. Fresh Lima Beans
50 gals. Cut Corn
50 gals. Diced Carrots
80 gals. Diced Onions
40 gals. Cut Celery
20 gals. Cut Mango Peppers
Salt to taste. Put in 40 large iron kettles and simmer from 6 A.M. until 11 A.M., adding water as needed. Makes 1000 gallons to serve 4000 homecomers

—From *Memorial Brochure, Edwards County Sesquicentennial* (1814–1964)

Clarida Hollow, Mansfield Hole, and other more re-mote "holes and hollers." The speleologist will want to examine Owl's Den Cave, in Hayes Creek Canyon, and Sand Cave. The geologist will seek out the great natural bridge in the Bell Smith Springs Recreation Area, the largest natural stone bridge in the Midwest, and the old lead mines where unusual fossils can still sometimes be found. The student of Indian lore will want to visit the twenty-odd surviving Kincaid mounds, the Millstone Knob petroglyphs, and the old Indian trails at Thacker's Gap and at One Horse Gap, where the latter crosses Benham Ridge.

For the fishing and hunting enthusiast Pope County offers Lake Glendale as well as leisurely stretches along the Ohio River. A new lake and state park are also being planned for Robinett Creek near Temple Hill. For the hunter there are many fields, lakes, and forests, as well as the state-owned hunting

The Southern Illinois "Deadeye" Slingshot is manufactured at Valier, Franklin County

Teeing off at one of many Southern Illinois golf clubs

and conservation park on the borders between Pope and Massac counties. For the camper there are modern facilities at Bell Smith Springs, Oak Point Campground at Lake Glendale, Dixon Springs State Park, and the Steamboat View Campgrounds along the Ohio. Multiply these opportunities roughly by thirty-three other counties, and you have some idea of the many choices open to the visitor who has done his homework beforehand.

Hunting deserves a special volume all by itself. Wildcats, coyotes, and bears, once so common, are sighted only occasionally these days. But fox, deer, coon, rabbit, squirrel, quail, duck, and geese—all in season of course—are abundant. And many a farmer will be glad to have you help get rid of his ground-hogs. For the horseman there are formal meetings like those of the pink-coated Southern Illinois Open Hunt, the Wolf Creek Hounds, and numerous clubs which sponsor Western-type horse shows and trail rides. And there are many miles of trails in state parks and the Shawnee National Forest, including a river-to-river trail from the Ohio River in Gallatin County to the Mississippi River at Grand Tower.

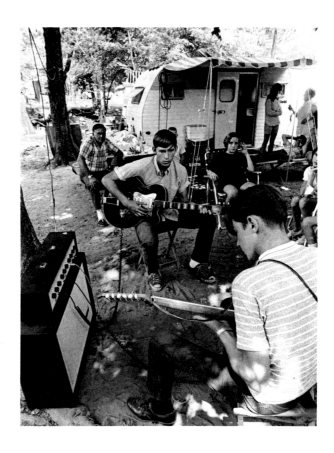

173

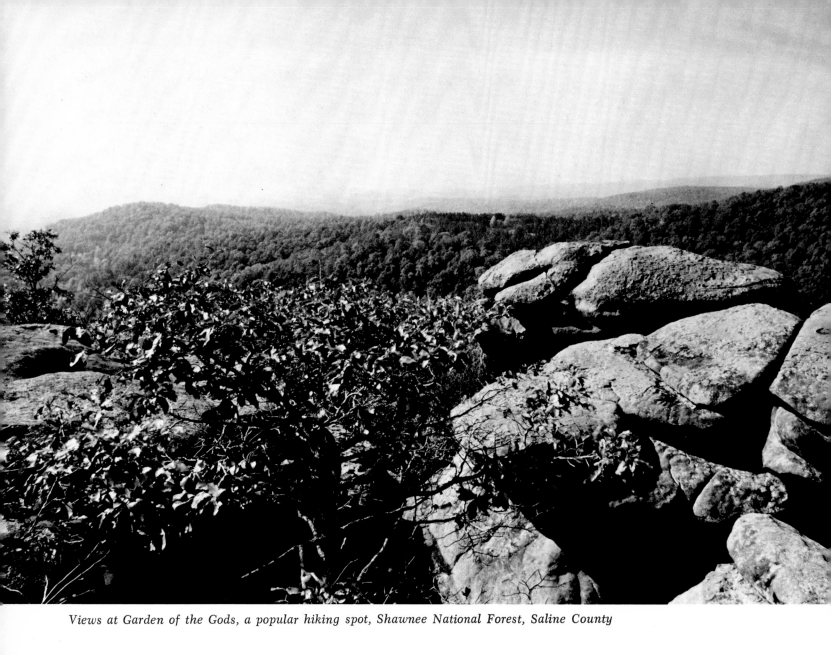

Views at Garden of the Gods, a popular hiking spot, Shawnee National Forest, Saline County

174

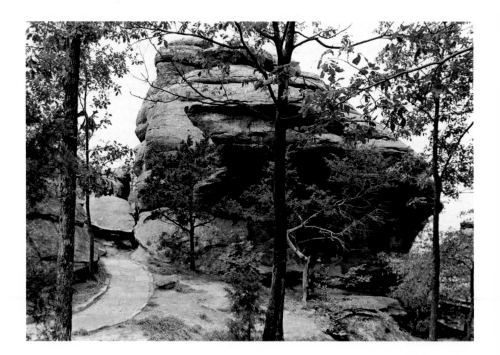

Hound and hunting-dog fanciers will want to investigate the various shows and field trials. The fisherman has his choice of either lake or river fishing. Spelunkers will find that most of the more interesting caves in the state are in Southern Illinois, with one of the largest in Monroe County near Burksville. They will not want to explore them alone, however, but in the company of an "expert."

Planning and developing the recreational and other natural resources of a region requires trained, skilled personnel. The thousands of acres adjacent to Southern Illinois University in the Shawnee National Forest and the Crab Orchard National Wildlife Refuge, together with the nearby lakes and state nature preserves, makes ideal laboratory sites for the training of such needed specialists. As a result, Southern Illinois University has developed extensive programs in Conservation, Wildlife and Fisheries Management, Forestry, and Outdoor Education and Recreation, and maintains a 6500-acre outdoor education laboratory at Little Grassy Lake, which offer many opportunities for the training of teachers and students in the enjoyment as well as the conservation of natural resources.

The University's staff are also cooperating actively with coal mining companies and state conservation agencies in the reclamation of worn-out mines. By means of well-planned programs of reforestation and landscaping, many formerly unsightly wastelands have been transformed into attractive public lakes and wildlife refuges. Indeed, new parks and lakes are being created so fast these days that the enterprising sportsman must make it his own responsibility to keep informed about them!

Fishing at Crab Orchard Lake spillway

Summer campers swimming, fishing, and canoeing at Little Grassy Lake, Jackson County

177

One evening I saw that the river was rising at a great rate, although it was still within its banks. I knew that the white perch were running, that is, ascending the river from the sea, and anxious to have a tasting of that fine fish, I baited a line with a crayfish, and fastened it to the bough of a tree. . . . Presently I felt a strong pull, the line slipped through my fingers, and next instant a large catfish leaped out of the water. I played it for a while until it became exhausted, when I drew it ashore. . . . On cutting it open, we, to our surprise, found in its stomach a fine white perch, dead, but not in the least injured.

—John James Audubon fishes in the Ohio off the Southern Illinois shore in 1810. From Audubon's *Journals*

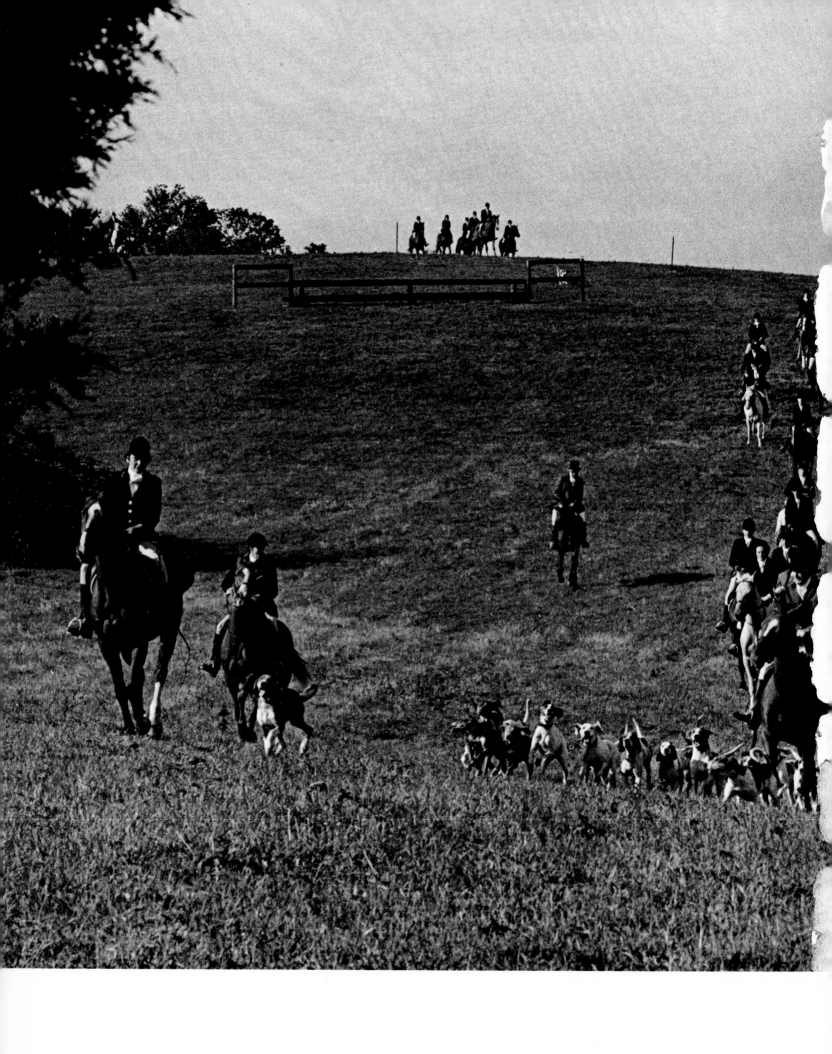

I wish I were a boy again;
 Such friends I'll ne'er see more;
How happy at the old home then
 In those blest days of yore;
All day we'd work about the farm,
 At night we'd hunt the coon,
And wind the horn, with its alarm
 Our dogs would echoes tune.

'Twas music when the hounds would run,
 The red fox bounding on,
With joyous shouts and full of fun,
 We'd follow one by one.
Now, far away the sounds came back;
 How eager then we'd chase,
Along the mountain side we'd track
 Down to the mountain's base.

See, what splendor in the light,
 Out in the valley wide;
The clear rays of the moon, how bright,
 The dogs, how smooth they glide.
Ringing, echoing melody,
 Along the plain they go,
Our pulses beating merrily
 With joyous, healthful glow.

We're near the little running stream,
 That mellow ring we hear—
Bubbling, gurgling, now a gleam
 Of silvery light to cheer.
We'd quaff its pure, sweet water bright;
 'Twas nectar to us boys:
How happy then; our hearts were light,
 And innocent our joys.

"A Fox Chase in Southern Illinois." From *Poems of Egypt and Other Poems* (1916) by James Thomas of Makanda

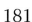
181

Autumn meeting of the Southern Illinois Open Hunt

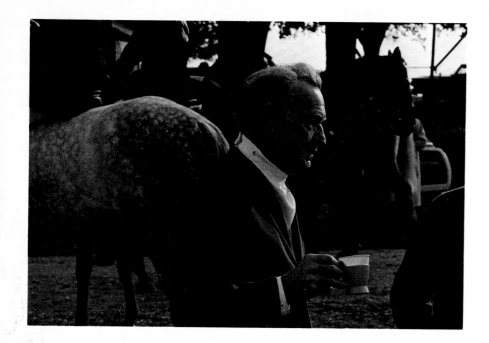

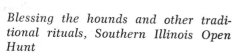

Blessing the hounds and other traditional rituals, Southern Illinois Open Hunt

182

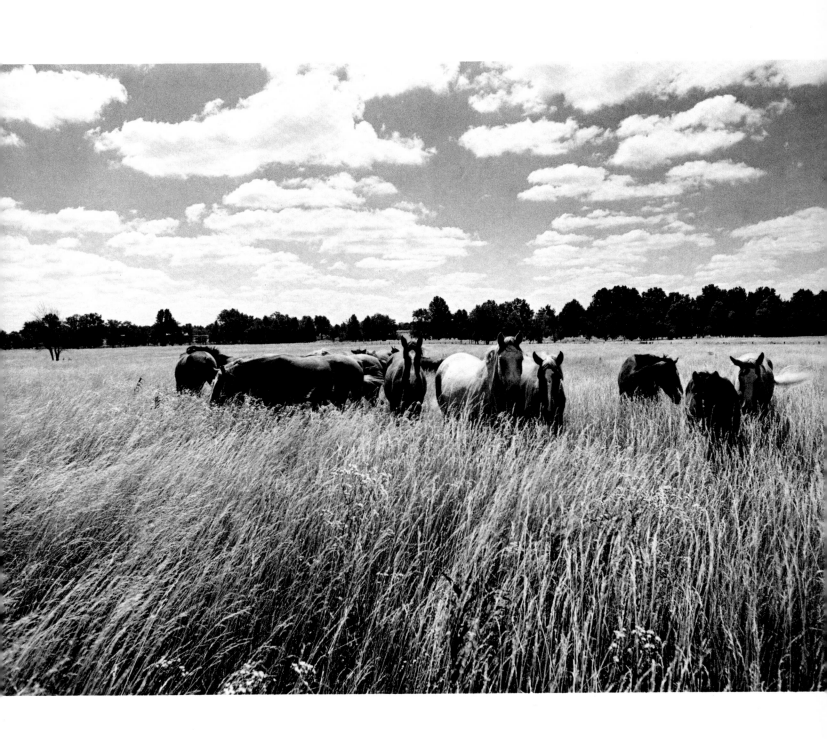

Not all local hunters dress up for the chase!

Members of the Jackson County Anti-Horse-and-Mule-Thief Association practice for their annual Turkey Shoot

Two views of the annual coon-dog water races, near Colp, Williamson County

Canadian Geese, Crab Orchard National Game Refuge

186

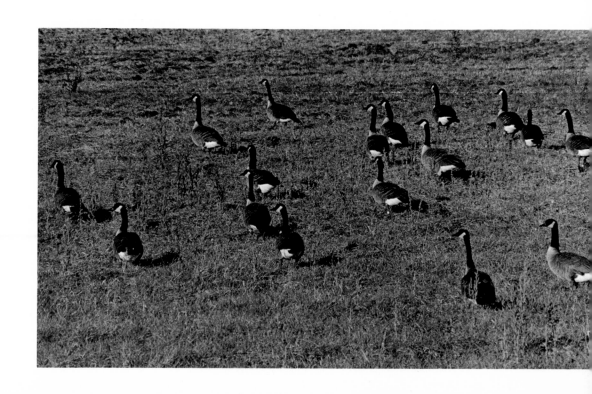

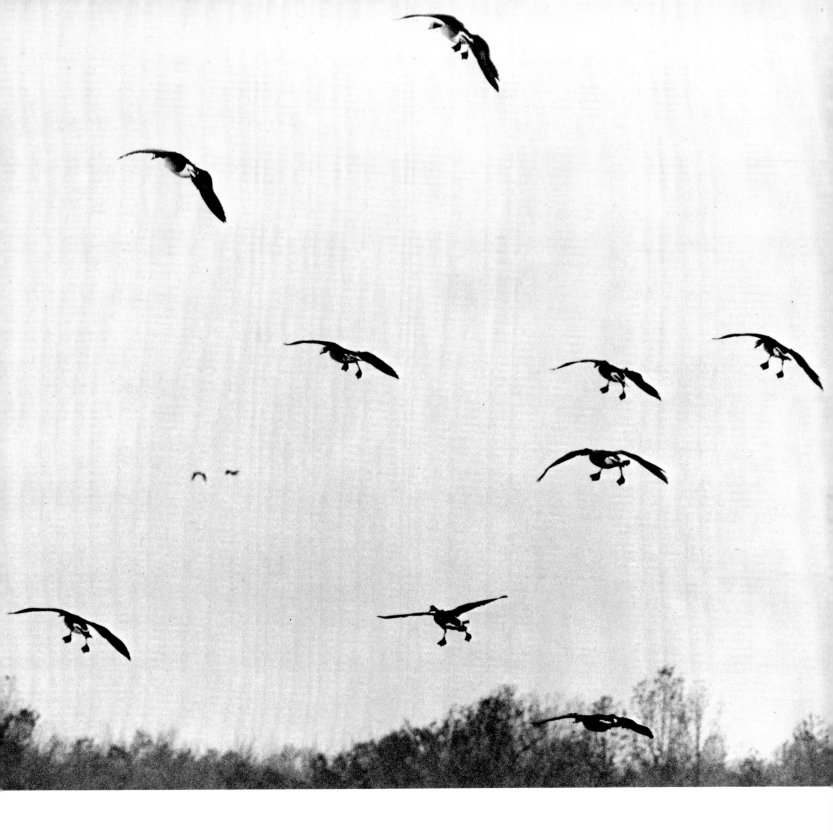

Out of the mists of March, out of the blackness
somewhere above the silent waters of the
Mississippi, voices of wild geese come strongly
and excitingly in the night. The cold mud of
the shores, the smell of waters not long re-
leased from the big thaw, the scent of willow
bark and the tight, small, ruddy flowers of
the silver maples, all mingle in this foggy
darkness.

—From *River World: The Wildlife of the Mississippi*
(1959) by Virginia C. Eifert.

188

Climbing at Burden Falls, Pope County

Forest glade, Long Spring, Massac County, with sphagnum moss and Osmunda ferns

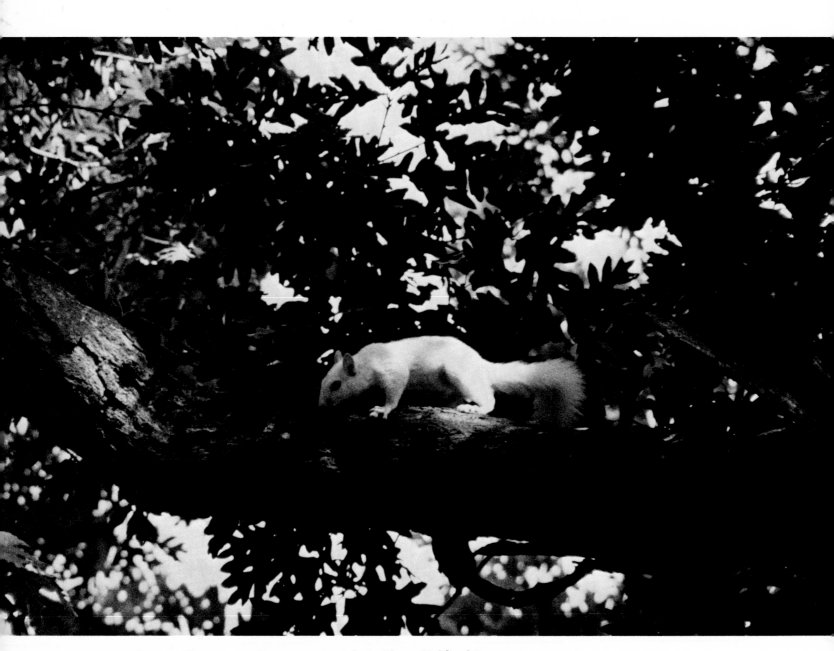

The rare albino squirrel is a common sight in Olney, Richland County

Female cottonmouth and young

People now can scarcely realize how little
money there was in this part of southern
Illinois fifty or sixty years ago. Men used to
give shooting matches to get a better price
for beef animals and poultry. . . . One old
Tennessean nearly always got the "hide and
taller." He was a fine shot and almost always
swapped the first prize for a jug of whisky, of
which there was plenty. The drunker he
became, the better he shot.

—Shooting for beef in the old days. From *This Is All
I Can Remember* (1954) by Frank Hickman

*Southern Illinois University scientist studies
reptiles at the university's Pine Hills Biological
Field Station, Union County*

Spring Cave fish (2½ times life size)

Rock Salamander, Pine Hills Biological Field Station, Southern Illinois University at Carbondale

192

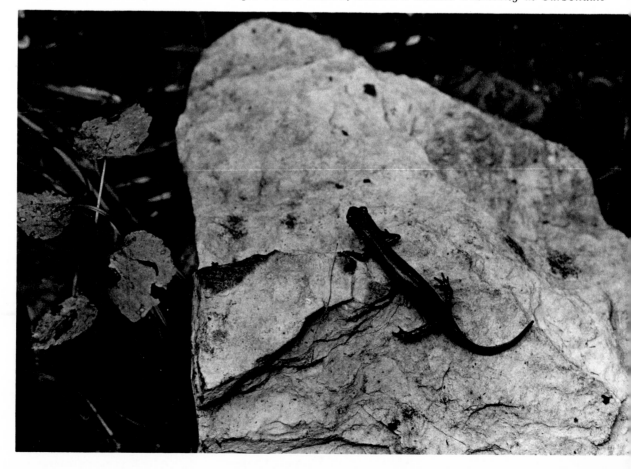

Bantam Sunfish (1½ times life size)

Male Banded Pygmy Sunfish (1¾ times life size)

White-tailed deer, Shawnee National Forest

Spring in southern Illinois was the most unpredictable season of the year. Winter always seemed reluctant to give way to the quickening urge of April and May. Just when everyone was eager and ready to welcome the first warm day, a cold, raw wind would set spring back on its haunches, forcing people to fire up their furnaces and stoves again. Then suddenly, without warning, the weather would switch to almost summer heat and everything seemed to blossom out overnight. Forsythia and bridal wreath turned the Abbotts' front yard into a mass of yellow and white blooms; and the young tender leaves of the maples, with their lacy green, gave the effect of a scene in a Japanese print.

—From *Elizabeth Abbott: A Novel of Southern Illinois* by Mae Smith Trovillion. Copyright © 1956 by Mae Smith Trovillion

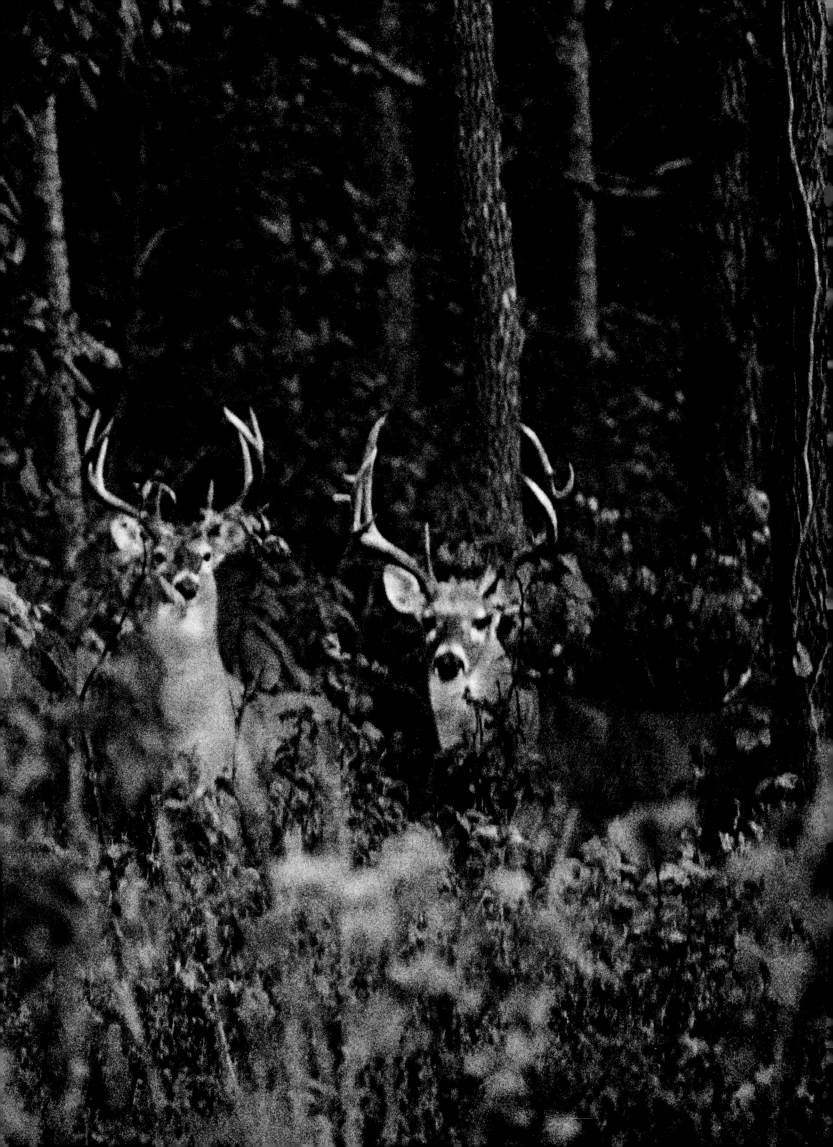

Smooth sumac

The Golden Mouse frequents the marshy river bottoms

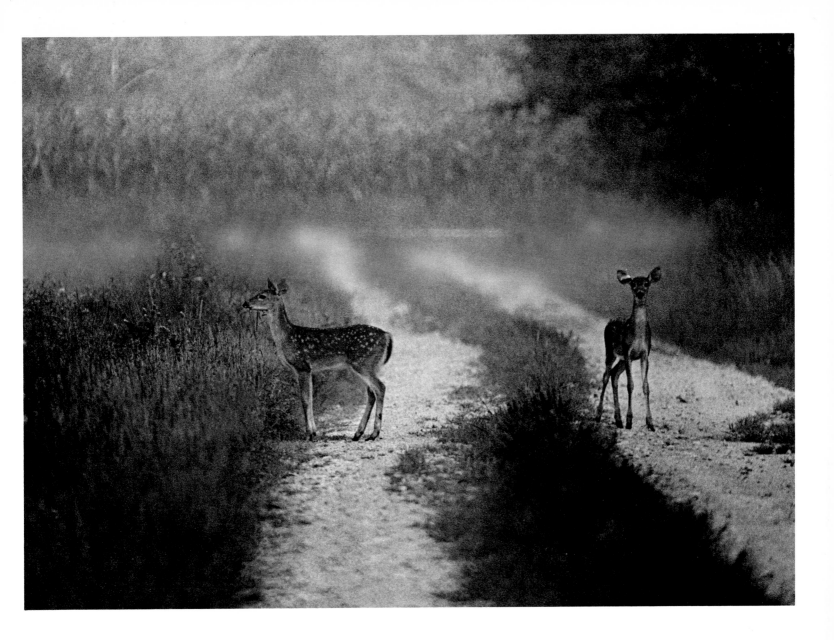

The writer had not been in the country one year before he had
learned half a dozen lessons in frontier knowledge of great value
in practical life. One was how Indians, hunters, surveyors, and
all others who had to travel over uninhabited deserts, made their
camping-place, and kept themselves comfortable. The first thing
is to select the right place, in some hollow or ravine protected
from the wind, and if possible behind some old forest giant which
the storms of winter have prostrated. And then, reader, don't
build your fire against the tree, for that is the place for your head
and shoulders to lie, and around which the smoke and heated
air may curl. Then don't be so childish as to lie on the wet, or cold
frozen earth, without a bed. Gather a quantity of grass, leaves,
and small brush, and after you have cleared away the snow, and
provided for protection from the wet or cold earth, you may sleep
comfortably.

—John Mason Peck, the famous Southern Illinois Baptist circuit-rider, tells how
to make camp. From Peck's *Forty Years of Pioneer Life* (1864), reprinted by
Southern Illinois University Press (1965)

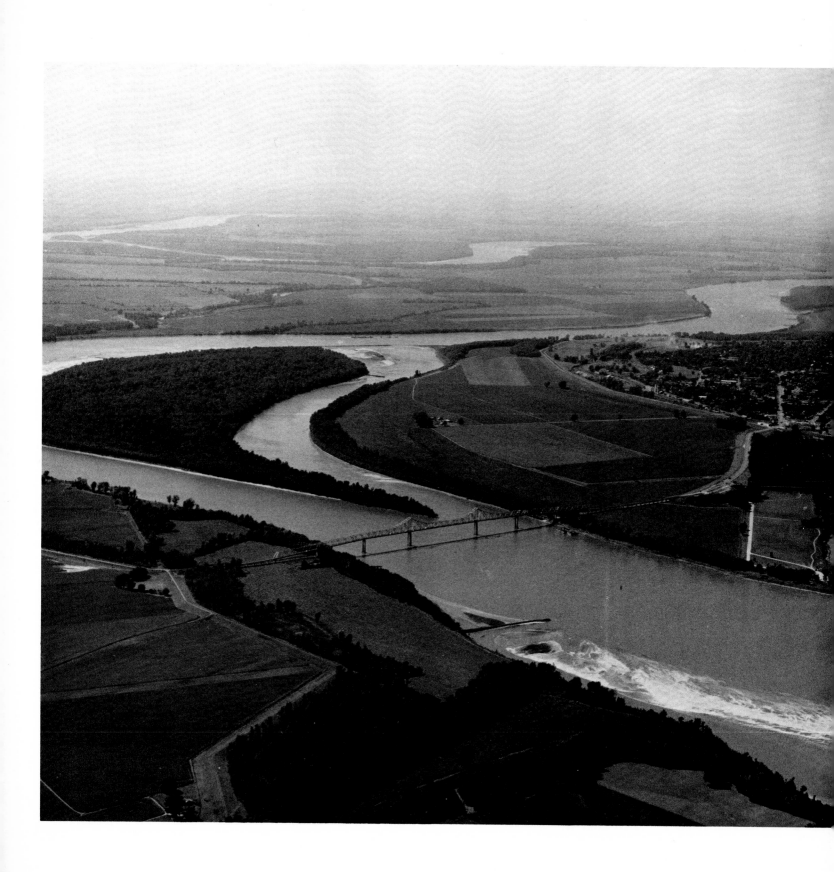

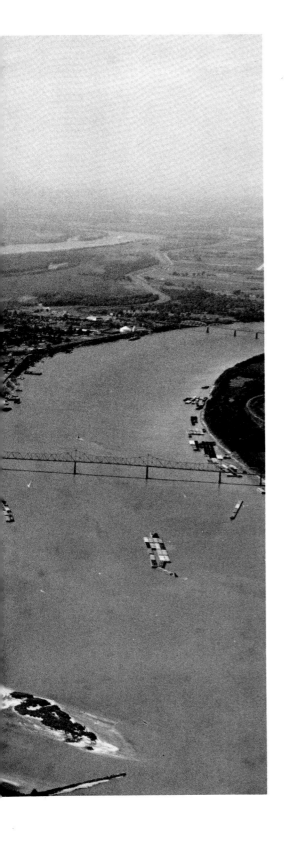

Southward, near Cairo passing, you can see
The Ohio merging,—borne down Tennessee;
And if it's summer and the sun's in dusk
Maybe the breeze will lift the River's musk
—As though the waters breathed that you might know
Memphis Johnny, Steamboat Bill, Missouri Joe. . . .

The River, spreading, flows—and spends your dream.
What are you, lost within this tideless spell?
You are your father's father, and the stream—
A liquid theme that floating niggers swell.

Damp tonnage and alluvial march of days—
Nights turbid, vascular with silted shale
And roots surrendered down of moraine clays:
The Mississippi drinks the farthest dale.

ACKNOWLEDGEMENTS AND PERMISSIONS

The authors wish to express here their appreciation to the Southern Illinois University Centennial Committee for the sponsorship of this volume as a Centennial Publication, and particularly to former Vice President Charles W. Tenney and Carroll L. Riley, Basil C. Hedrick, and Harold W. Kaplan, for their continued interest and encouragement. We are grateful to the University's Office of Research and Projects in the Graduate School for financial assistance in the processing of the photographs and the preparation of the text.

We are also indebted to a number of individuals, both present or one-time members of the faculty and staff of the University, as well as to many Southern Illinois residents, who generously furnished a great deal of special information about the region, and who in many instances also read the text and offered corrections and other helpful suggestions. They are: Melvin Fowler, formerly of the Department of Anthropology and now at the University of Wisconsin at Milwaukee; Robert W. Harper, formerly of the Department of Geography and now at the University of Maryland; Milton Edelman and former President Robert W. Layer, both of the Department of Economics; Jon Muller and John Belmont of the Department of Anthropology; Stanley Harris, Department of Geology; David W. Kenney, Department of Government; David McIntosh, Professor Emeritus, Department of Music; John Mercer and Robert Davis, Department of Cinema and Photography; William B. Pitkin, Professor Emeritus, and John Simon, Department of History; Willard Klimstra and William Lewis, Department of Zoology; Herman Lantz, Department of Sociology; Irvin M. Peithmann, Department of Recreation and Outdoor Education; Frances Barbour and Jesse W. Harris, professors-emeriti, and E. Earle Stibitz, William Simeone and Howard W. Webb, Jr., all of the Department of English; Nancy Gillespie of Murphysboro; the Reverend Robert W. Hastings, formerly of Carbondale and now of Springfield; Dan Malkovich, editor and publisher of *Outdoor Illinois;* Goffrey Hughes, director of Southern Illinois, Inc.; and Frank Rackerby of the University Museum.

The authors wish to credit these individuals who supplied the following color photos: John Schwegman (Yellow Lady's-slipper Orchid, Spring Lady's-tresses Orchid, Crested Coralroot Orchid, Indian Pink, and Long Spring); Robert Mohlenbrock (Prickly Pear Cactus); Marion Mitchell (Indian pictograph and petroglyphs); William Lewis and the Cooperative Fisheries Research Laboratory (Spring Cave fish, Bantam Sunfish, and Male Banded Pygmy Sunfish); W. D. Klimstra (the Golden Mouse).

We are also indebted to Vernon Sternberg, the director of the Southern Illinois University Press, for his continued interest and advice, and to the book's designer, Andor Braun, for the imaginative and sensitive manner in which he brought to creative fruition this complex interdisciplinary, and multi-media, undertaking.

Despite the attention that we have given to the editorial material, some errors may not have been entirely avoided. The authors cordially welcome any corrections, either of the facts reported here or their interpretation.

The authors and publishers wish to thank the publishers and individuals listed below for permission to quote from the following works in copyright:

The American Folklore Society and Edith S. Krappe for Grace Partridge Smith, "The Super-Mosquitoes" in "Folklore from 'Egypt,'" *Journal of American Folklore*, Vol. 54 (1941), Philadelphia, Pennsylvania.

American Philosophical Society and John Francis McDermott for J. F. McDermott, ed., "The Western Journals of Dr. George Hunter, 1796–1805," *Transactions of the American Philosophical Society*, Vol. 53 (1963), Philadelphia, Pennsylvania.

Dodd, Mead & Company for Virginia Eifert, *River World: Wildlife of the Mississippi,* copyright © 1959 by Virginia S. Eifert.

Doubleday & Company, Inc. and Ethel M. Sinclair for Harold Sinclair, *Years of Illusion,* copyright © 1941 by Doubleday & Company, Inc., New York.

Exposition Press, Inc. for Mae Smith Trovillion, *Elizabeth Abbott: A Novel of Southern Illinois,* copyright © 1956 by Mae Smith Trovillion.

H. T. FitzSimons Company, Inc. for "La Guillannée" from Cecelia Ray Berry et al., *Folk Songs of Old Vincennes,* copyright © 1946 by H. T. FitzSimons Company, Inc., Publishers, Chicago.

The Estate of Ruby B. Goodwin for Ruby Berkley Goodwin, *It's Good to Be Black,* copyright © 1953 by Ruby Berkley Goodwin.

Hall, Dickler & Howley and R. Buckminster Fuller for R. Buckminster Fuller, "Southern Illinois University: An Address, 1969," unpublished address.

Harcourt Brace Jovanovich, Inc. for Carl Sandburg, Ed., "El-a-Noy" in *The American Songbag,* copyright © 1927 by Harcourt Brace and Company, Inc., New York.

Holt, Rinehart and Winston, Inc. for R. E. Banta, "The Banks of the Ohio" in *The Ohio*, text copyright © 1949 by R. E. Banta; photographs copyright © 1949

Carbondale, Ill.

October 18, 1971

C. W. H.

H. D. P.

J. W. V.

SUGGESTIONS FOR FURTHER READING

General

John W. Allen, *Legends and Lore of Southern Illinois*, Area Services Division, Southern Illinois University, Carbondale, 1963.

————, *It Happened in Southern Illinois*, Area Services Division, Southern Illinois University, Carbondale, 1968.

Baker Brownell, *The Other Illinois*, Duell, Sloan and Pearce, New York, 1958. (Probably the best single introduction to the region.)

Charles C. Colby, *A Pilot Study of Southern Illinois*, Southern Illinois University Press, Carbondale, 1956.

Will Griffith, Ed., *Idols of Egypt*, Egypt Book House, Carbondale, Illinois, 1947. (Essays on major personalities; first printed in the magazine *Egyptian Key*.)

Walter Havighurst, *Voices on the River: The Story of the Mississippi Waterways*, Macmillan Company, New York, 1964.

George Kimball Plochmann, *The Ordeal of Southern Illinois University*, Southern Illinois University Press, Carbondale, [1959].

Robert G. Layer, *The Fundamental Bases of the Economy of Southern Illinois*, Southern Illinois University, Business Research Bureau, School of Business, 1965.

Physical and Recreational

Clarence Bonnell, *The Illinois Ozarks*, Register Publishing Company, Harrisburg, Illinois, 1946.

Virginia L. Eifert [Snider], *River World: Wildlife of the Mississippi*, Dodd, Mead, New York, 1959. (Charmingly written account of a trip down the Mississippi River, describing wildlife encountered along the Southern Illinois shore.)

Stanley Harris Jr. and J. Harlen Bretz, *Caves of Illinois*, Illinois State Geological Survey, Urbana, Illinois, 1961. (Mainly about Southern Illinois speleology.)

Robert H. Mohlenbrock and John W. Voigt, *A Flora of Southern Illinois*, Southern Illinois University Press, Carbondale, 1959.

John W. Voigt and Robert H. Mohlenbrock, *Plant Communities of Southern Illinois*, Southern Illinois University Press, Carbondale, 1964.

Stuart Weller, *The Story of the Geologic Making of Southern Illinois*, Illinois State Geological Survey, Urbana, 1927.

(In addition the reader is referred to the various articles in the *Transactions* of the *Illinois State Academy of Sciences* dealing with Southern Illinois, as well as to pamphlets and other publications relating to the region, published by the State Geological, Water, and Natural History Surveys, at Urbana, by the Illinois State Museum at Springfield, and by the Departments of Business and Economic Development, the Department of Conservation, and other State agencies. Maps and other information can also be obtained from the Southern Illinois Tourism Council, Southern Illinois, Inc., P.O. Box 85, Carterville, Illinois.)

General History

Clarence W. Alvord, general editor, *The Centennial History of Illinois*. The earlier volumes of this six-volume series are concerned primarily with Southern Illinois. See especially Volumes I and II: Clarence W. Alvord, *The Illinois Country 1673–1818*, Illinois Centennial Publications, Springfield, 1920, and T. C. Pease, *The Frontier State, 1818–1848*, Illinois Centennial Publications, Springfield, 1918.

Solon J. Buck, *Illinois in 1818*, Introductory volume, *The Centennial History of Illinois*, Illinois Centennial Publications, Springfield, 1917; reprinted, University of Illinois Press, Urbana, 1967. (This excellent overview of Illinois at the time it became a state is largely concerned with Southern Illinois.)

George Rogers Clark, *The Conquest of Illinois*, M. M. Quaife, Ed., R. R. Donnelley Co., Chicago, 1920. (Clark's record of his historic march across Southern Illinois in 1778.)

Everett Dick, *The Dixie Frontier*, A. A. Knopf

Publishers, New York, 1948. (This readable study of everyday life on the Southern frontier applies to most of Southern Illinois before the Civil War.)

James J. Hall, *Letters From the West*, H. Colburn Publishers, London, 1828; reprinted by the University of Florida Press, 1967. (Descriptions of frontier life by a newspaper editor in Shawneetown, who became the most celebrated man of letters to write about early Southern Illinois.)

W. H. Milburn, *The Pioneers, Preachers, and People of the Mississippi Valley*, Derby and Jackson Publishers, New York, 1860.

Irvin M. Peithmann, *Indians of Southern Illinois*, Charles C. Thomas Co., Springfield, Illinois, 1964. (A revision of his earlier *Echoes of the Red Man*, Exposition Press, Inc., New York, 1955.)

George W. Smith, *A History of Southern Illinois: A Narrative Account* . . . three volumes, The Lewis Publishing Company, New York and Chicago, 1912. (Out of date, but filled with interesting details.)

Joyce Thompson, Ed., *Stories of Historic Illinois*, Illinois Power Company, 1968. (Illustrated pamphlet commemorating the state's 150th birthday, primarily devoted to early Southern Illinois history.)

(In addition, the reader will find considerable historical and other information in *The Egyptian Key* magazine, Carbondale, April, 1943 – September 1951, and the *Journal of the Southern Illinois Historical Society*, Carbondale, January, 1944 – April, 1953, as well as the monthly *Outdoor Illinois* magazine published in Benton, the daily *Southern Illinoisan* newspaper, published at Carbondale, and other local newspapers. Microfilms of most newspapers, including many now defunct, are preserved in the Morris Library, Southern Illinois University, and some have been the subject of unpublished M.A. dissertations.

Two other valuable publications series are the Publications of the Illinois Archeological Survey at the University of Illinois, especially Bulletin 1, *Illinois Archeology*, and Bulletin 2, *Indian Mounds and Villages in Illinois;* and the *Southern Illinois Studies Series* in the Research Records Publications of the University Museum, Southern Illinois University, Carbondale. See under the latter, for example, *Historic Profiles of Fort Massac*, by William G. Farrar and JoAnn Farrar, Southern Illinois Studies, No. 5, Carbondale, 1970.)

Local History and Culture

Paul Angle, *Bloody Williamson*, Knopf, New York, 1952. (A lively account of violence in the coal-mining region of Southern Illinois.)

Natalia M. Belting, *Kaskaskia Under the French Regime*, University of Illinois Press, Urbana, 1948.

Charles E. Boewe, *Prairie Albion: An English Settlement in Pioneer Illinois*, Southern Illinois University Press, Carbondale, 1962.

Fay-Cooper Cole, *et. al., Kincaid: A Prehistoric Illinois Metropolis*, University of Chicago Press, Chicago, 1951. (Illustrated description of archeological surveys of the Kincaid Mounds.)

John McMurray Lansden, *A History of the City of Cairo, Illinois*, R. R. Donnelley and Sons Co., Chicago, 1910.

Herman R. Lantz (with the assistance of J. S. McCrary), *People of Coal Town*, Columbia University Press, New York, 1958. (A sociological study of a typical coal-mining community.)

George W. May, *Massac Pilgrimage*, Edwards Bros., Publishers, Ann Arbor, Michigan, 1964.

John Francis McDermott, Joseph P. Donnelley *et. al., Old Cahokia*, St. Louis Historical Documents Foundation, St. Louis, Missouri, 1949.

Otto A. Rothert, *The Outlaws of Cave-In-Rock*, Arthur H. Clark Co., Cleveland, Ohio, 1924.

(In addition, the reader is referred to the various histories of Southern Illinois counties, most of them assembled during the late 19th century and long out-of-date, as well as several recent county and town histories of varying reliability, often rich in anecdotes and other human interest material. A number of unpublished Masters and Ph.D. dissertations concerning the region will be found in the Morris Library, Southern Illinois University, Carbondale.)

Reminiscences

W. W. Blackman, *The Boy of Battle Ford and the Man*, Egyptian Press Printing Co., Marion, Illinois, 1906.

Daniel H. Brush, *Growing Up With Southern Illinois,* M. M. Quaife, Ed., R. R. Donnelley and Sons Co., Chicago, 1944.

Peter Cartwright, *Autobiography of Peter Cartwright, The Backwoods Preacher*, W. P. Strickland, Ed., Cranston and Curts, Cincinnati, 1857. (Life of a famous Methodist circuit-riding preacher.)

Ruby Berkley Goodwin, *It's Good to be Black*, Doubleday Publishing Co., New York, 1953. (A Black girl grows up in Du Quoin, ca. 1905–1915.)

John Laurence Heid, *River City: A Home-town Remembrance of Cairo, Illinois*, Exposition Press, New York, 1966.